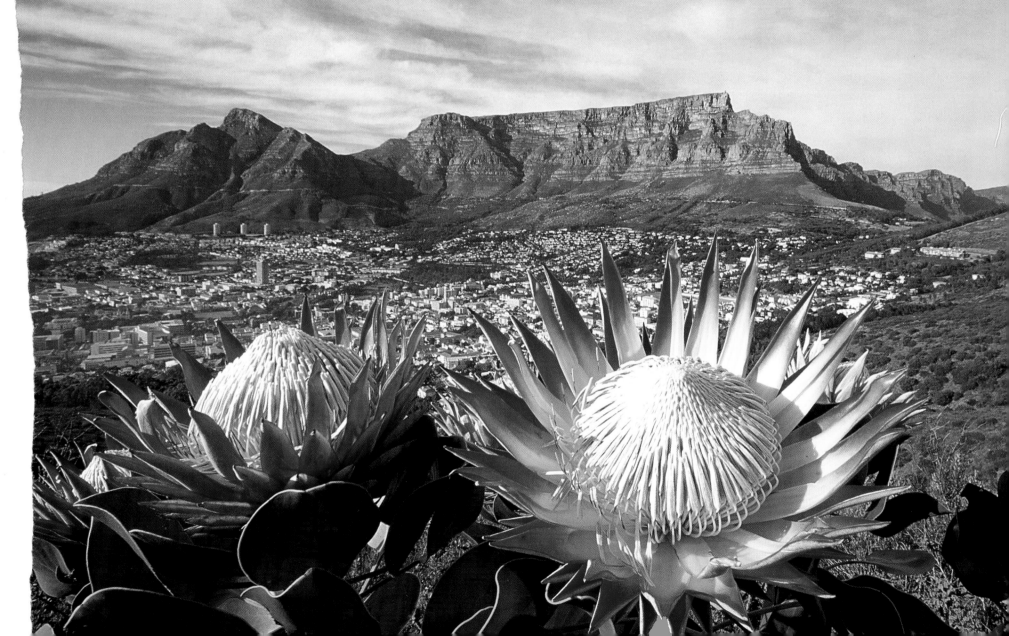

SCENIC
CAPE TOWN

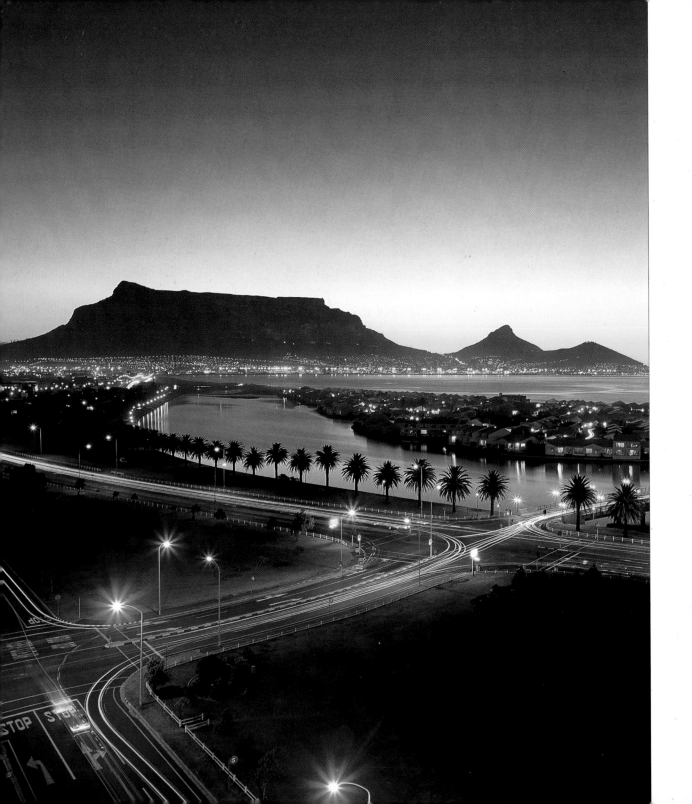

SUNBIRD
PUBLISHERS

2 4 6 8 10 9 7 5 3 1
First Published 1999
Second Edition 2006
Sunbird Publishers (Pty) Ltd
PO Box 6836, Roggebaai, 8012 Cape Town, South Africa

www.sunbirdpublishers.co.za

Registration number: 4850177827

Publisher Natanya Mulholland
Designer Mandy McKay
Editor Brenda Brickman
Production Manager Andrew de Kock

Reproduction by Unifoto (Pty) Ltd, Cape Town
Printed and bound by Tien Wah Press (Pte) Ltd, Singapore

ISBN 0 62403 793 2

PREVIOUS PAGE *Table Mountain, with its spectacular assortment of vegetation, forms a vital part of the Cape Floral Kingdom, which includes fynbos, the most notable of which is the unmistakable protea.*

LEFT *As the summer sun sets over the Mother City, the streets come to life, adding a rainbow of colour to the nightlife.*

OPPOSITE *As the confines of the city began to expand, a considerable sweep of land was reclaimed from the sea, so that the modern City Bowl – enclosed by Table Mountain, Lion's Head, Signal Hill, and Devil's Peak – now extends to the new Waterfront complex, some two kilometres into what was originally the waters of Table Bay.*

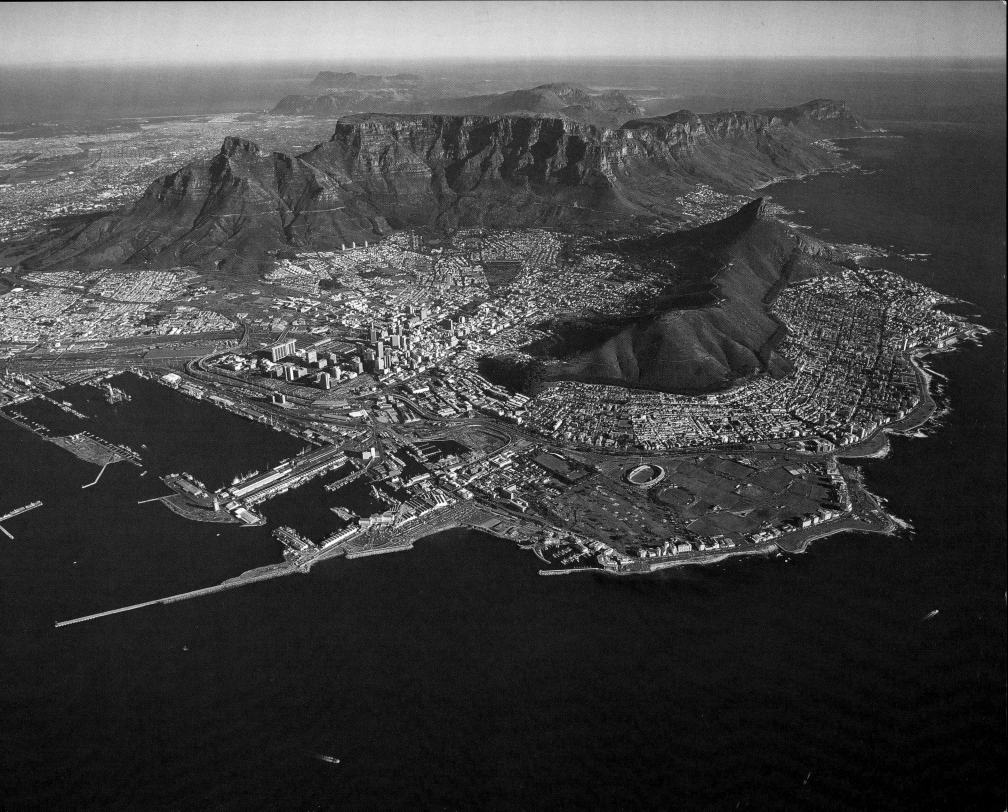

Introducing Cape Town

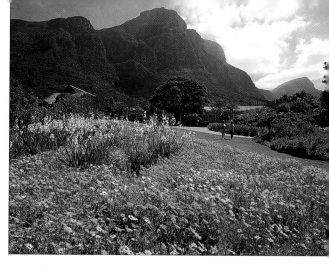

Cape Town, dominated by its famed flat-topped mountain and virtually encircled by the crashing waves of the Atlantic Ocean, is arguably Africa's most celebrated city. First inhabited by the San thousands of years ago, the city has in more recent times come to symbolise the renaissance of the entire continent.

The site of the founding European colony and not for nothing known as the Mother City, modern Cape Town is peopled with an eclectic blend of cultures, which include people of Dutch, English, Malay, Khoi and black descent, the legacy of all reflected in the many faces of the

BELOW *Scattered along the busy pavements of Adderley Street are the bright and cheery flower sellers.*

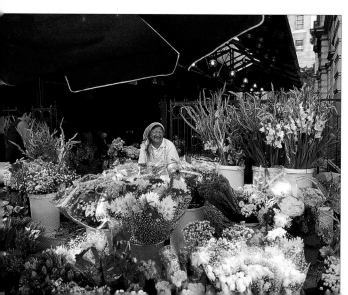

cosmopolitan city, from its grand old Cape Dutch homesteads and whitewashed fishermen's cottages to its striking cathedrals, synagogues, mosques and kramats.

Once revered as the continent's most coveted harbour, majestic Table Bay has borne witness to more than three centuries of maritime trade but, although currently enjoying renewed interest in its role in the broader African economy of today, is more popularly entrenched in the hearts and minds of its people and ever-increasing number of visitors for the symbolism represented by the tiny island some 11 kilometres off its shore.

The 574-hectare Robben Island, once reserved for the livestock raised by the early colonists to sustain the crews of ships passing the fledgling settlement en route to the lucrative trading grounds of the East, and later as a leper and penal colony, is now more renowned – or, rather, infamous – as the long-time home of Nelson Mandela during his 27-year incarceration in the dark years of apartheid.

Pounded by the stormy Atlantic, the island is the breeding ground of a multitude of seabirds and home to an array of indigenous flora, and historians and conservationists have succeeded in having the sensitive ecosystem proclaimed a national monument and World Heritage Site.

Far across the 11.5-kilometre stretch that separates the wave-lashed island from the mainland looms landmark Table Mountain, which, according to local legend, watches over and protects the people of Cape Town. With Signal Hill to the northeast and Lion's Head to the southwest, the great sandstone mountain envelops what is today known as the City Bowl, the economic hub of Cape Town. At the centre of this relatively small metropolis – the population of the greater metropolitan area is currently around four million – is the centuries-old Castle of Good Hope, the pentagonal fort built from stone excavated on Robben Island in the 1660s by the Dutch governor to protect the citizens of the small colony. As one of the country's foremost museums and the regional headquarters of the national defence force, the old Castle now presides over a bustling Grand Parade, once the stomping ground of British and Dutch militia who occupied the Cape at various times during its rather turbulent history. Today, its paved confines serve as a much-needed

car-park in the city centre and, on Wednesdays and Saturdays, as the site of an eclectic market specialising in fabric and haberdashery. Alive with the animated banter of vendors and the chit-chat of pedestrian traffic, the market is second only in popularity to the most famous of Cape Town's many flea markets, that on Greenmarket Square.

Originally established as the local market-place in the early 1700s, Greenmarket Square attracted farmers from far and wide and, true to its tradition as a meeting place and trading ground, it continues to hum with the feverish activity of bargain-hunters sifting through the stalls of knick-knacks and souvenirs, which appear to cover every inch of the cobbled square overlooked by the grand old edifices of the Old Town House – housing the old masters of the Michaelis Art Collection – and the Metropolitan Methodist Church.

BELOW At the foot of the Klein Leeukoppie lies Llandudno, its picturesque beach hedged in by granite boulders and one of the best beaches for surfing and sunbathing.

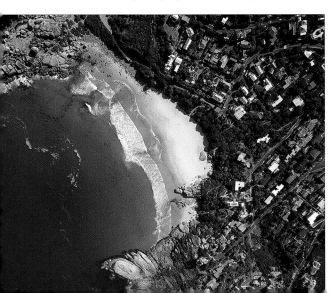

In fact, interspersed with the contemporary structures of modern times is a conglomeration of Dutch and Victorian architecture, from both the Cultural History Museum in Adderley Street to the stately Houses of Parliament that run down the western stretch of the Company Gardens on Government Avenue. At the top of Government Avenue, where it meets up with Oranje Street, is one of Cape Town's most recognisable buildings, the candy-coloured Mount Nelson Hotel, for 100 years the home-away-from-home for heads of state, royalty and movie stars alike.

The stately luxury of 'The Nellie', however, is a far cry from the row upon row of neat little cottages to the west, which are known collectively as the Bo Kaap (upper Cape). As it has been for decades, this Malay Quarter is occupied largely by the city's Muslim community, descendants of the slaves shipped in from Indonesia, Malaysia and other Dutch possessions in the East. These devout followers of the Islamic faith continue to celebrate their rich heritage passed on to the varied culture of modern Cape Town, most notably in the New Year festivities when the dancing minstrels don gaudy costumes and paint their faces to parade in the annual, self-styled Coon Carnival.

Another old tradition that has passed into the hands of a new generation and now a major economic boost to the city is the leisure land on what was once Cape Town's rather run-down and neglected docklands. Today the Victoria & Alfred Waterfront complex – alongside the working harbour – is a vibrant collection of trendy shops, entertainment venues, sophisticated restaurants

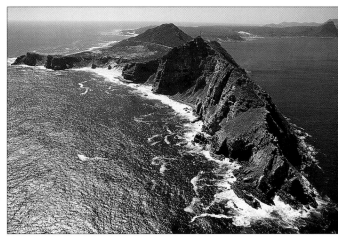

ABOVE The rugged landscape and rocky, wave-lashed coast of Cape Point is today a protected wildlife sanctuary.

and fast-food outlets. Adjoining the ever-growing complex, which has become the city's top tourist attraction, is the Royal Cape Yacht Club and marina, dotted with private sailing vessels and the occasional charter boats, taking visitors on cruises beyond the harbour, past the sophisticated new hotel developments of Table Bay and Granger Bay to the leisure strip on the peninsula's western seaboard.

Plush residential suburbs stretch from Green Point – venue of the busy Sunday market – and Mouille Point (pin-pointed by the red-and-white candy stripes of the landmark lighthouse on the beachfront) along the lower slopes of Lion's Head through to Sea Point, and the city's famed beach meccas of Bantry Bay, Clifton, Camps Bay, Llandudno and Sandy Bay, unofficially sanctioned as Cape Town's own nudist beach. Looming above the grand homes and scenic viewpoints of this African Riviera is the mountain range of 17 peaks known as the

Twelve Apostles, which, in turn, ends in the tranquil fishing village of Hout Bay. One of the few remaining havens of artists and poets, the semi-rural landscape is graced with wooded mountain slopes – *hout* is the Dutch word for 'wood', after the timber sourced here in earlier times – and the white expanses of soft sand that stretch along the shores of the bay that was once a vital link in the economy of the early colony.

Beyond the confines of the picturesque cove, along the winding Chapman's Peak Drive etched into the rocky face of the mountain slopes, lie yet other sleepy little villages that appear to have been lost in a less frenetic time. Noordhoek, Kommetjie and Scarborough, unspoilt and refreshingly untainted by modern development, still serve as the refuge of Capetonians intent on escaping the rat race that is life in the city.

BELOW The awe-inspiring views from the top of Table Mountain extend to the fishing village of Hout Bay and beyond.

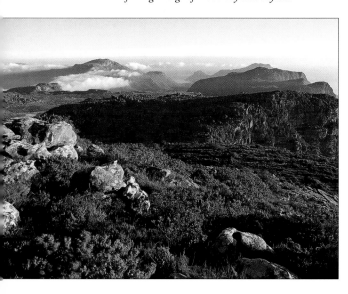

The entire Cape Peninsula, stretching from Signal Hill to Cape Point and including Table Mountain, was declared a national park in May 1998, and the new Table Mountain National Park covers some 30,000 hectares of state and privately owned land. It includes under its protection a wealth of animal and plant species – including *fynbos* of the Cape Floral Kingdom – and is thus eligible for status as a World Heritage Site, but it is the Cape of Good Hope Nature Reserve and Cape Point, the most southerly tip of the Peninsula, that is the heart of this wildlife haven. The land north of Cape Point between Witsand, Olifants Bay and Mast Bay in the east and Buffels Bay and Smitswinkel Bay on the False Bay coast is a protected paradise visited by more than 400 000 people every year. The nearly 8 000 hectares virtually enclosed by the 40-kilometre coastline is home to over a thousand floral species and an extraordinary wealth of wildlife such as the endemic bontebok and the waters, too, are inhabited by migrating whales, dolphins and seals. The conservation of the both the reserve and the broader region remains priority for custodians, and is the reason why nearby Boulders – home to a colony of African penguins – is also a protected area.

A few kilometres north is the small naval 'town' of Simon's Town, the centre of southern Africa's maritime operations since the earliest days of colonialism and now the seat of the South African Navy. Jubilee Square is the heart of Simon's Town, and its bustling new waterfront complex of shops, stalls and bistros looks down over the harbour, with its parade of military ships and colourful leisure boats.

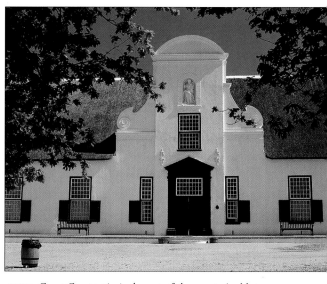

ABOVE Groot Constantia is the seat of the country's oldest manor house and vineyard.

Much like Simon's Town, many of the quaint little suburbs that line the shores of False Bay saw their heyday as fashionable holiday getaways at the turn of the century. Statesmen, princes and industrialists kept homes in Fish Hoek, St James, Kalk Bay and Muizenberg, neatly tucked between the warm waters of False Bay and the looming hulk of Silvermine. But the pride of the residential stretch remains the hills and valleys of Constantiaberg in the heart of the Peninsula. These plush southern suburbs are enveloped by plantations of trees and the cultivated vineyards of Constantia.

Prime among these lush lands are the national botanical gardens at Kirstenbosch, one of the country's most visited tourist spots and a vital research centre focusing on the floral heritage of both the Cape and the rest of the country.

The mountain slopes on which the gardens are located are interlaced with winding hiking paths and the gardens themselves make for a welcome rest after a Sunday walk through the *fynbos* of Table Mountain. Although much of the indigenous wildlife that once traversed the mountainside here has long since vanished with the development and growth of the city at its feet, there is still much to be seen of the local plants and animals, most conspicuous of which are the mischievous little dassies, or rock rabbits, that scamper around an impressive granite tribute to statesman Cecil John Rhodes that graces the mountain – much as they do in similar high-lying, mountainous areas of the Cape – and overlooks the picturesque southern suburbs at the foot of the mountain.

BELOW Fish Hoek's stretch of popular beaches are inevitably alive with colour, action and laughter – and very often dotted with families at play.

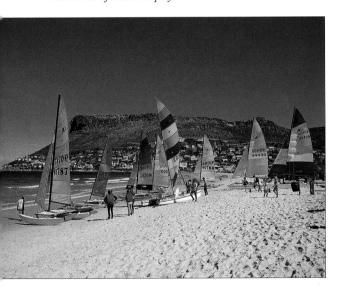

The residential stretch commonly referred to by locals as the 'southern suburbs' lies in the shadow of the mountain ranges that form the spine of the Cape Peninsula, and is situated in the green belt, an area generally blessed with exceptionally good rainfall. These lush – and, quite often, tree-lined – suburban streets and open parklands offer much sought-after real estate, but their real value lies in their close links with the development of Cape society and politics since the earliest days of the colonial settlement, and continue to offer a fascinating look into the history of the city itself, particularly during the days of English and Dutch occupation.

Beyond the immediate city limits and far on the distant horizon, however, lie some of the Western Cape's most impressive gems: to the north of the peninsula, the rugged beauty and gentle *fynbos* of the West Coast stretching from the suburb of Milnerton and, to the east, the verdant and tranquil vineyards of the winelands in the hinterland for which the Cape is renowned throughout the world.

It is, in fact, these two distinctly different environments – with their diverse and often contrasting landscapes – that have proven to be the Cape's most revered assets, and primary tourist destinations in their own right. In August and September every year, thousands of enthusiastic visitors flock to the West Coast to wonder at the miracle of nature that produces the vast expanse of brilliantly coloured blooms that cover the seemingly inhospitable landscape, and spot the whales that cavort in the cold ocean just off the coast.

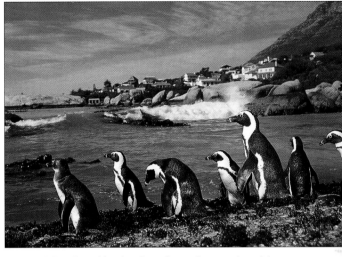

ABOVE Sheltered Boulders beach on the southern reaches of the peninsula is home to a colony of endangered jackass penguins.

The rolling hills and emerald vineyards of Stellenbosch, Paarl and Franschhoek, on the other hand, offer a very different view of the Cape than the sometimes stark West Coast. These vineyards lie at the heart of South Africa's wine-producing land, and tourists and visitors flock there from all over the world to sample the fine wines and experience the rustic enchantment of these famed winelands, rich in history and a proud contributor to the country's renowned liquor industry, creating some of the world's fines wines and brandies.

Stepping confidently and proudly from the social and political chains that shackled its humble beginnings as a colonial settlement, Cape Town has moved into the new millennium to take its rightful place as the shining jewel on the magnificent crown that is Africa. This is the spirit of the modern city, and these are its many and varied faces.

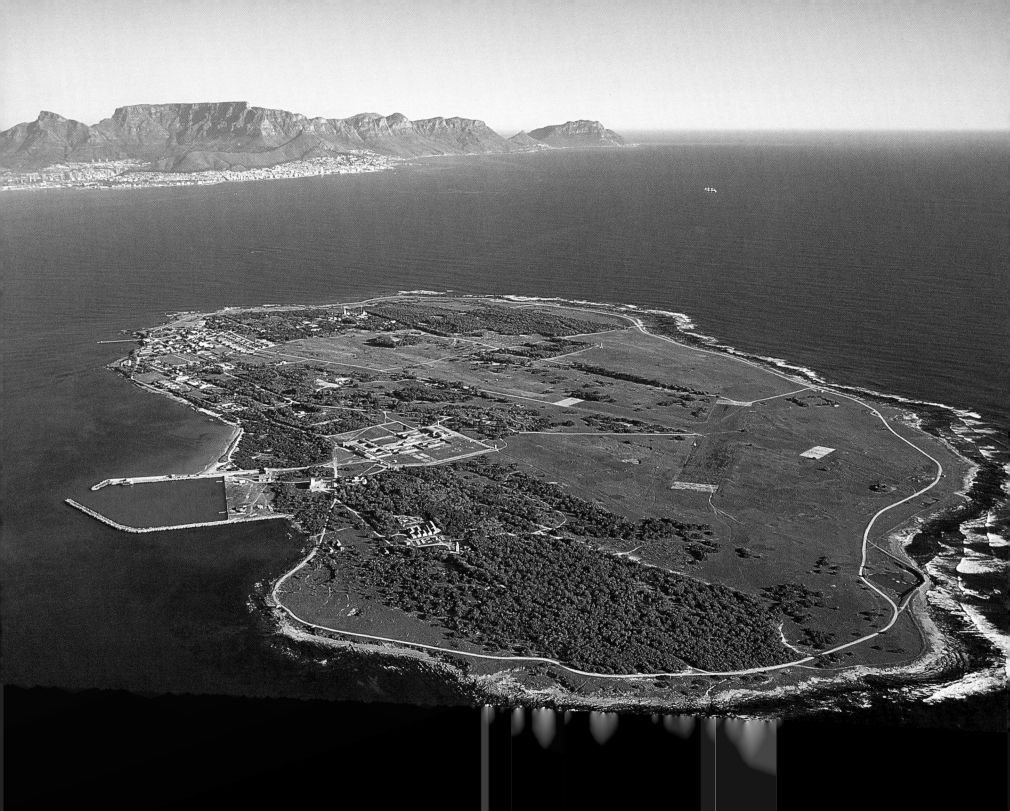

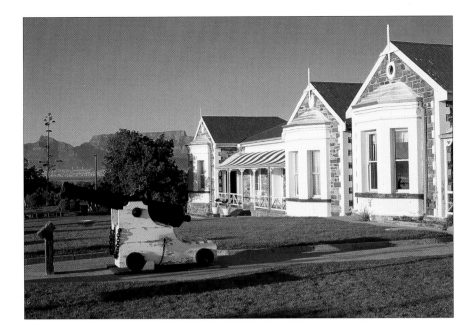

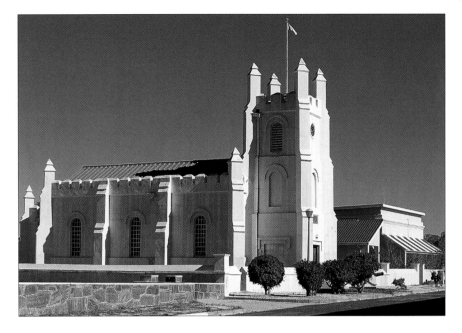

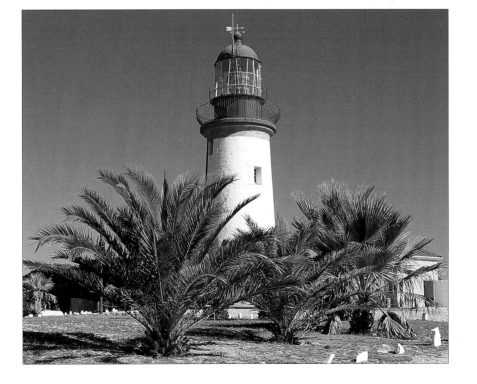

OPPOSITE Isolated as it is by an expanse of more than 11 kilometres of the often savage Atlantic Ocean, Robben Island is perhaps most renowned as the holding place of political prisoners during the country's apartheid years.

ABOVE Erected in 1895 in grand Victorian style, the restored Governor's home and guesthouse on Robben Island is today used as a conference centre for visitors to the island.

ABOVE RIGHT The Garrison Church was once the place of worship of the island's military occupants, and today continues to serve the community on Robben Island.

RIGHT The 18-metre lighthouse, erected on Minto Hill in 1863 to warn approaching vessels of impending danger, is, at 30 metres above sea level, the highest point on Robben Island.

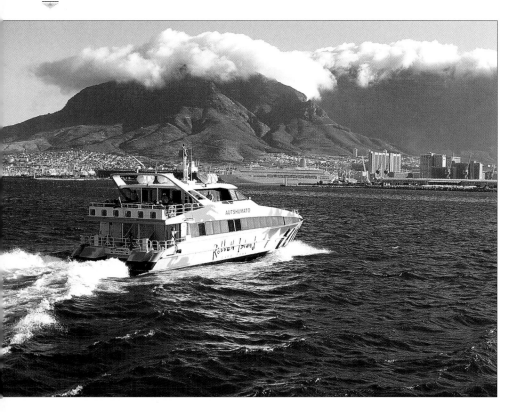

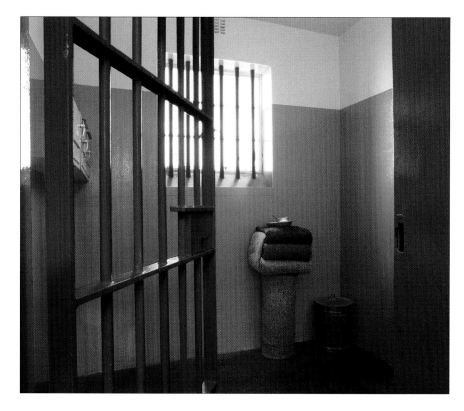

ABOVE Although the old ferries once transported prisoners, the modern vessels carrying visitors to the island reserve offer a considerably more jovial and comfortable experience. TOP RIGHT Former president Nelson Mandela spent almost 19 of his 27-year imprisonment in cell Number 5, overlooking the courtyard of the prison's B-section.

OPPOSITE Shielded by the stormy Atlantic, the treacherous coastline of Robben Island is scattered with the wrecks of many a maritime victim. As a result, the island proved an ideal holding place for prisoners, but its isolation has also meant that the delicate ecosystem of the 574-hectare island has remained well protected from outside influence.

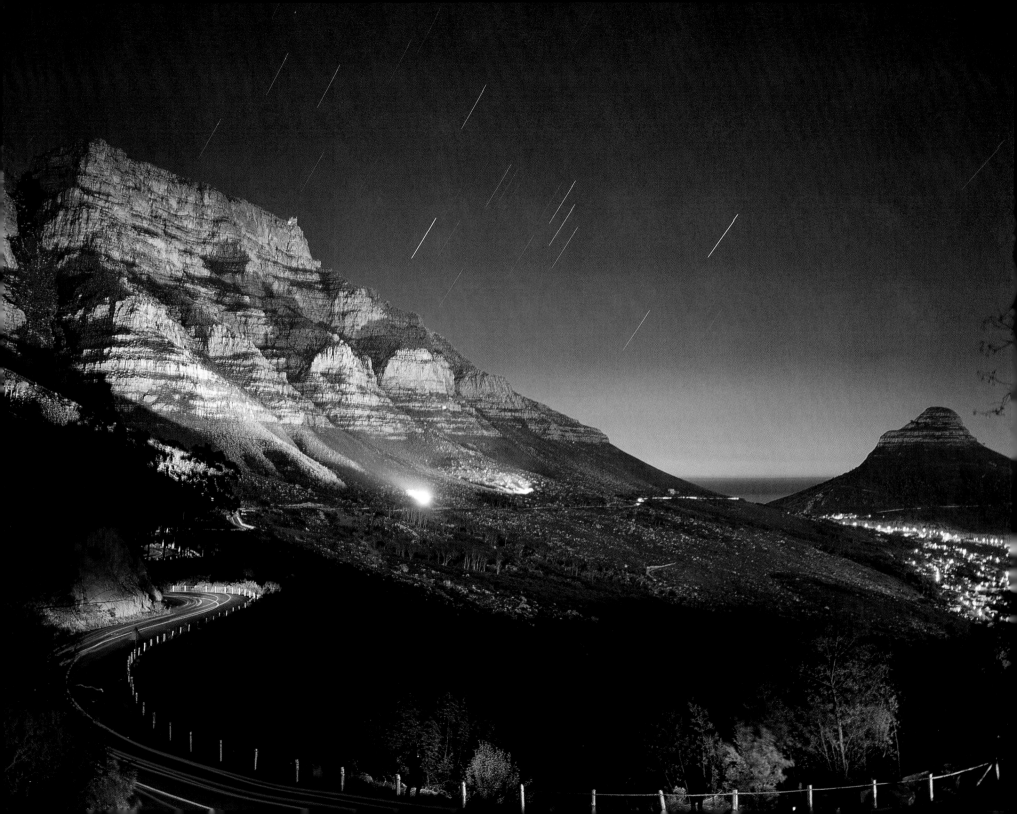

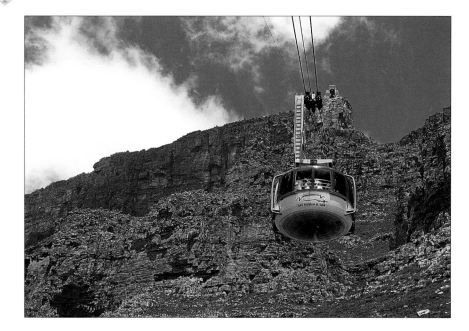

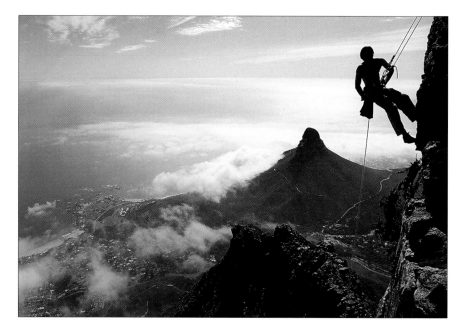

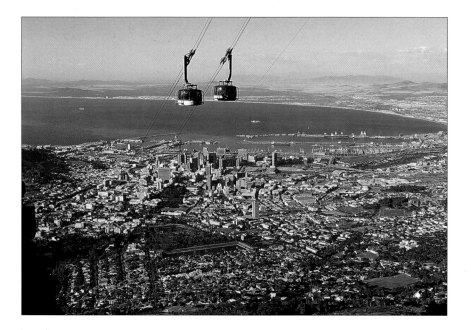

PREVIOUS PAGE, LEFT Table Mountain, the country's most famous landmark, watches over the city as its citizens settle into sleep – or prepare to hit the popular nightspots.

PREVIOUS PAGE, RIGHT Lit at night by spotlights, the imposing facade of Table Mountain is bathed in a soft, romantic glow.

TOP LEFT The Table Mountain Aerial Cableway Company recently renovated and upgraded the old cableway, which had been in service since early this century, so that the more than two million annual visitors may enjoy a faster service and even more spectacular view.

LEFT The two new cable cars, imported from Swtizerland, each seat 65 people and rotate 360 degrees during the four-minute ride up the slopes of Table Mountain.

ABOVE The natural heritage of Table Mountain remains its most popular attraction, and the array of flora and fauna invites endless opportunities for birders, hikers, and rock-climbers.

OPPOSITE Recently upgraded, the plush new facilities at the summit of the mountain, impressive as they are, remain no match for the seemingly endless vista from the cable car.

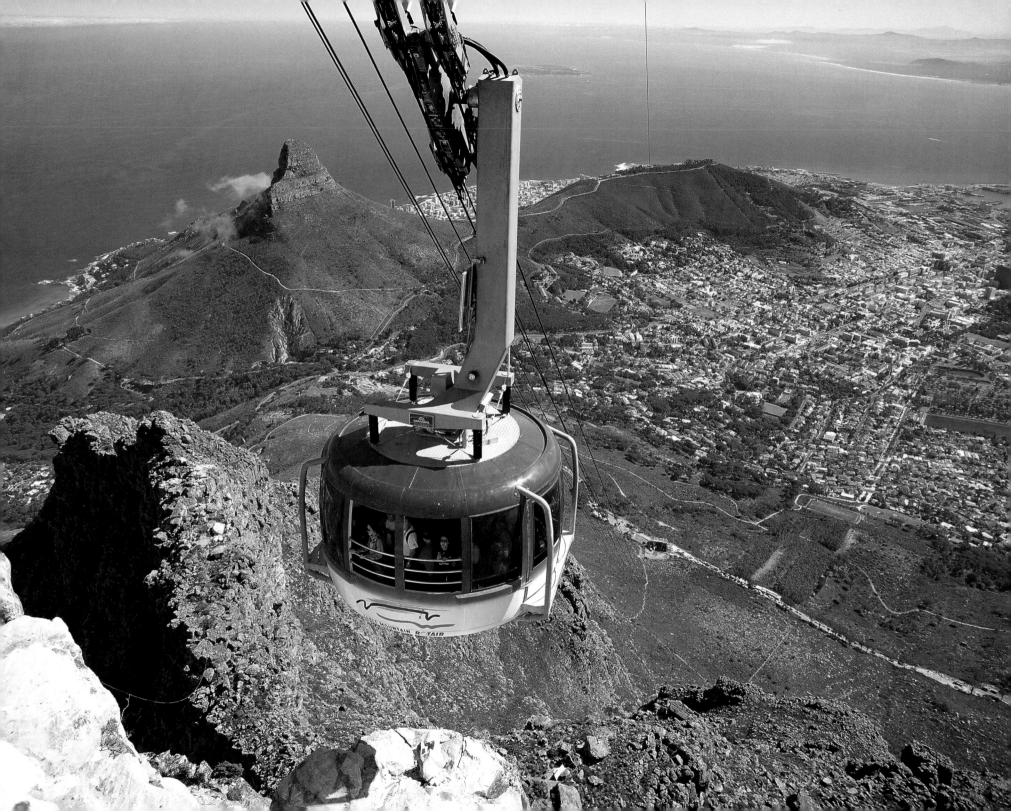

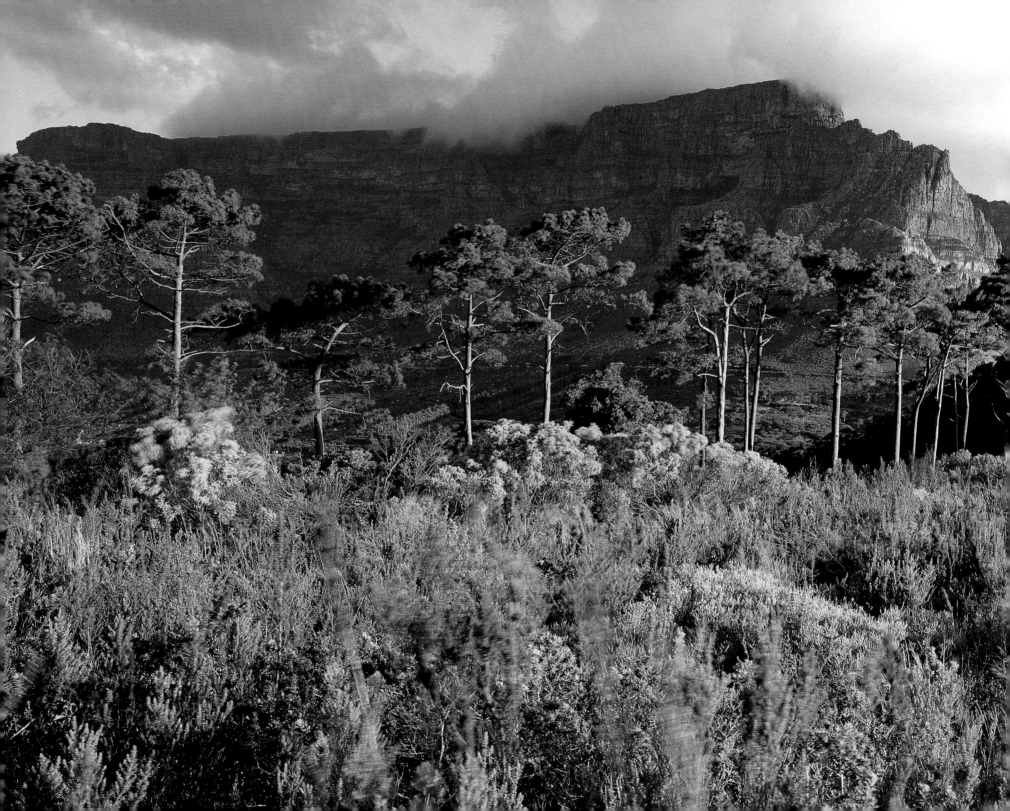

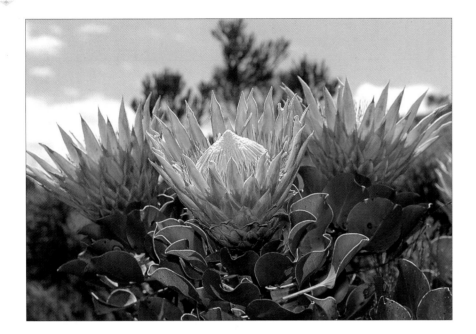

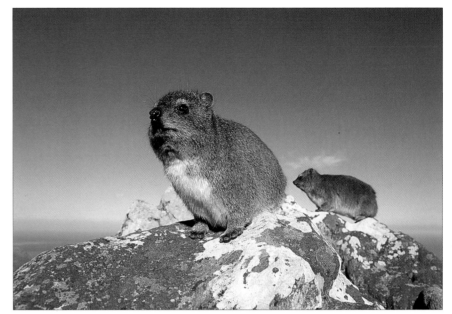

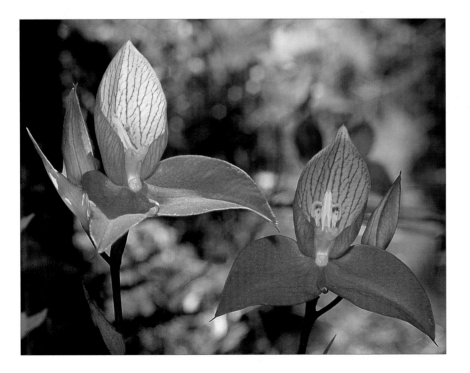

PREVIOUS PAGES The mountain's indigenous flora comprises the unique and hardy *fynbos*, and the peak flowering season sees nearly 1 500 species erupt in colour and texture. The kramat, a holy Muslim shrine, on Signal Hill is one of many that dot the mountain landscape in honour of Muslim spiritual leaders of the Cape's Muslim community.

TOP LEFT Varying greatly in size and form, the protea family – to which South Africa's large-bloomed national flower, the King Protea (*Protea cynaroides*), belongs – occurs only in the southern hemisphere, but is not restricted to South Africa alone. A variety of species may also be found in South America, Australia and New Zealand.

LEFT As a member of the orchid family, the *Disa uniflora* – more commonly known in the Cape as Pride of Table Mountain – is a delicate bloom that is fairly typical of the disa species found in the Peninsula. The most distinct characteristic of these attractive flowers is its hood-like petal flanked by two smaller ones.

ABOVE Scampering along the rocks are dassies, or rock hyraxes, whose stocky appearance and short-haired coats belie their close genetic ties to the African elephant.

OPPOSITE The Cape Peninsula National Park was recently renamed the Table Mountain National Park in honour of the most significant landmark within its far-reaching boundaries. The park itself covers approximately 30,000 hectares of state and private land, with its official borders growing annually and extending across the entire Peninsula and, in parts, into the ocean.

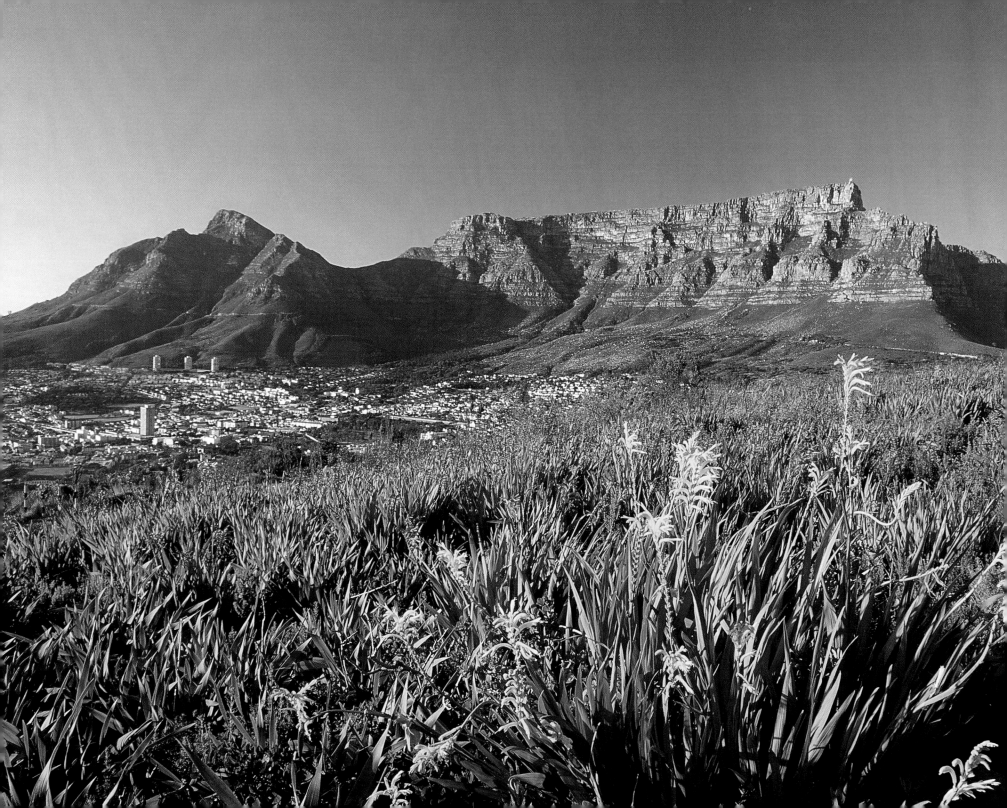

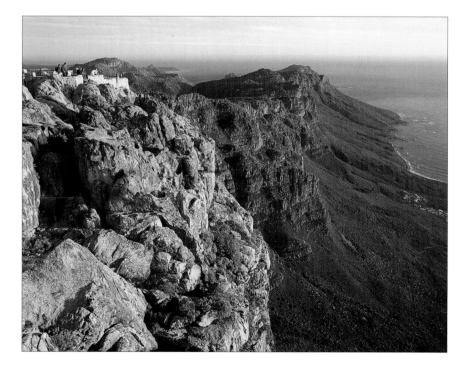

Top left Towering some 1 086 metres above the shoreline, Table Mountain and its surrounding terrain have an impressive geological make-up, comprising an almalgamation of sandstone, shale and granite that have been weathered by the elements over the millennia to form uniquely shaped nooks and crannies that give the flat-topped mountain its gnarled appearance.

Left With a panoramic view from the Twelve Apostles – there are, in fact, 17 peaks in the range – to Cape Point and the Atlantic Ocean, the mountain is a popular walking ground for hikers and even casual strollers.

Above Although the city is blessed with unsurpassed natural splendour, the erratic weather patterns of the Cape winter may mean days of cold and wet – although snow has only been experienced a handful of times in recorded history.

Opposite Boasting more than 8 500 species of plants, flowers, trees and shrubs of the Cape Floral Kingdom, the most notable of Table Mountain's indigenous floral heritage is the evergreen vegetation of Cape *fynbos*, the Afrikaans word for 'fine bush'.

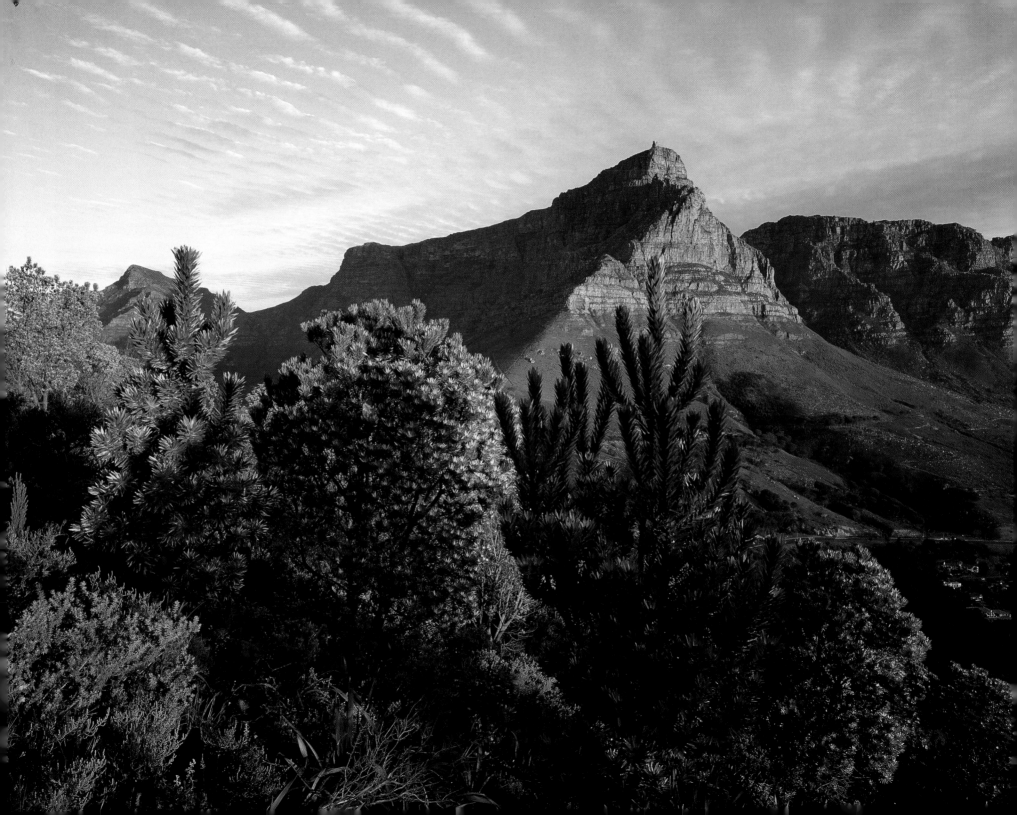

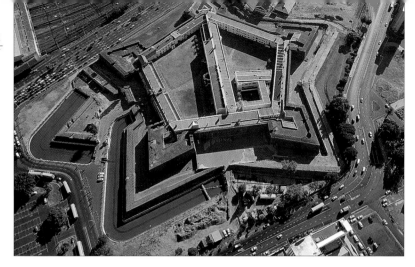

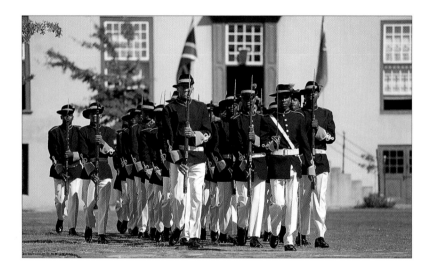

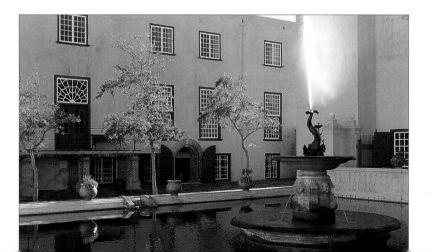

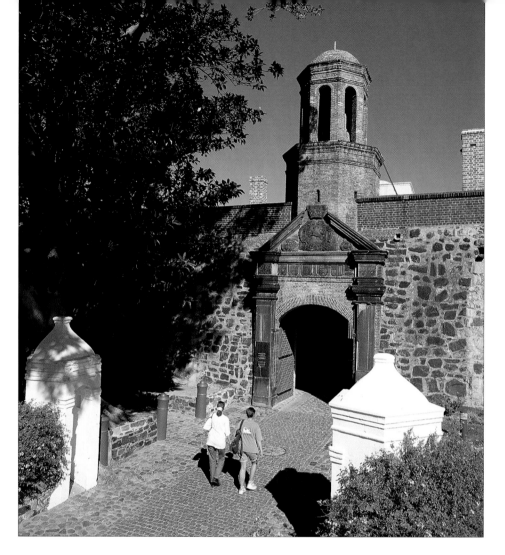

TOP LEFT The five bastions of the Castle of Good Hope – completed in 1679 – were named after the main titles of Wilhem, Prince of Orange: Leerdam, Buuren, Catzenellenbogen, Nassau, Oranje.

LEFT CENTRE The oldest surviving building in South Africa, the Castle is primarily a museum and military base, both of which are symbolised in the Changing of the Guard ceremony every weekday.

LEFT Remnants of the long-lost dolphin-shaped fountain in the inner courtyard were unearthed during renovations carried out on the Castle during the 1980s.

ABOVE The design of the Castle's stately gateway incorporates the coats of arms of six major Dutch cities and the VOC monogram.

OPPOSITE The entrance to the Castle was originally located on the seaward side of the fortification, but its proximity to the wave-lashed shore demanded that it be moved to its western wall.

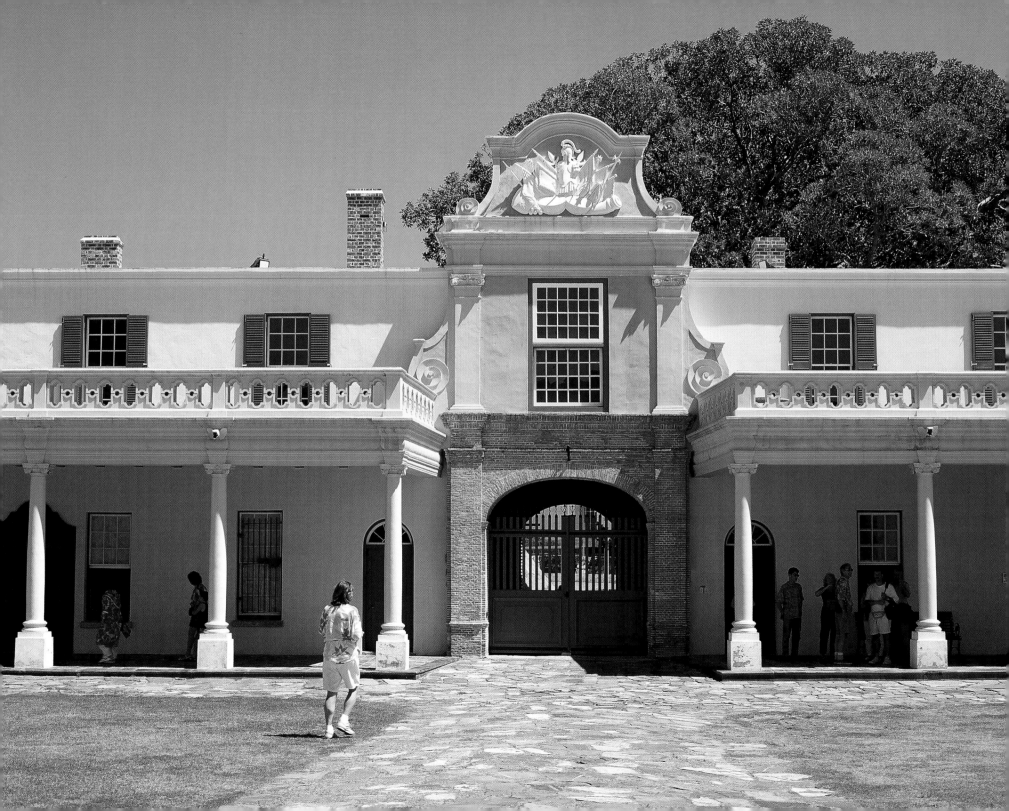

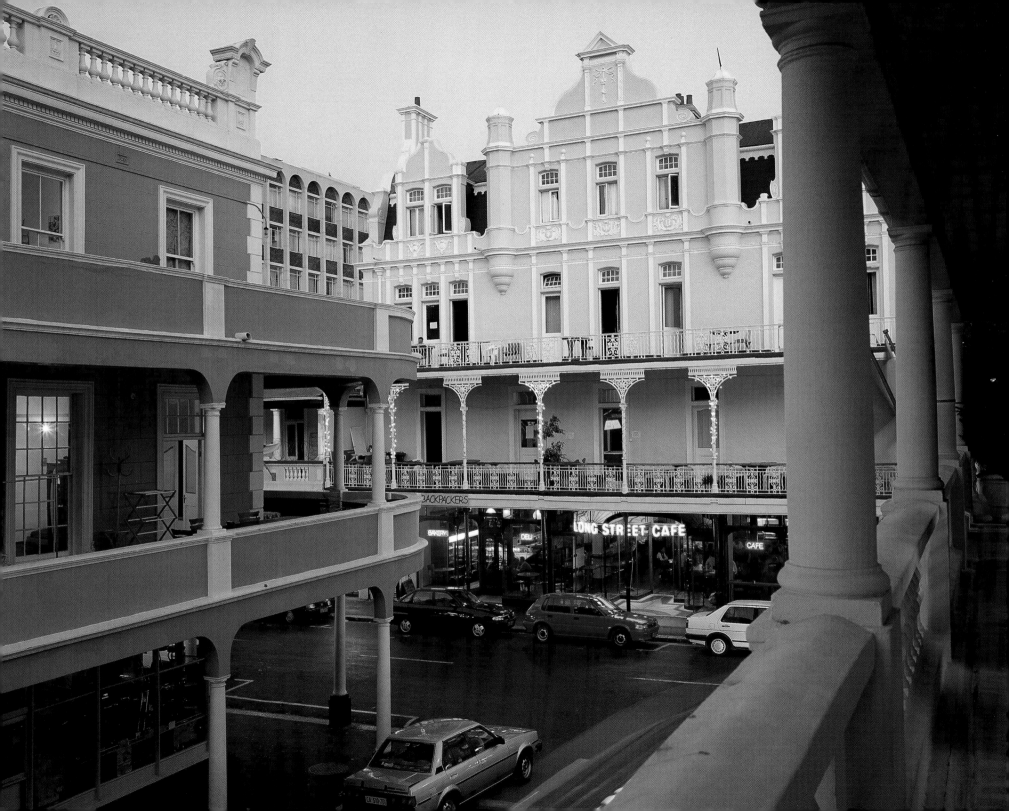

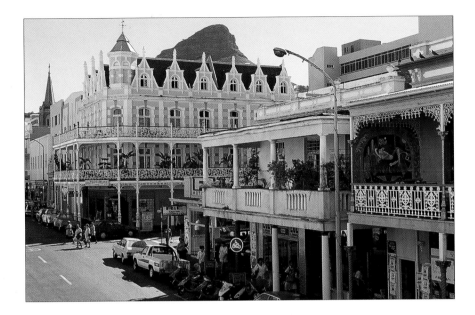

OPPOSITE Typical of the modern city, many of the ornate Georgian, Victorian, and Art Nouveau structures that line famed Long Street are now home to a variety of lively pubs and sophisticated restaurants so popular among Cape Town's trendy set.

ABOVE Long Street, best known for its magnificent old edifices and cosy bookshops, is over 300 years old, and yet continues to reflect the charm of a bygone era when trams plied the length of the thoroughfare.

RIGHT The Italian Renaissance design of Cape Town's granite-and-marble City Hall on Darling Street is topped with a clocktower, a copy of London's Big Ben added to the 1905 facade in 1923.

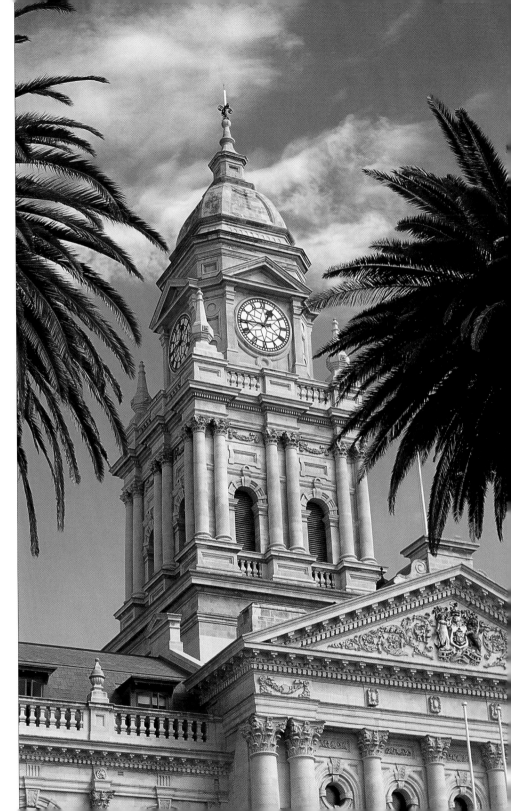

TOP LEFT Bustling Greenmarket Square, at the cobbled intersection of Longmarket and Burg streets, is one of Cape Town's most popular attractions and it usually rings with the lively melodies of local buskers.

LEFT The wagonloads of fresh produce, for which the original market square was established in the early 18th century, have since made way for an assortment of outdoor market stalls.

BOTTOM LEFT Informal vendors on Greenmarket Square stock a variety of goods, from clothing and collectibles, arts and crafts, to jewellery and leatherware, and the inevitable souvenirs and curios.

ABOVE On Saturday mornings, the square is usually filled with enthusiastic shoppers sifting through the treasures and haggling over prices with the resident stallholders.

OPPOSITE Greenmarket Square lies at the heart of the CBD and the shaded trading stalls are virtually encircled by the facades of some of the city's most impressive architectural gems.

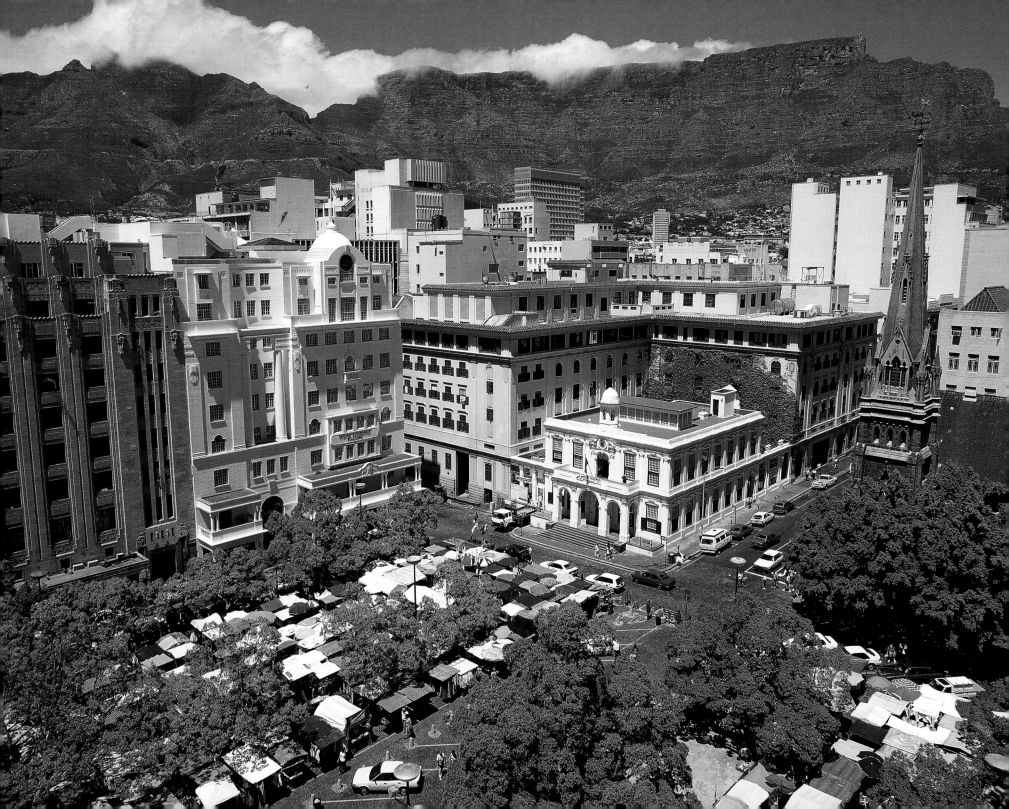

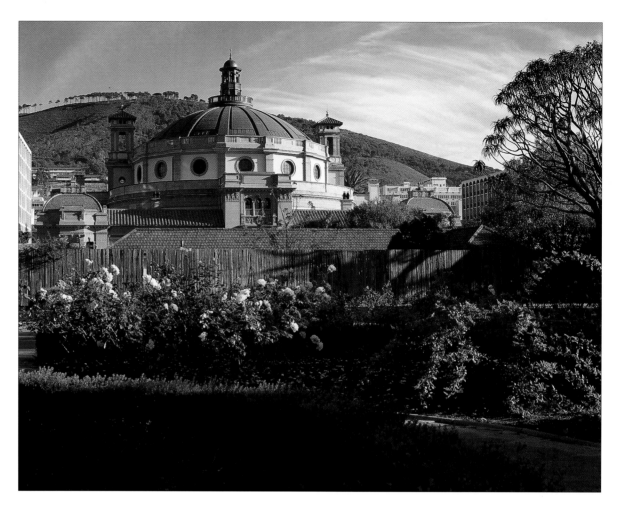

TOP LEFT Flanked on one side by the six acres of the Company's Garden and on the other by the grand Houses of Parliament, Government Avenue is a tranquil pedestrian thoroughfare, whose most animated residents are exotic grey squirrels.

LEFT The vegetable garden originally laid by Governor van Riebeeck's gardener, Hendrik Boom, in 1652 is today the site of a splendid botanical garden, home to indigenous and exotic vegetation, and dotted with reminders of its Victorian heyday.

ABOVE Many of the city's oldest and most impressive structures have been lost to development, but others have been preserved for posterity and have taken on a modern role. This magnificent building is home to the Planetarium.

OPPOSITE Officially inaugurated in 1884, the imposing seat of government in the Cape is the Houses of Parliament, a Victorian treasure that has seen considerable modification since it was originally designed by Charles Freeman.

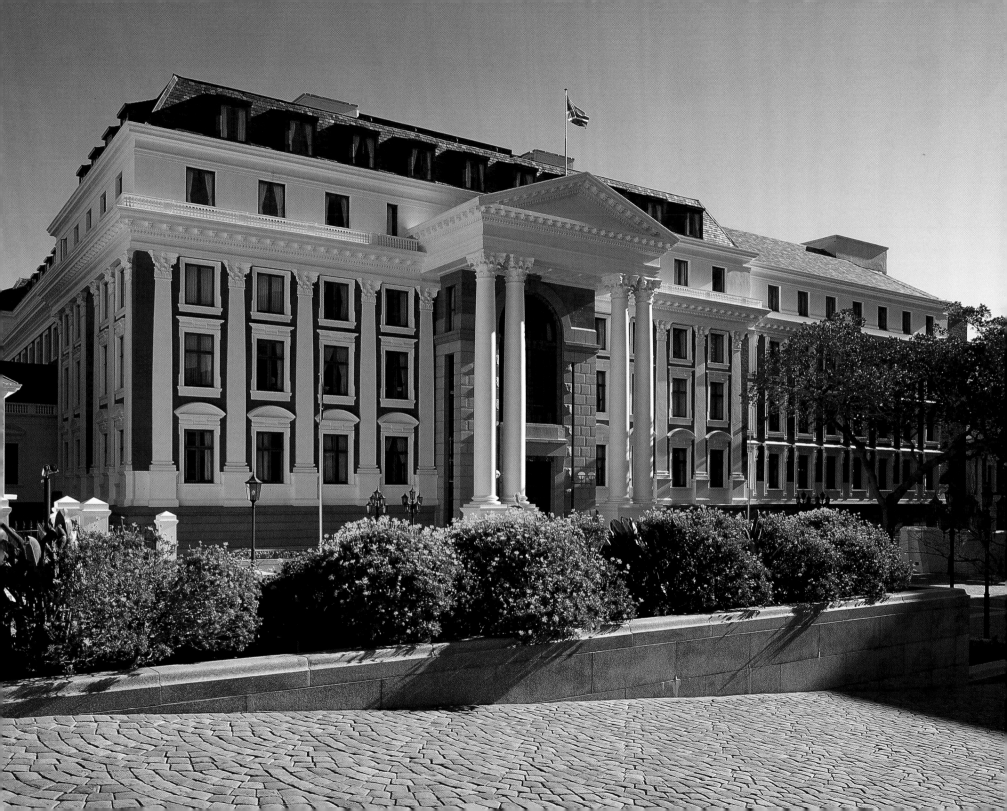

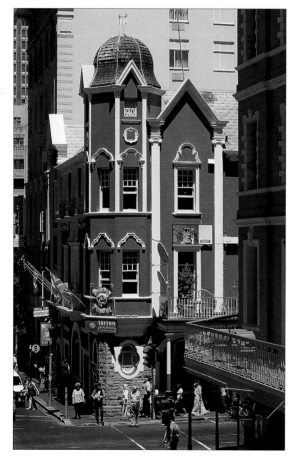

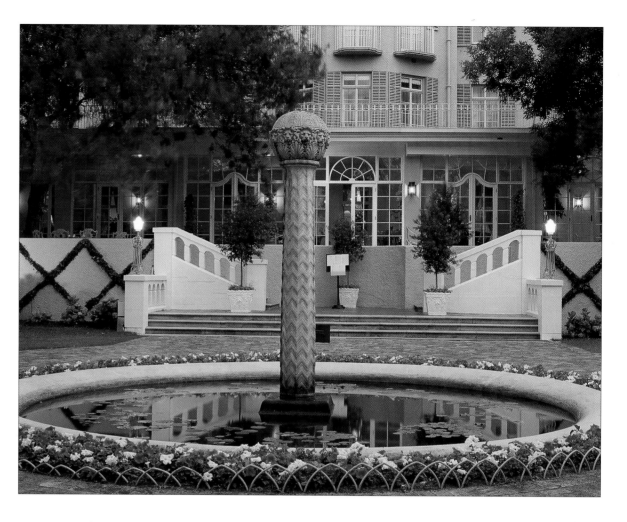

TOP LEFT Late afternoon means high tea at Cape Town's world-famous five-star hotel, The Mount Nelson, where guests are treated to a sumptuous array of pastries and confectionary on the enclosed patio that overlooks the gardens.

LEFT Testimony to Cape Town's varied cultural heritage is the fine example of Victorian architecture on Long Street that today houses a string of trendy retailers, pubs and restaurants.

ABOVE The colonial grace of what is The Mount Nelson has been the Cape Town home of many a visiting dignitary, royalty and movie star and remains the epitome of sophistication and luxury.

OPPOSITE Running the length of the Foreshore – prior to the 1930s, the beach and shore of Table Bay – is the Heerengracht, fringed with overshadowing office blocks and punctuated with fountains and statues of the city's founding fathers.

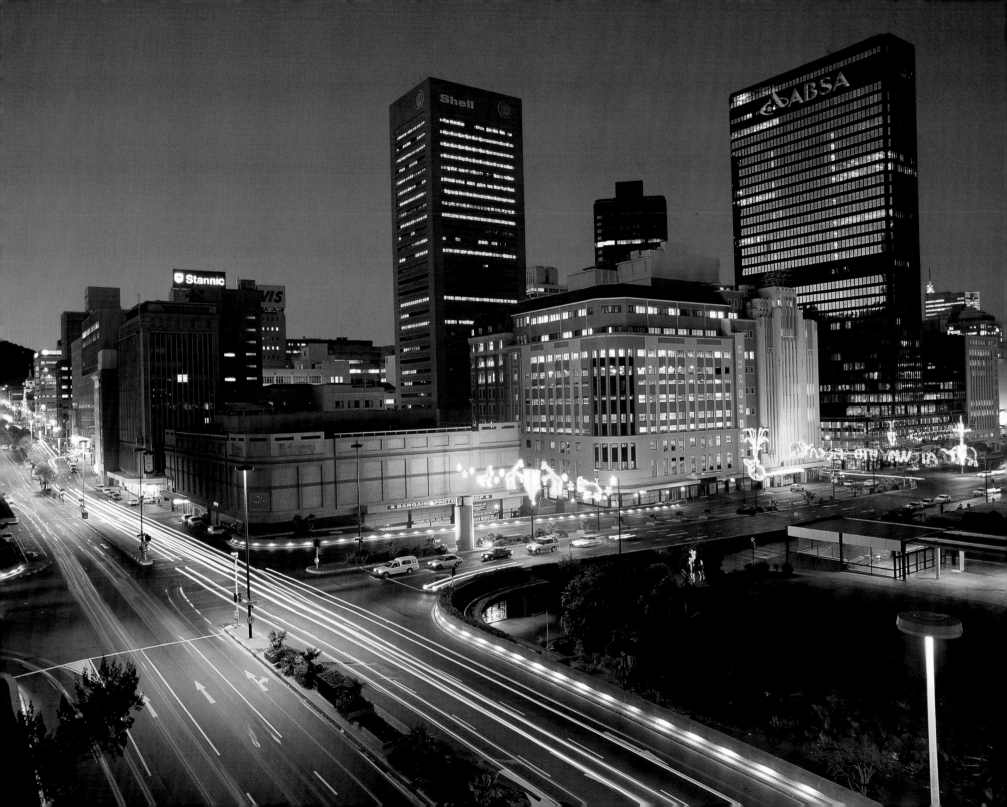

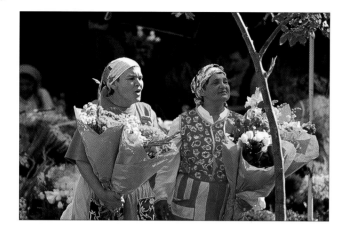

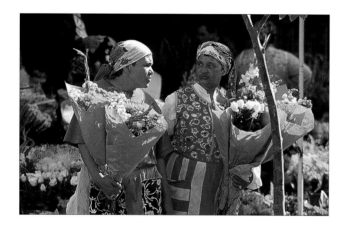

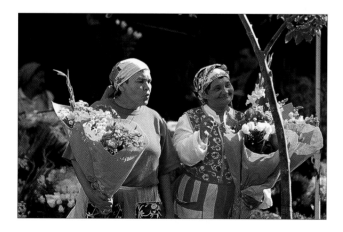

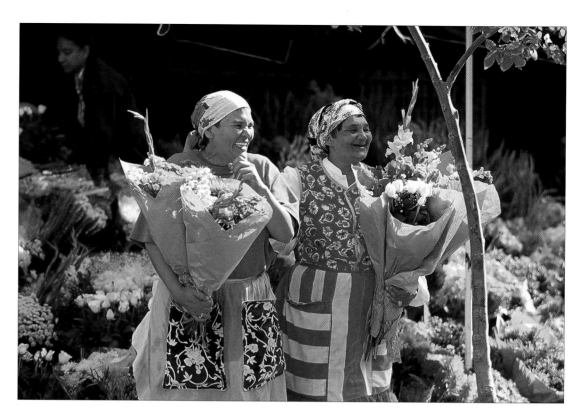

THIS PAGE The social fabric of Cape Town is interwoven with a mix of diverse cultures and population groups, all of which have made considerable contributions to contemporary life in the Mother City. With the integration of Eastern, European and English cultures, each group has come to play a significant role in the development of this colourful, lively and cosmopolitan city. Symbolic of this rich heritage is the local coloured community, an integral role player in Cape Town's social, economic and political make-up. Shown here are the colourful flower sellers on Adderley Street who, with a charm and wit of their own, engage a passerby with their lively sales pitch.

OPPOSITE Reflecting the innovation and entrepreneurship of the local communities, street vendors tout their produce on the busy streets, adding a festive note to city's already colourful parade of pedestrian traffic.

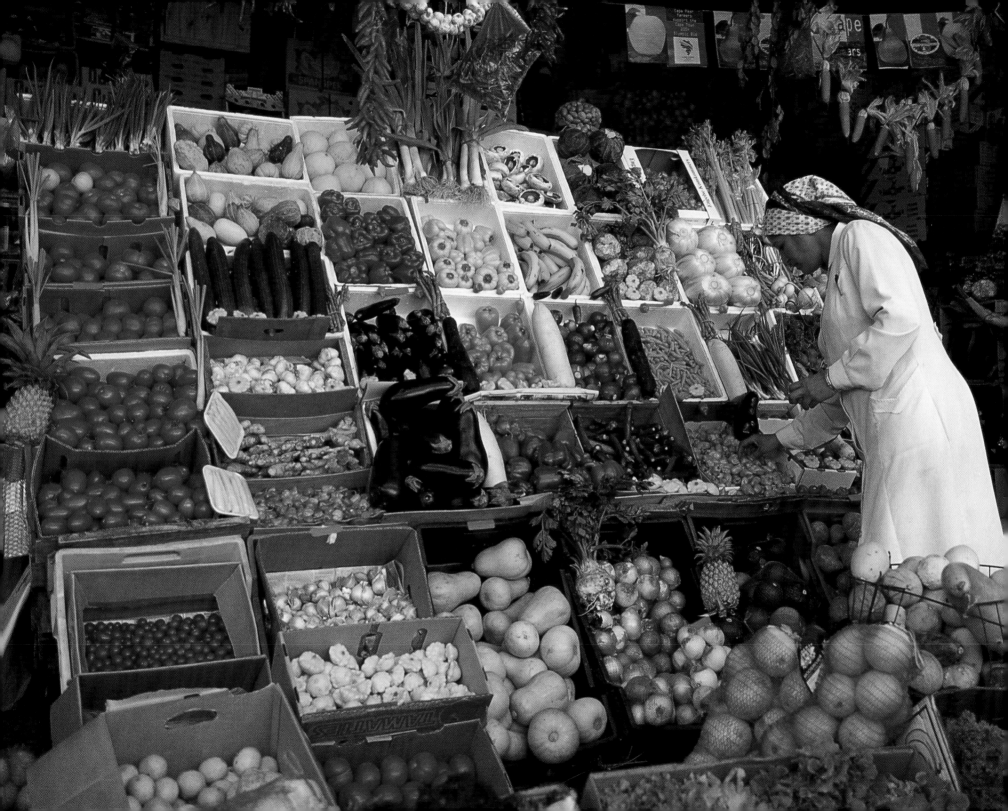

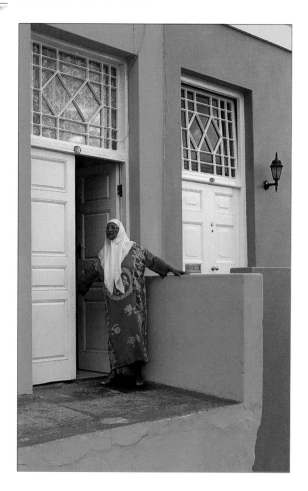

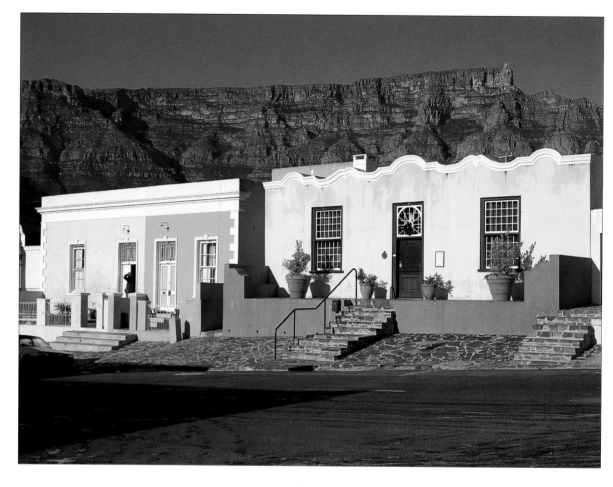

TOP LEFT Cape Town has an active Muslim community that continues to embrace the culture that followed its ancestors here, and much of their day-to-day lives reflect the Eastern heritage.

LEFT The Bo Kaap, or 'upper city', area of central Cape Town was established by the Muslim community after they were freed from slavery in 1834 and started to make their own in-roads in commercial life at the Cape.

ABOVE The Bo Kaap Museum at 71 Wale Street is furnished in the style of an 18th-century Muslim home, and on display is a fine illustrated history of the followers of Islam at the Cape.

OPPOSITE Still true to their cultural origins, pretty young Muslim girls preparing to celebrate the feast of *rampisny*, a prelude to the festivities surrounding the birth of the Prophet.

OVERLEAF The annual Coon Carnival is an important part of the city's New Year festivities, when the lively minstrels paint their faces, dress in vibrant costume and dance their way through the streets in celebration of both their own colourful history and Cape Town's diverse past.

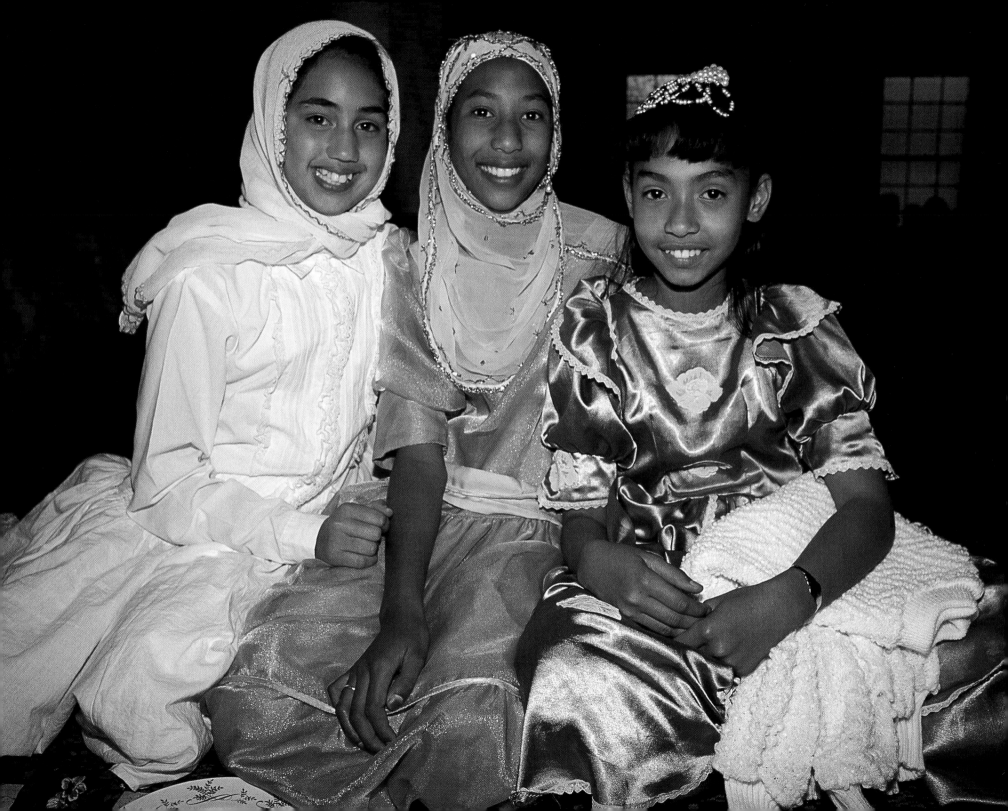

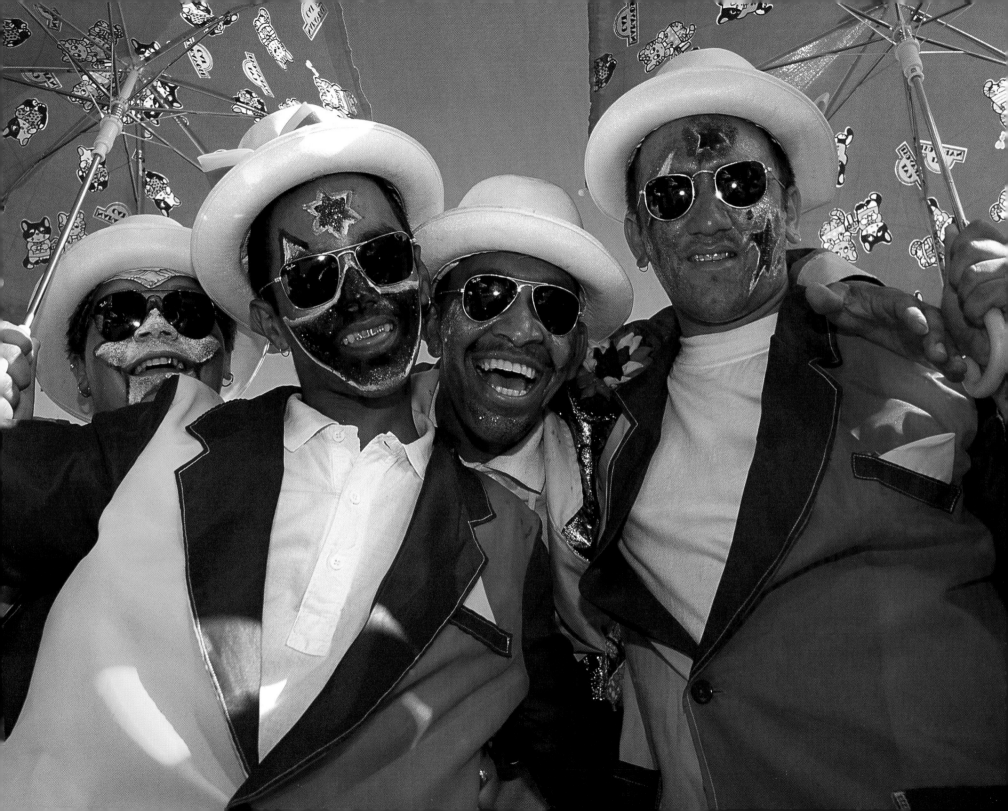

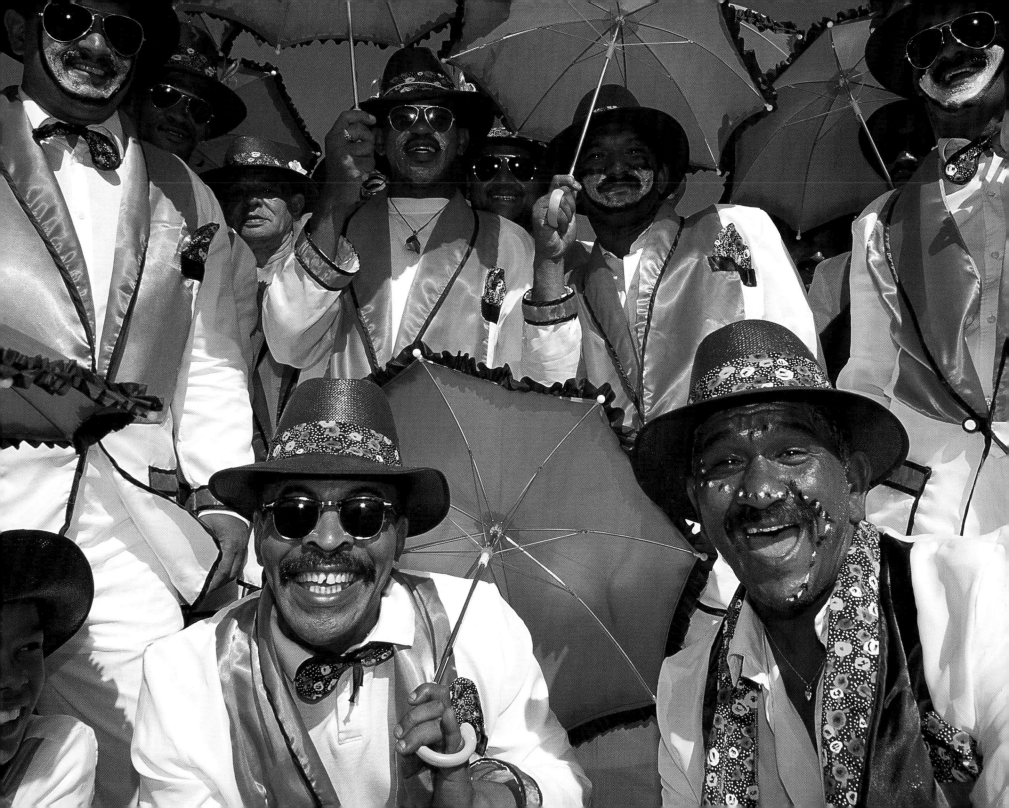

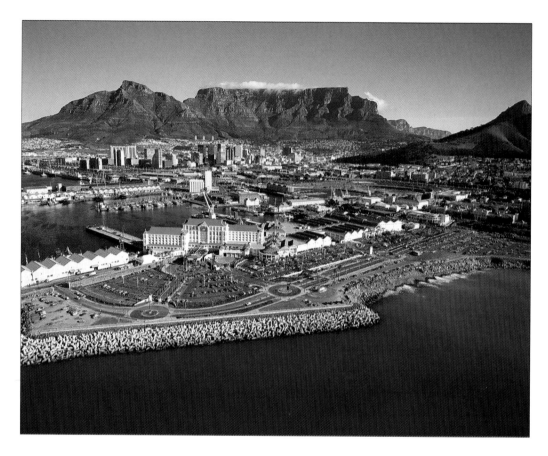

Top left Despite the electric atmosphere and festive spirit of the Victoria & Alfred Waterfront, part of its precinct remains a working harbour and host to the passing maritime trade.

Left Embracing as it does the shores of Table Bay, the sea remains integral to the pleasures of the V&A Waterfront and visitors may opt to take water taxis that ferry them across the basins.

Above From its humble beginning as a harbour fast falling into disrepair, the V&A Waterfront has flourished to become the country's most successful entertainment complex.

Opposite The V&A Waterfront's collection of designer boutiques, fashionable restaurants and entertainment venues attracts more than 20 million visitors a year, and the massive urban renewal project has a string of international awards to its credit.

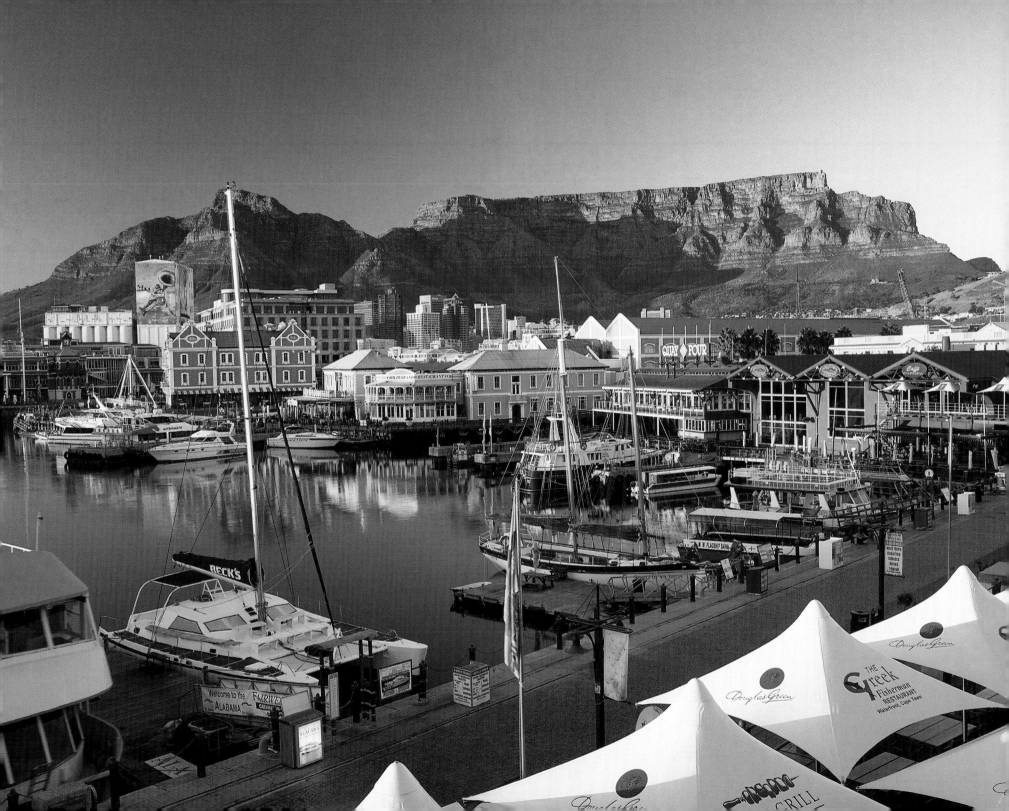

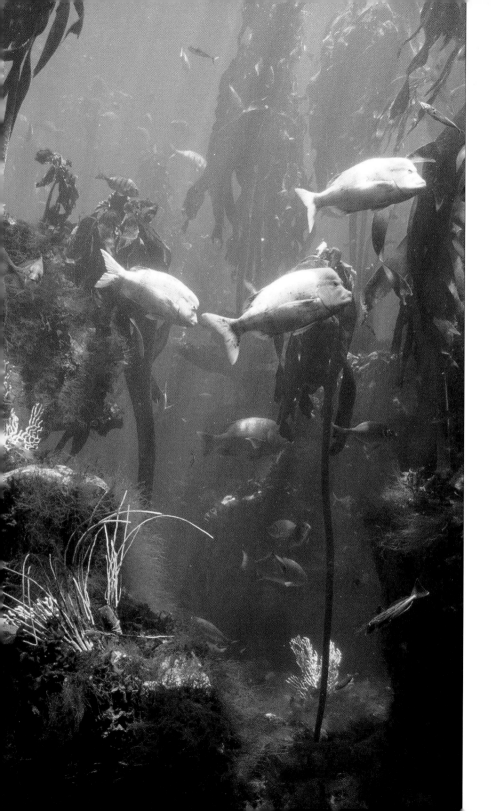

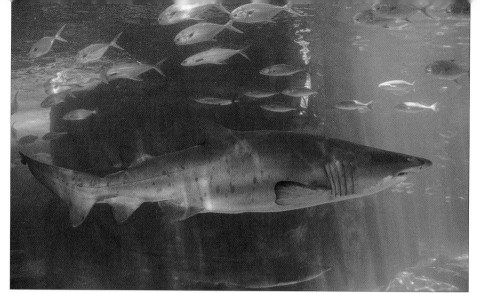

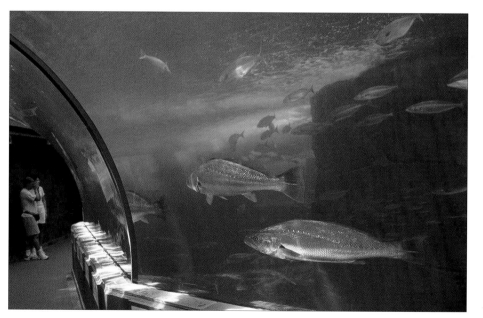

LEFT The world-class Two Oceans Aquarium introduces to an enthralled public the endless variety of sealife found along both the Atlantic and Indian Ocean coast of southern Africa.

TOP AND OPPOSITE The aquarium's Predator Exhibit, where visitors can come face to face with sharks and rays, is one of the most popular attractions of the Two Oceans Aquarium.

ABOVE The transparent underwater tunnel, touch tide pool, and tanks are fed by over two million litres of seawater from the Atlantic Ocean and hold a fascinating array of marine life.

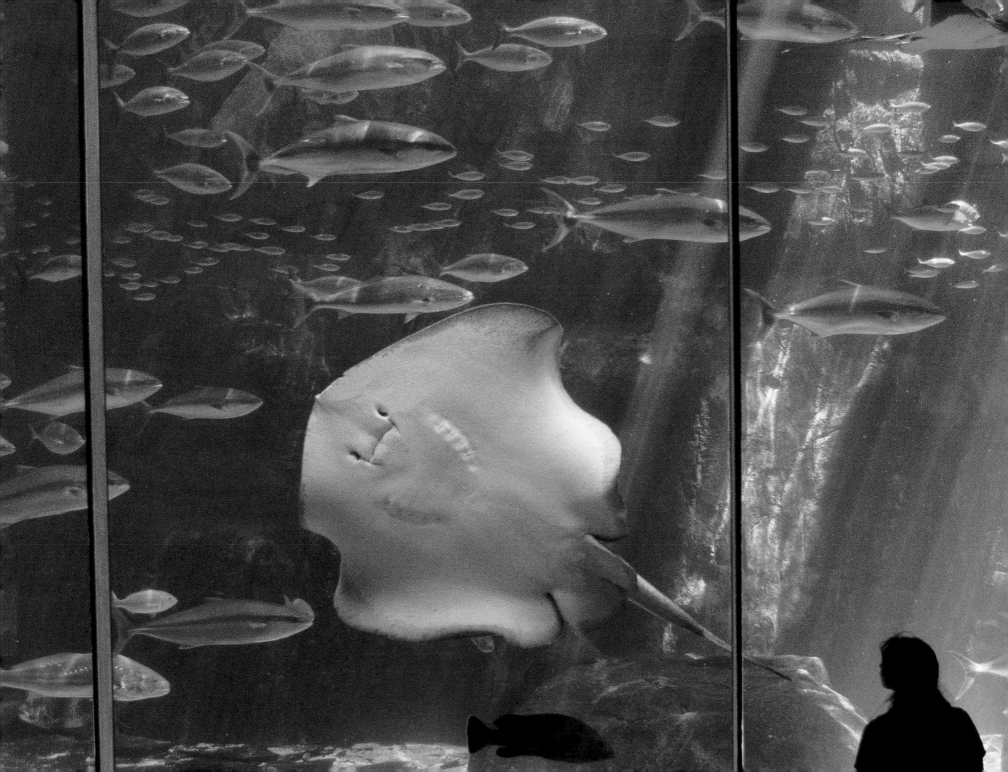

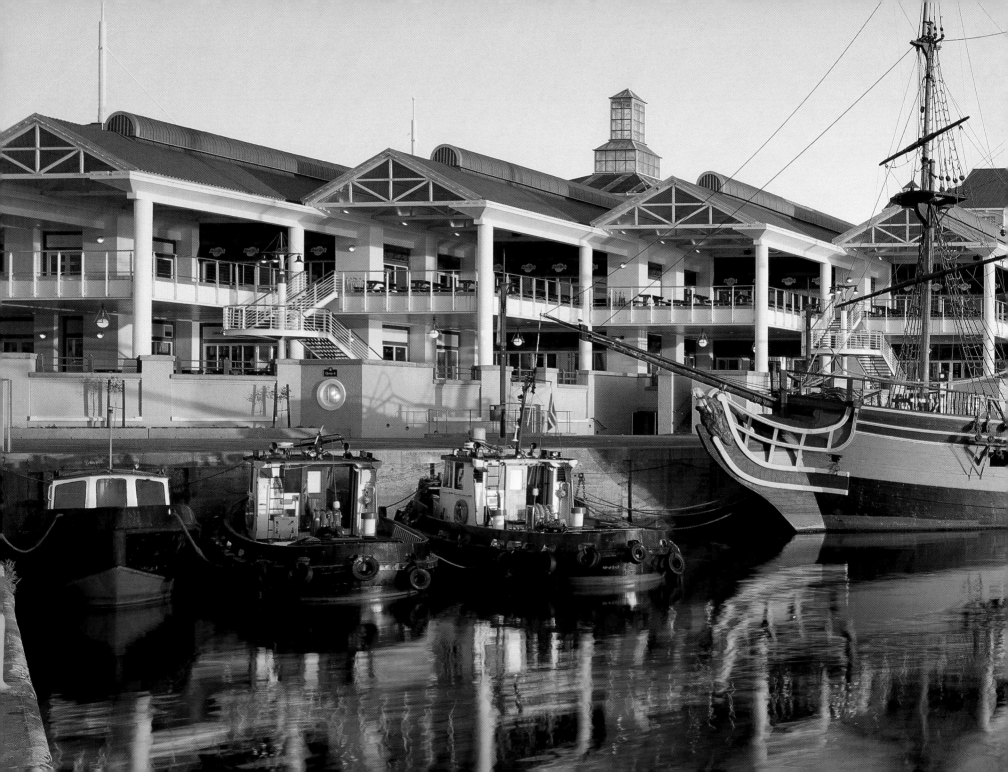

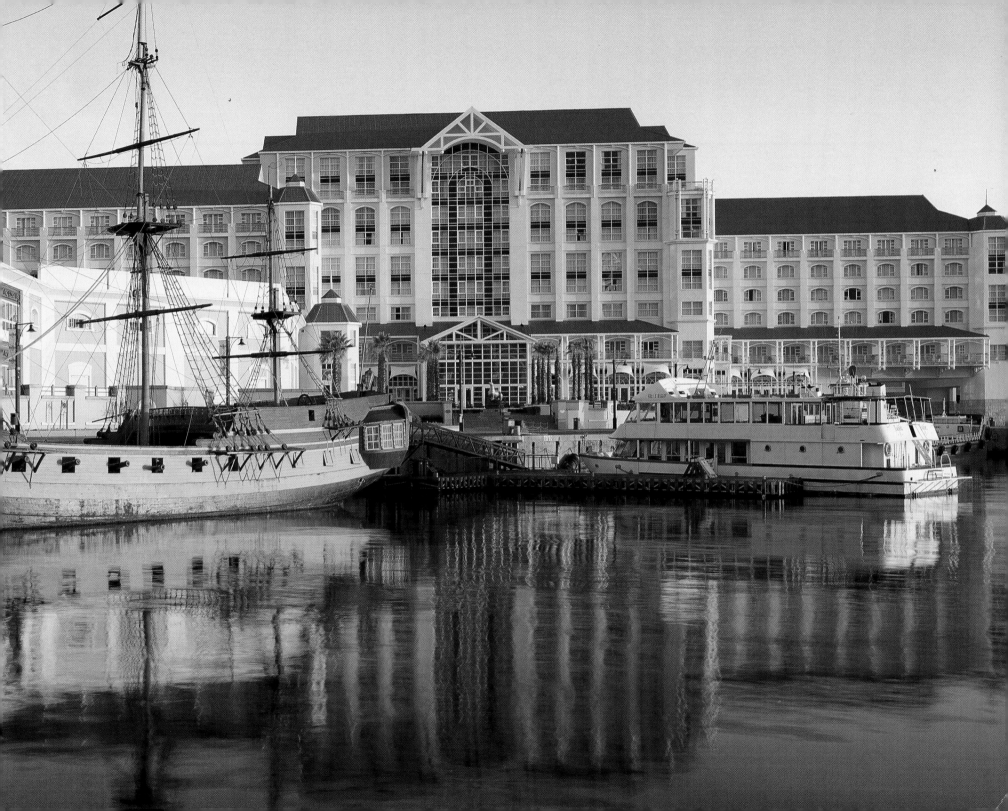

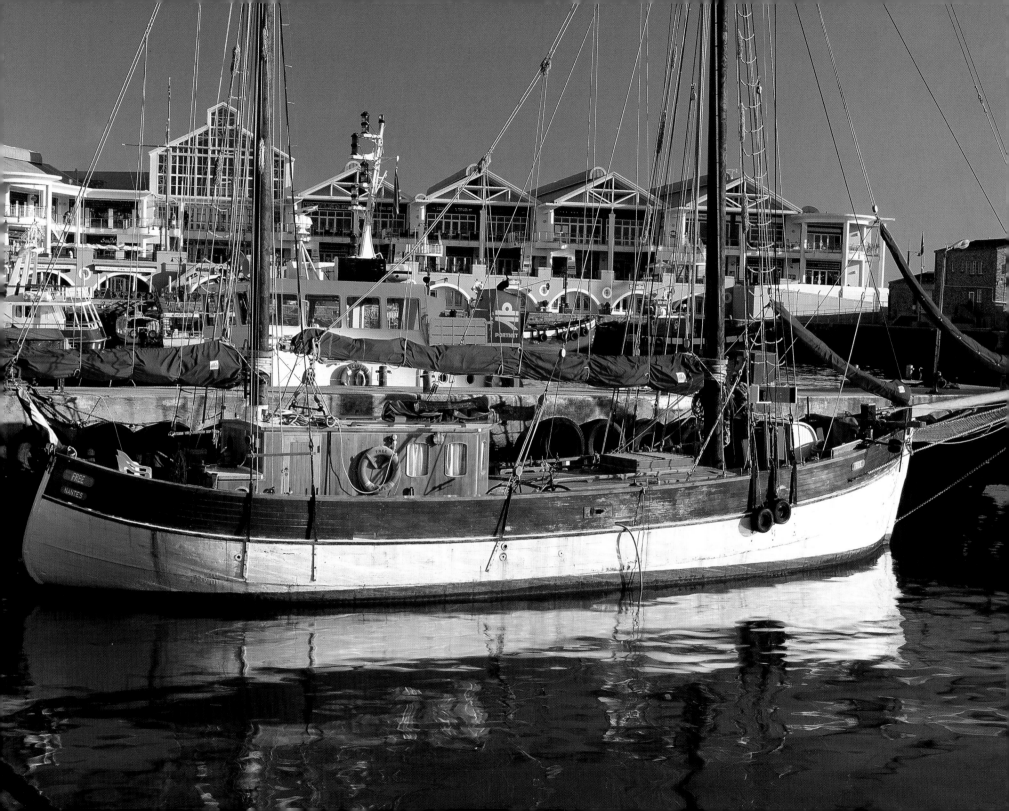

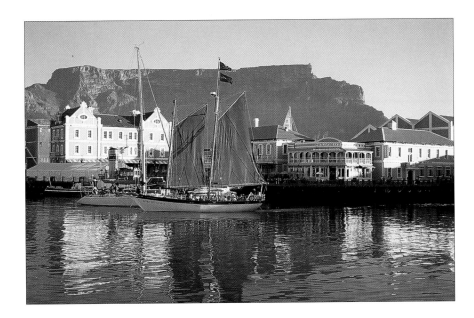

PREVIOUS PAGES The Victoria Wharf shopping emporium, with its blend of swanky eateries and trendy stores, overlooks the waters of the Victoria Basin. The city's flourishing hospitality industry has firmly established itself on the V&A Waterfront, and the fine cuisine, vintage wines and dramatic vistas of its five-star establishments – among them, the elegant Table Bay Hotel – has ensured an endless stream of well-heeled guests.

OPPOSITE Widely acknowledged as the perfect playground for the rich and famous, Table Bay is a seafront leisure wonderland, visited not only by commercial vessels – including cruise ships of impressive size – but also a variety of pleasure craft. Situated on the shores of the bay, the V&A Waterfront is thus a popular stopover for visiting sailors as well as the mooring for a number of both conventional and unconventional boat-trip operators.

ABOVE AND RIGHT Many of the leisure craft that dock on the waters of Table Bay serve not only as all-night party venues, but also offer charters into the harbour and beyond.

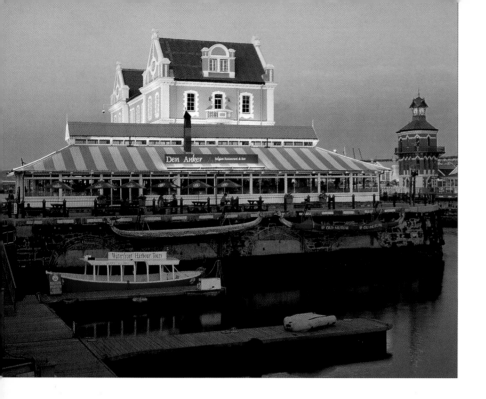

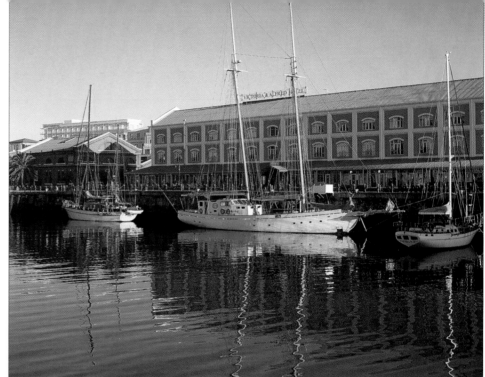

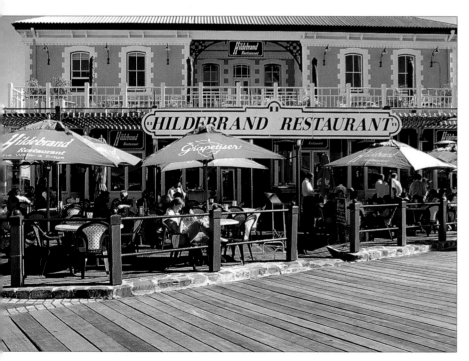

Adjacent to the Old Port Captain's Building – the headquarters of the V&A Waterfront Company that manages the complex – are a series of extremely popular restaurants that have earned fine reputations as some of the most cosmopolitan restaurants in the city.

Boasting a fine view over Table Bay and the Alfred Basin is the Victoria & Alfred Hotel, one of the first to be erected on the developing Waterfront.

Set against a backdrop of Table Mountain, the revitalized dockland has today become the city's primary entertainment venue. The upstairs restaurant at Quay Four specialises in excellent seafood, while the downstairs pub is popular with the younger set as a venue for live music.

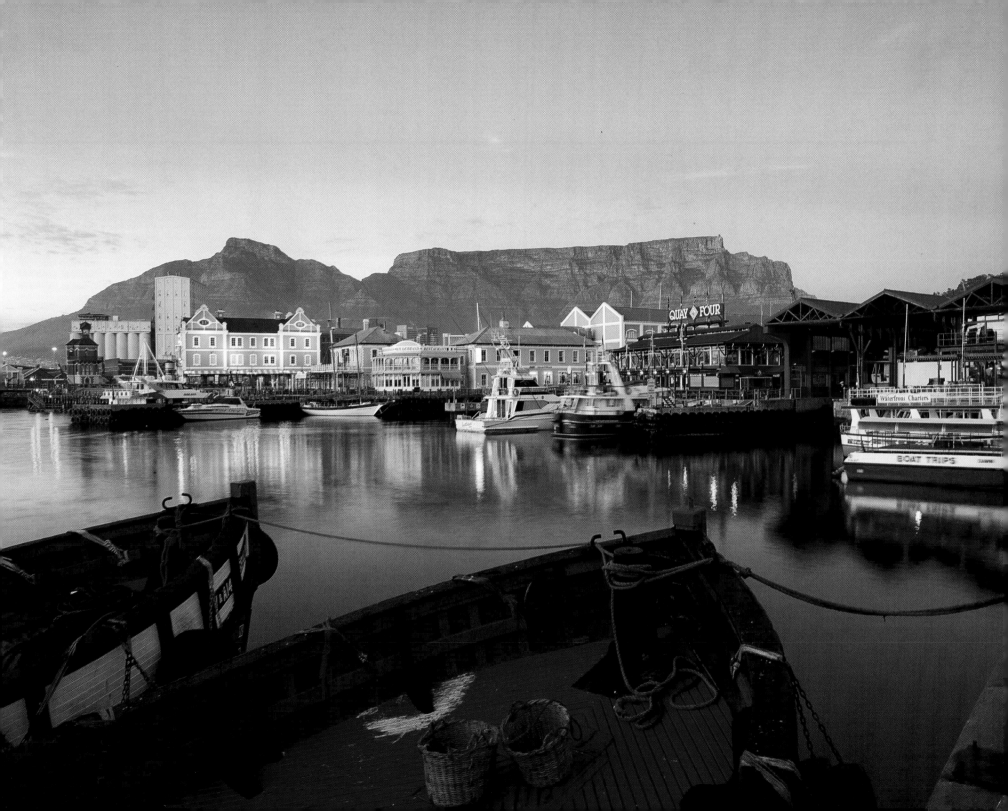

THIS PAGE Apart from the endless stream of foreign visitors who visit these shores, the V&A Waterfront is equally popular with Capetonians as the city's favourite leisure spot. The public squares and open spaces therefore attract a variety of impromptu entertainers: from acrobats and mime artists to clowns and musicians.

OPPOSITE Lined with alluring shopfronts and bistros bubbling with the animated laughter and conversation of their patrons, the cobbled walkways of the V&A Waterfront surround the Victoria Wharf mall.

OVERLEAF LEFT From ferry rides taking visitors to tour the intrigues of Robben Island to chartered trips to the bays nestling on the peninsula's Atlantic seaboard, boats of every description dot the waters of Table Bay.

OVERLEAF RIGHT The Bascule Bridge leads to the luxurious Cape Grace Hotel on the West Quay, the Waterfront's last attraction before it merges into the working harbour.

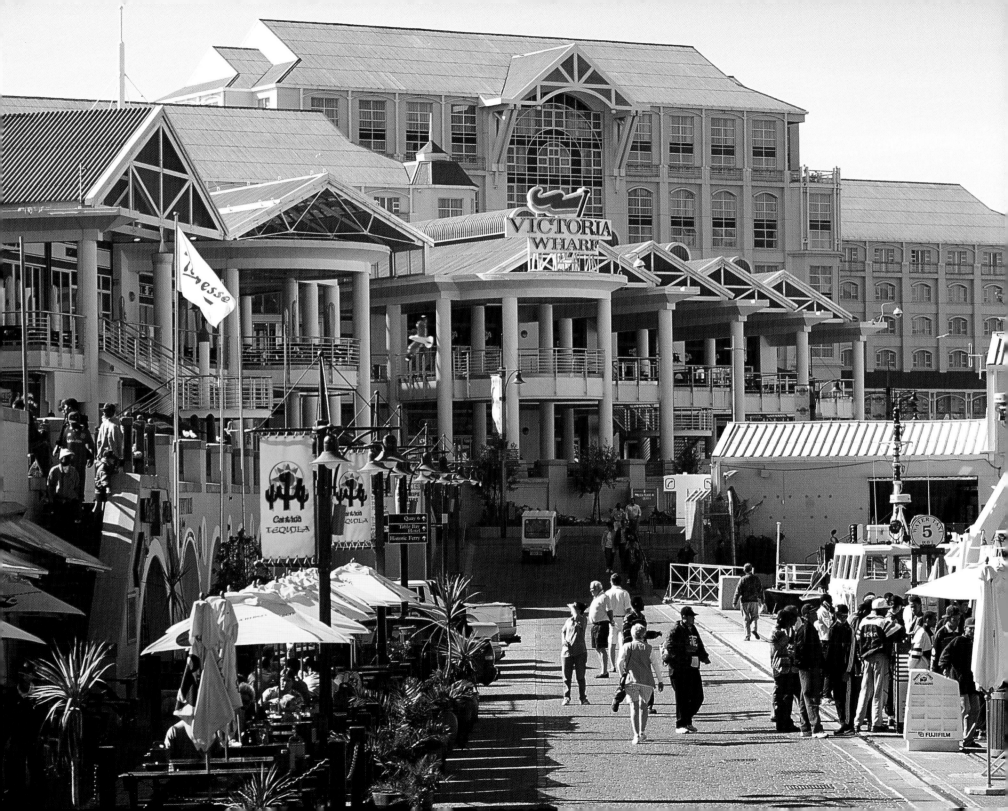

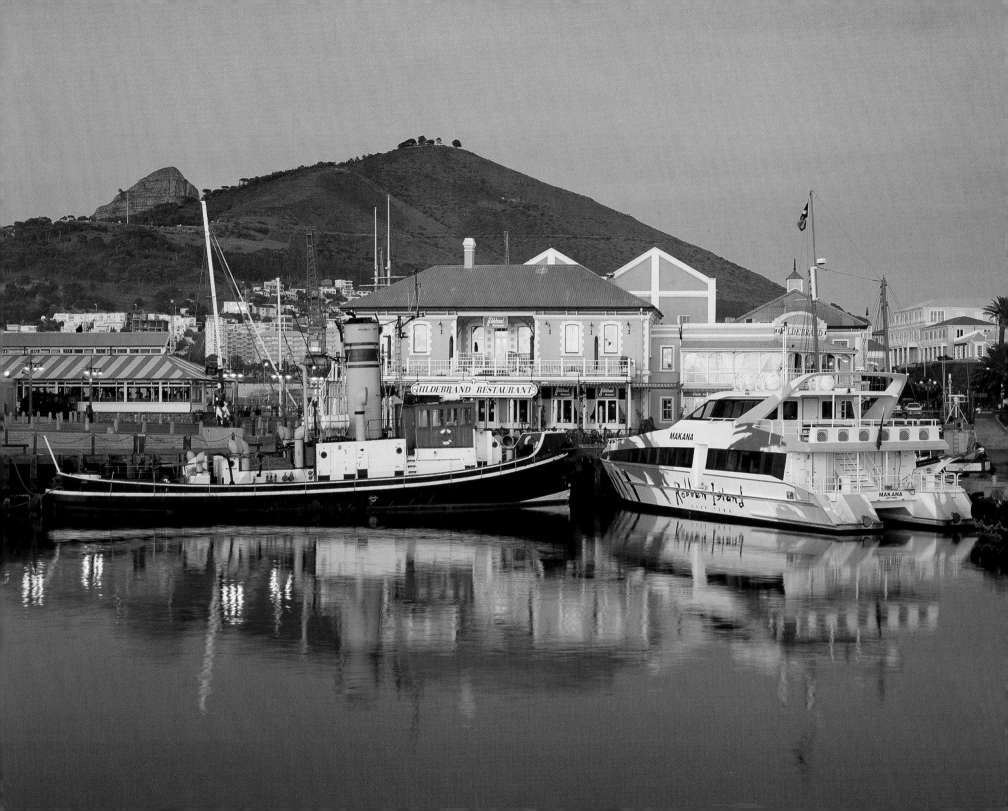

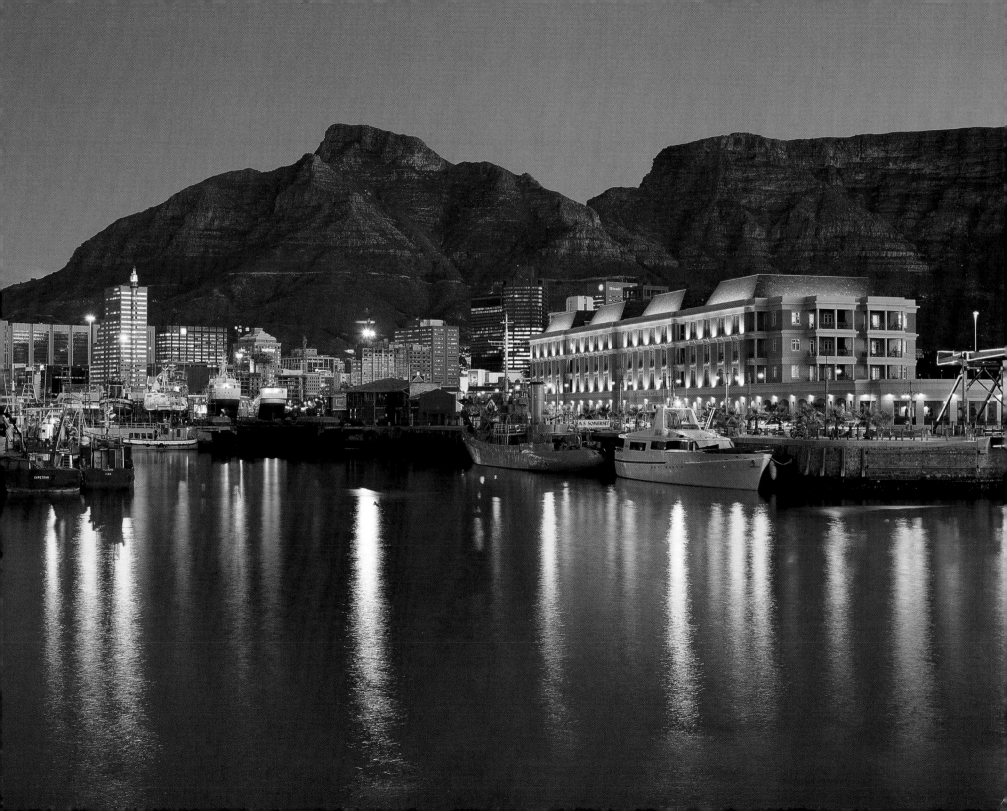

RIGHT AND BELOW The city of Cape Town and its bay feature prominently on the sailing calendar, and play host to a number of world-class racing events, among them the bi-annual Cape-to-Rio Yacht Race – as shown here – and the Whitbread and BOC single-handed round-the-world races. Table Bay is also the proud host to a number of international sailors – in crafts of every style and era – paying a visit to South African shores.

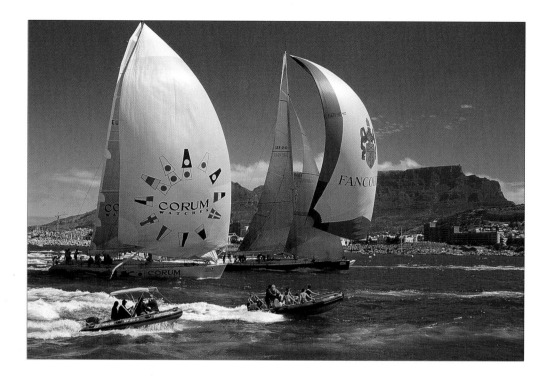

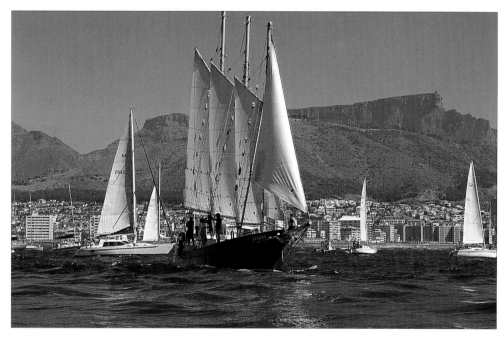

OPPOSITE The existence of the docks once relied almost entirely on the maritime traffic that fed the city's economy, but although the harbour remains a vital part of Table Bay, an equally important element is the spirit of adventure that now pervades the waters. Here, yachts take part in the most important of the local round-the-buoys events.

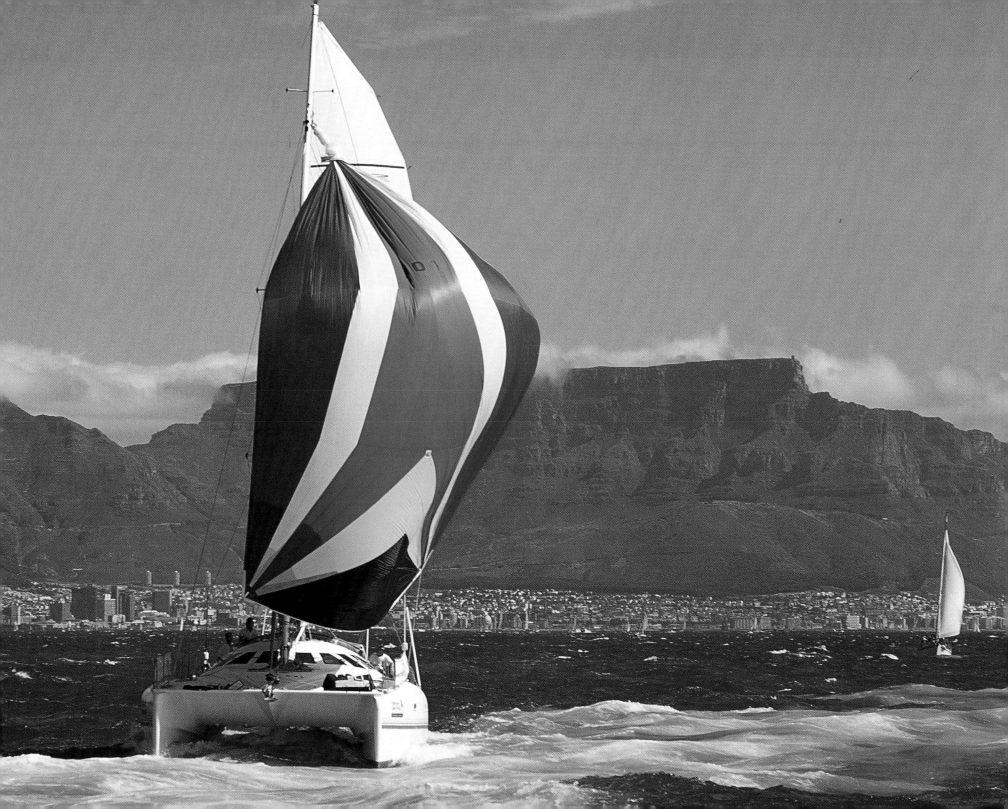

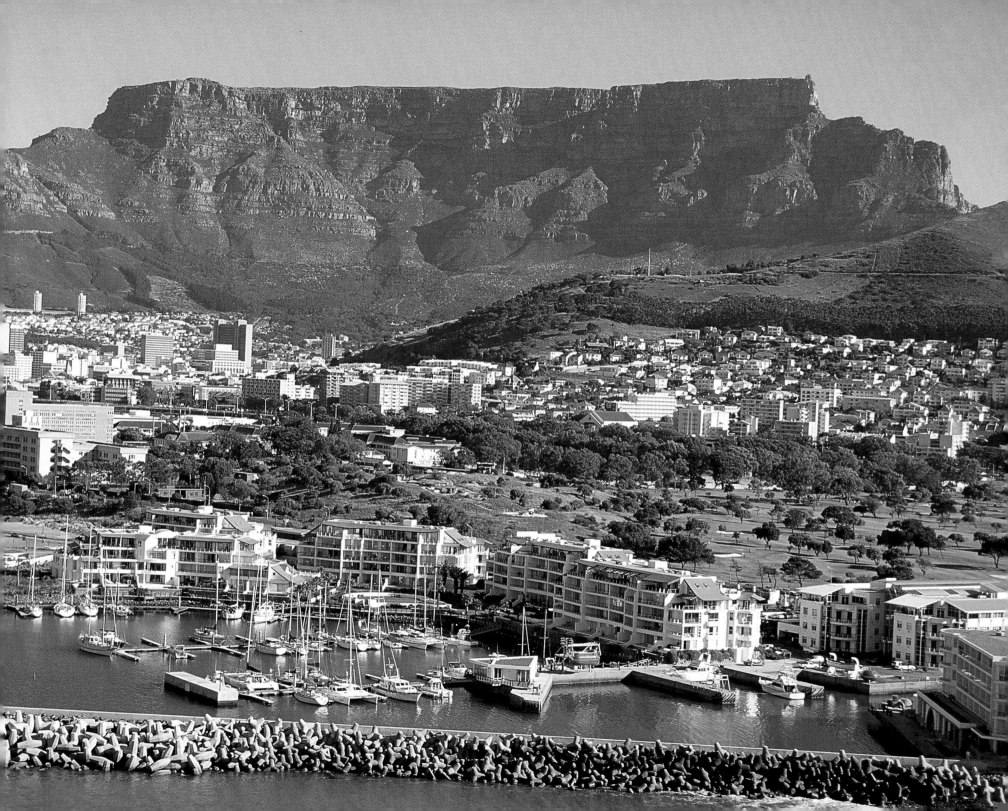

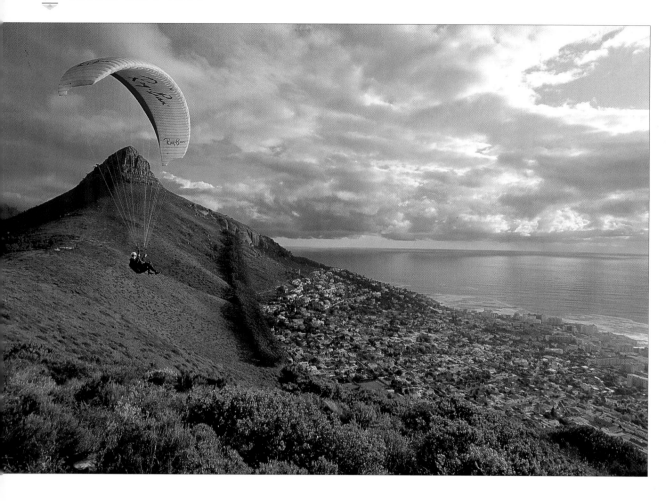

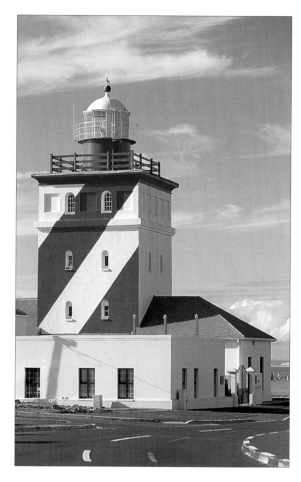

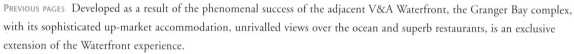

PREVIOUS PAGES Developed as a result of the phenomenal success of the adjacent V&A Waterfront, the Granger Bay complex, with its sophisticated up-market accommodation, unrivalled views over the ocean and superb restaurants, is an exclusive extension of the Waterfront experience.

ABOVE Blessed as it is with so much open space, a balmy climate and stretches of pristine beches, the peninsula landscape is an adventurer's dream. With the Atlantic suburbs far below and the endless Cape sky stretching far into the distant horizon, a fearless skydiver soars over the slopes of Signal Hill.

ABOVE The striped Mouille Point lighthouse may be the oldest of its kind in the country, but technology has ensured that its light is seen 25 kilometres out to sea.

OPPOSITE Much lauded as Cape Town's Riviera, the suburbs along the Atlantic seaboard are fringed with beaches of fine, white sand and blessed with glorious sunsets.

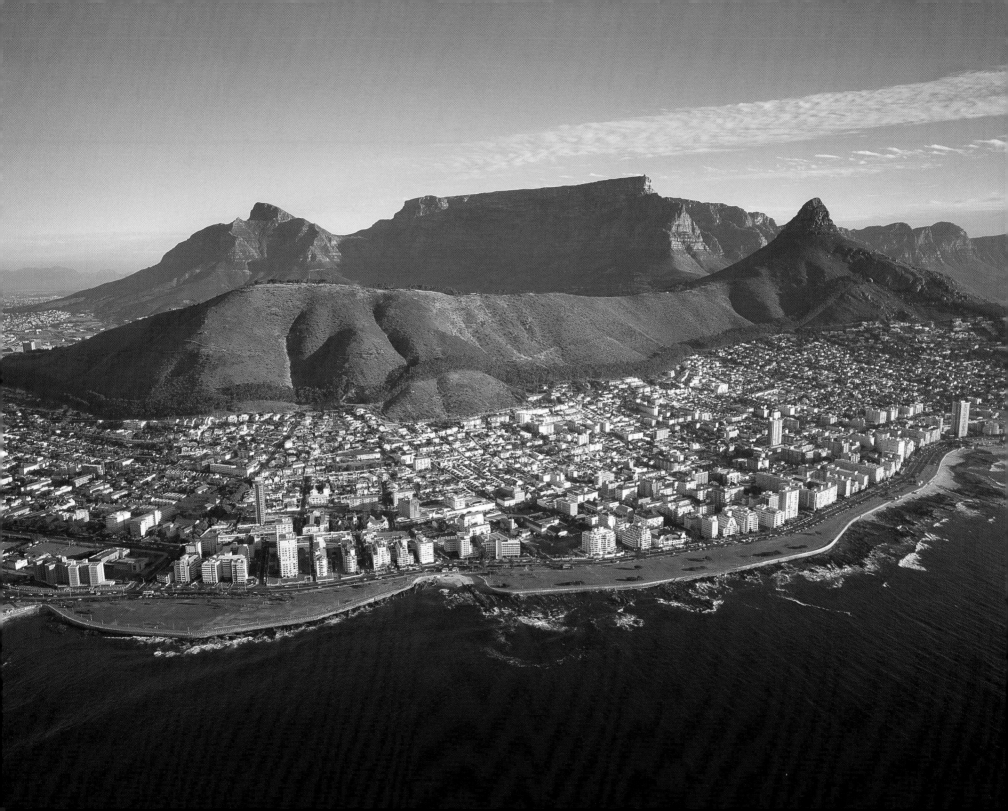

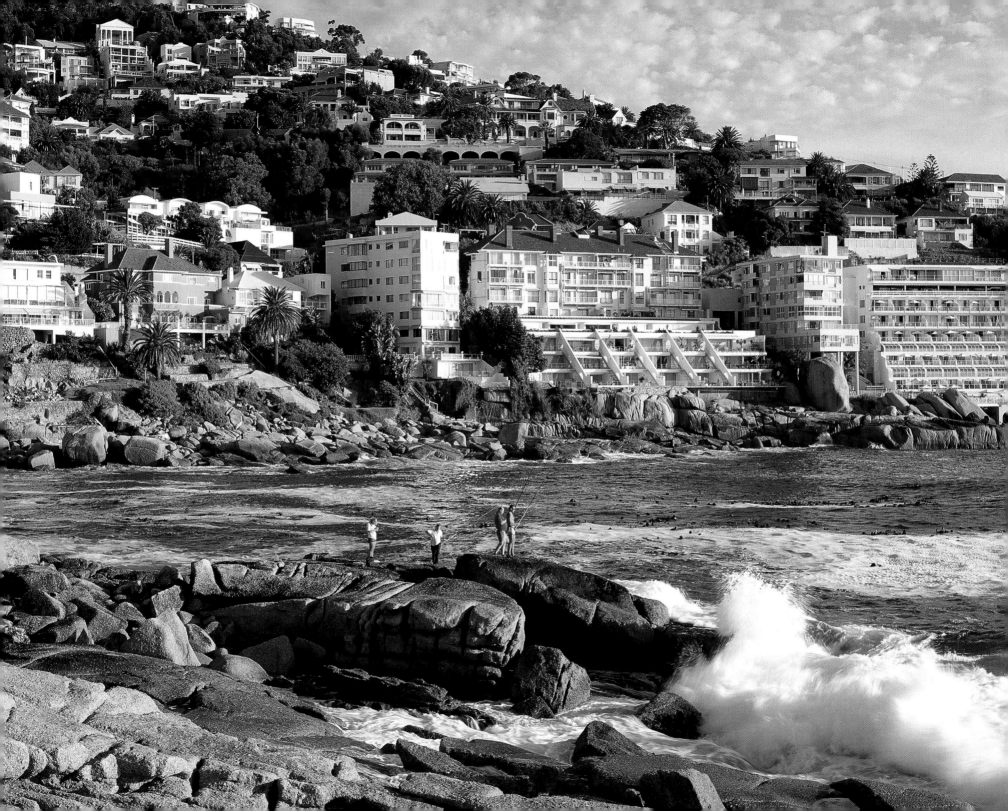

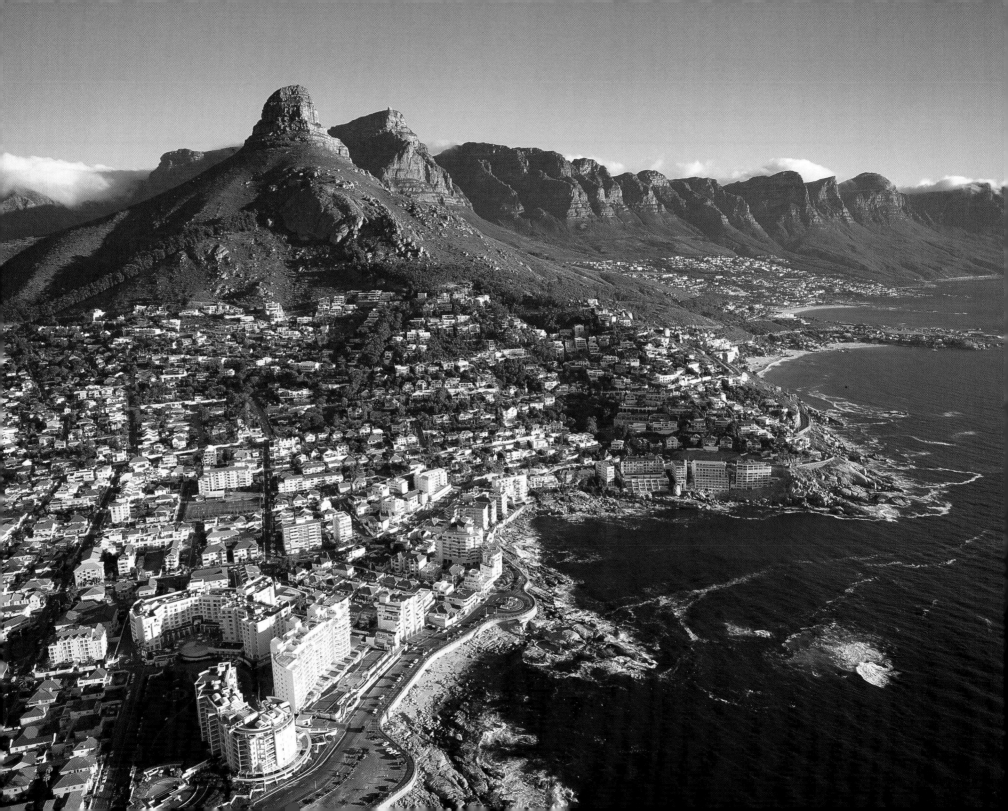

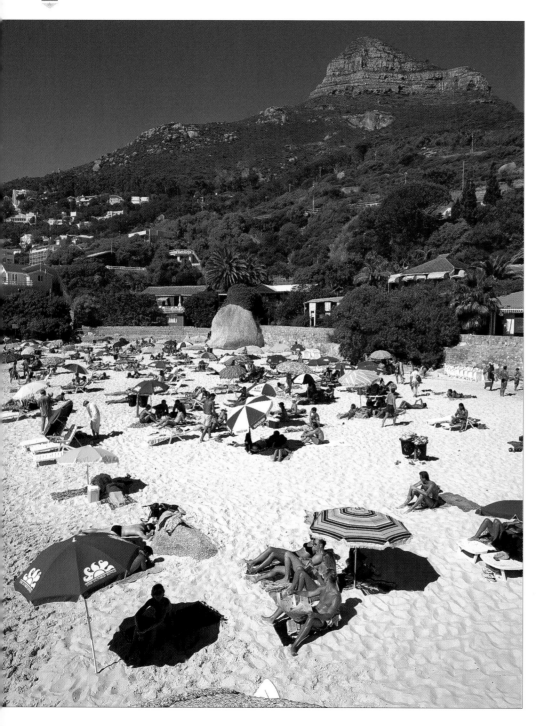

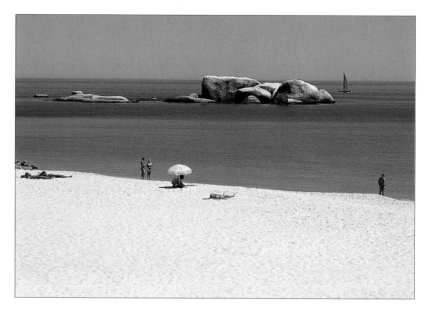

PREVIOUS PAGE, LEFT The steep slopes above Bantry Bay and the adjacent coves have ensured that the lavish homes sprawled across this scenic coastline are much sought after by the rich and, occasionally, the famous.

PREVIOUS PAGE, RIGHT With a backdrop of the Twelve Apostles and breathtaking panoramas over the Atlantic, the plush suburbs of Bantry Bay, Clifton, Camps Bay, Bakoven and Llandudno constitute the finest Cape Town real estate.

LEFT Shielded from the southeasterly winds that so often plague the peninsula, the sunny beaches of the Atlantic seaboard provide an idyllic setting for summer holidays.

ABOVE Of all four of Clifton's beaches – named chronologically as First, Second, Third and Fourth – Fourth Beach is the Cape's premier sun-bathing spot.

OPPOSITE Considering the unobstructed views from its gentle, wave-lapped shores, there is little wonder the beaches that stretch along the peninsula's west coast are renowned the world over.

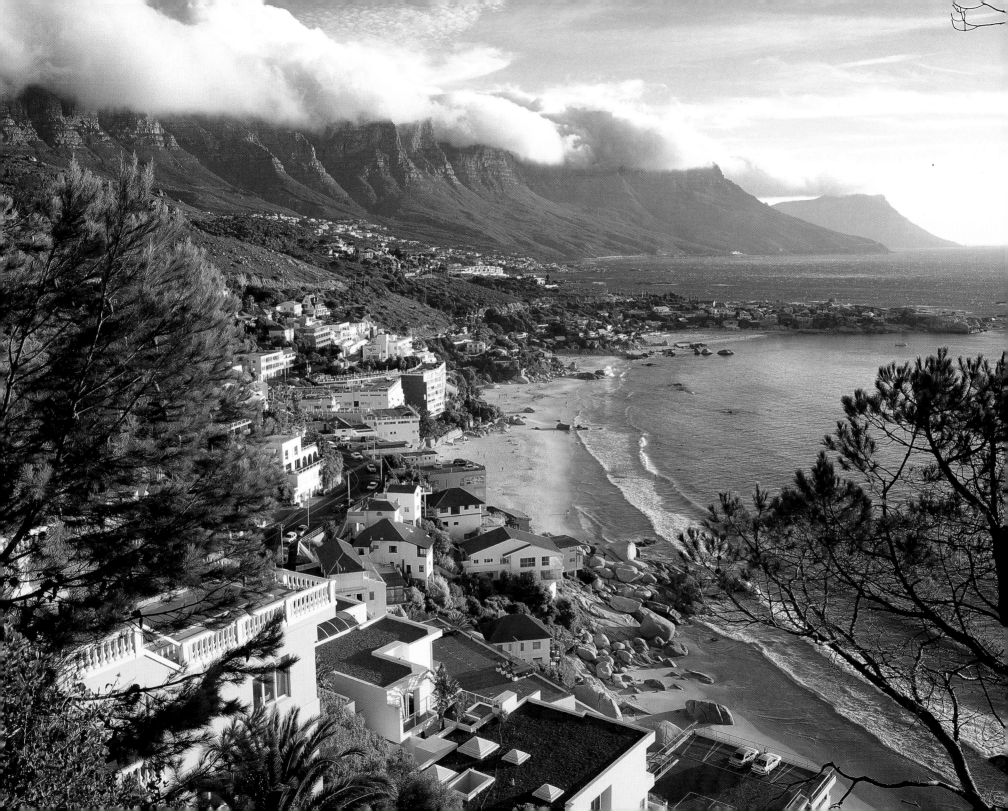

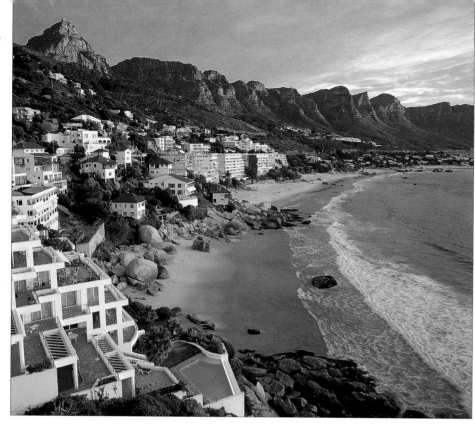

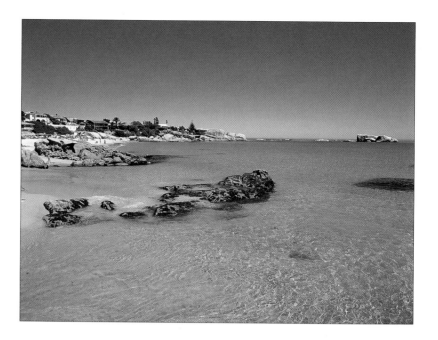

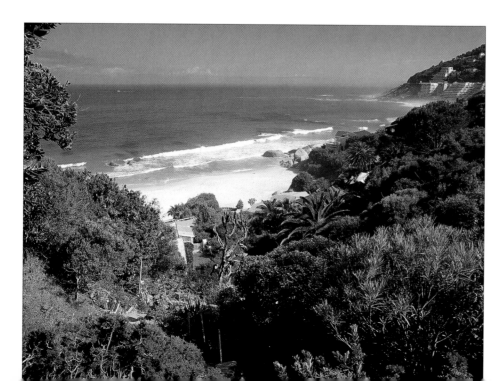

TOP LEFT Fringed on one side by the peaks that constitute the Twelve Apostles and the vast expanse of the ocean on the other, Clifton is the ideal setting for sundowners.
LEFT Cape Town's famous Clifton beaches are well secluded and surrounded by virtually impenetrable fynbos shrubbery and rocks.
ABOVE Soft white beaches bathed by crystal blue waters of this coastline are reminiscent of the most picturesque Mediterranean holidays spots.
OPPOSITE As you drive south along the shoreline, the coastal route becomes even more scenic as one languid bay emerges with the next. With Clifton to the left and Camps Bay to the right, lively La Med – a favourite spot for late-night revellers – boasts one of the world's most magnificent locations.

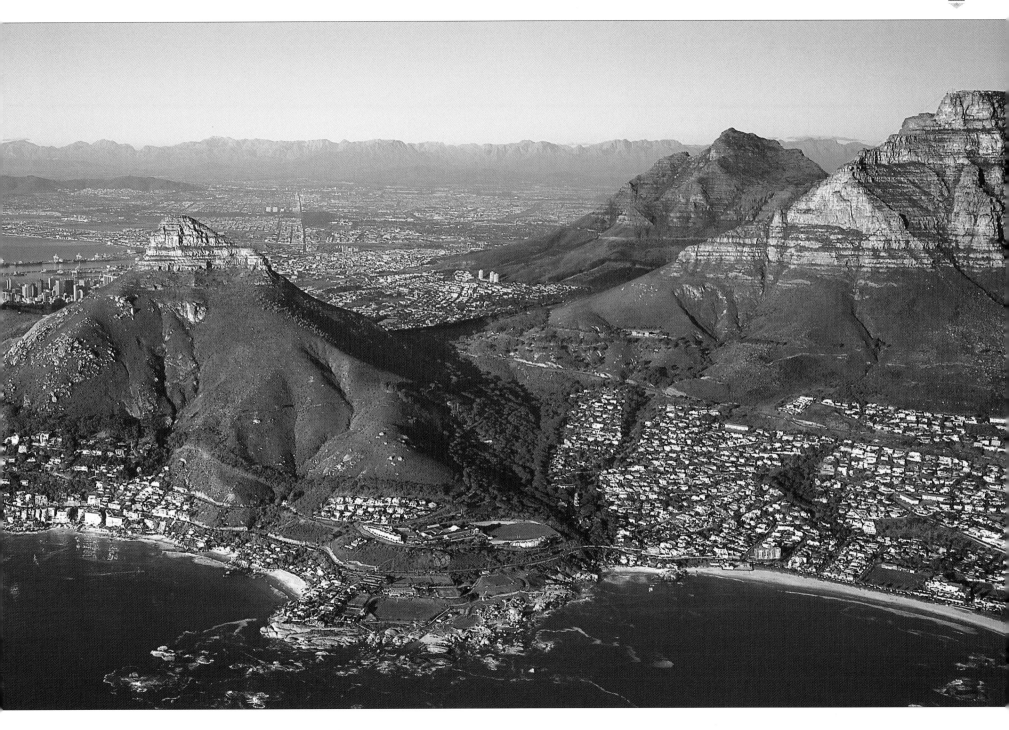

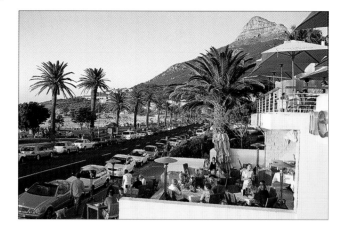

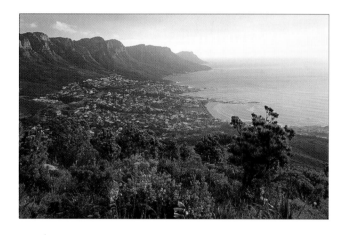

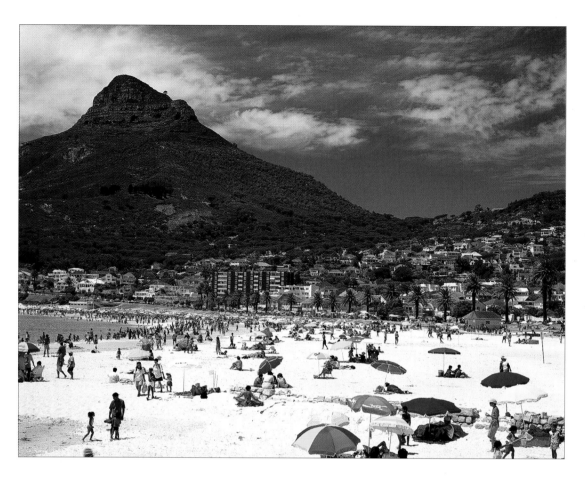

OPPOSITE Camps Bay, at the foot of the Twelve Apostles, which constitute the western front of Table Mountain, is a long palm-fringed expanse of fine white sand ideal for beach games.

THIS PAGE Camps Bay is a lively place: the beach is not only the home turf during the summer volleyball season but also provides a soft cushion for skydivers descending from the mountain above. The plush Atlantic suburb has also become famous for its laid-back café society, the young and moneyed set who patronise the chic bistros and restaurants that line the waterfront.

OVERLEAF, LEFT Beyond the sheltered enclave of Llandudno, in the foreground, is world-famous Sandy Bay, the country's only nudist beach. Both these coves ara ideal for surfing, fishing, hiking and other leisure activities.

OVERLEAF, RIGHT From Klein Leeukoppie ('Little Lion's Head'), with Sandy Bay and Llandudno below, the panorama extends towards its 'big brother', Lion's Head, in the distance, and the back of famed Table Mountain to the right – a view seldom seen by other than the most dedicated hikers.

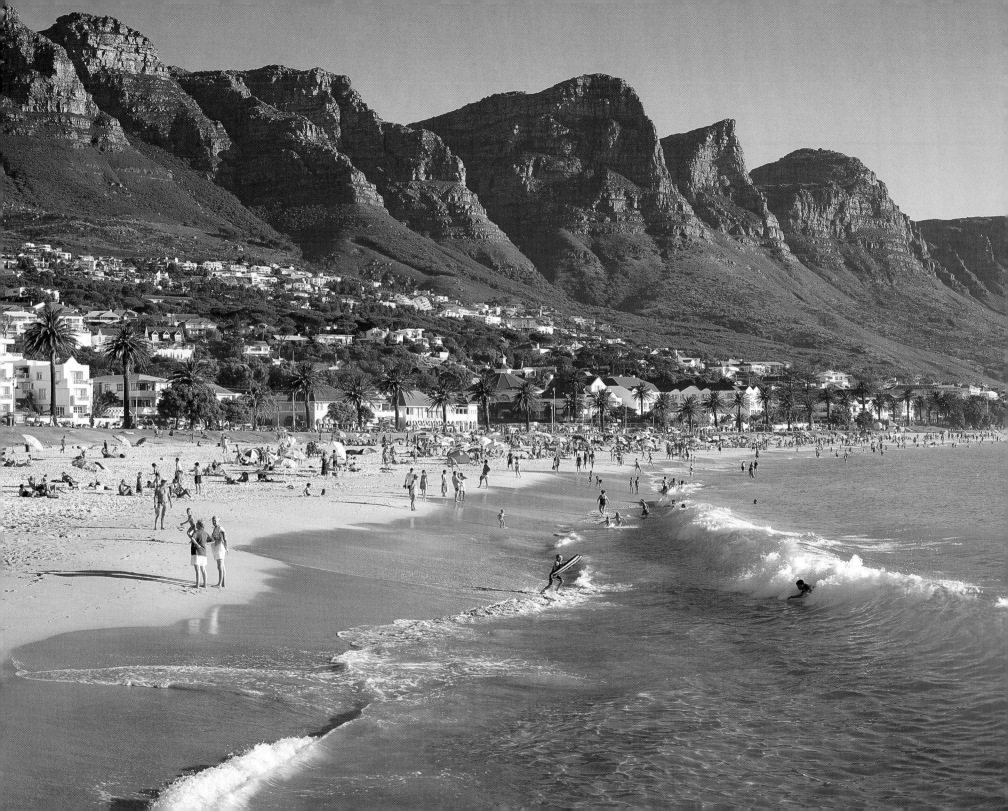

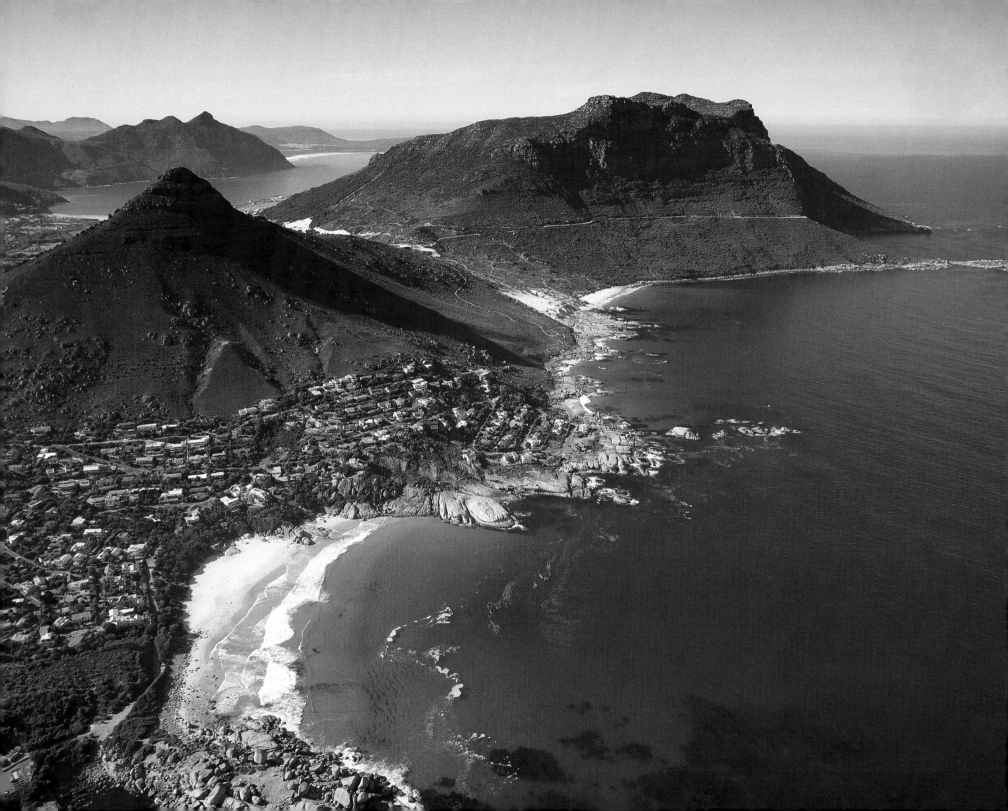

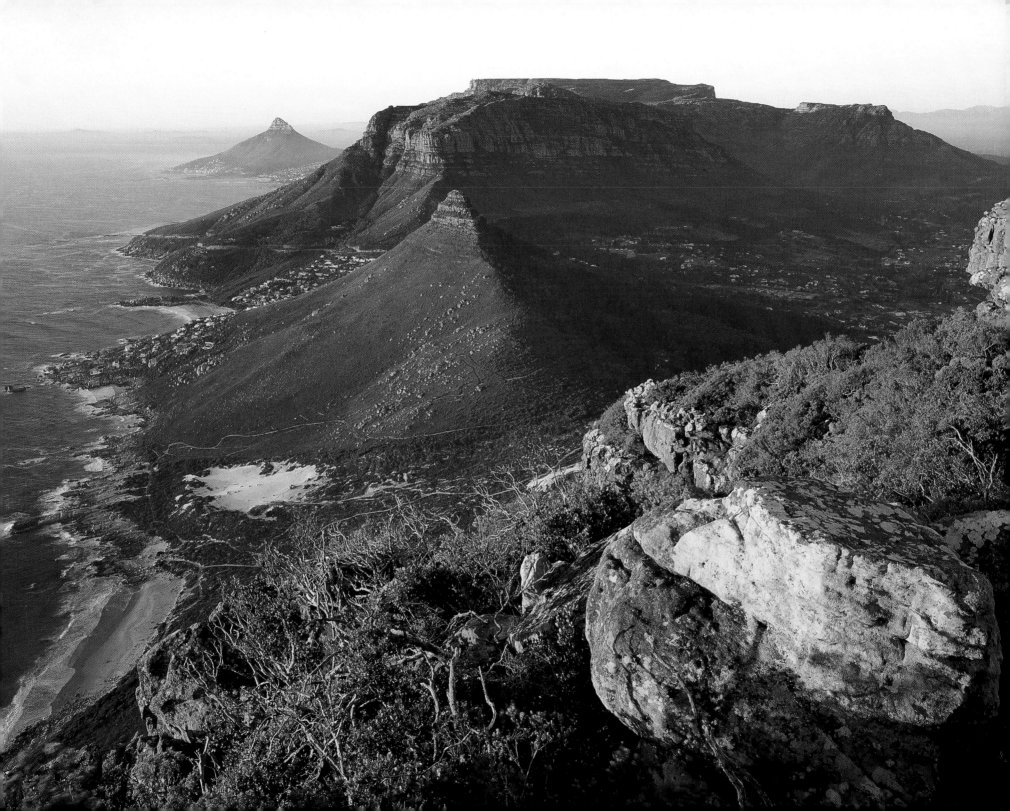

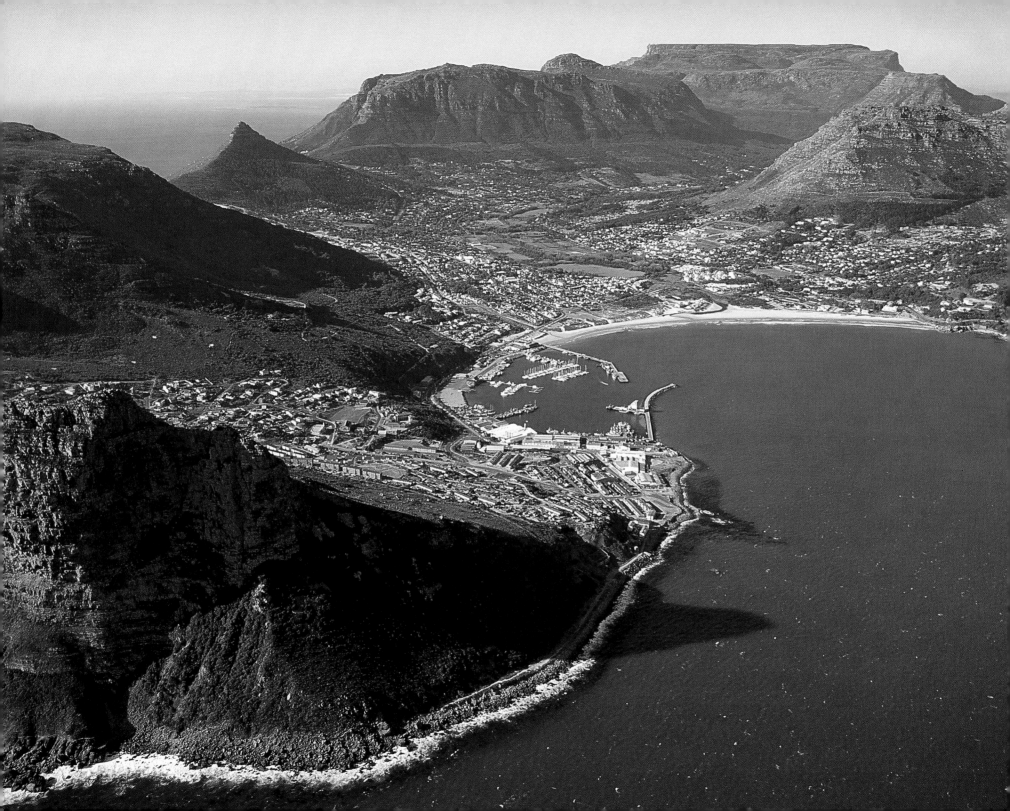

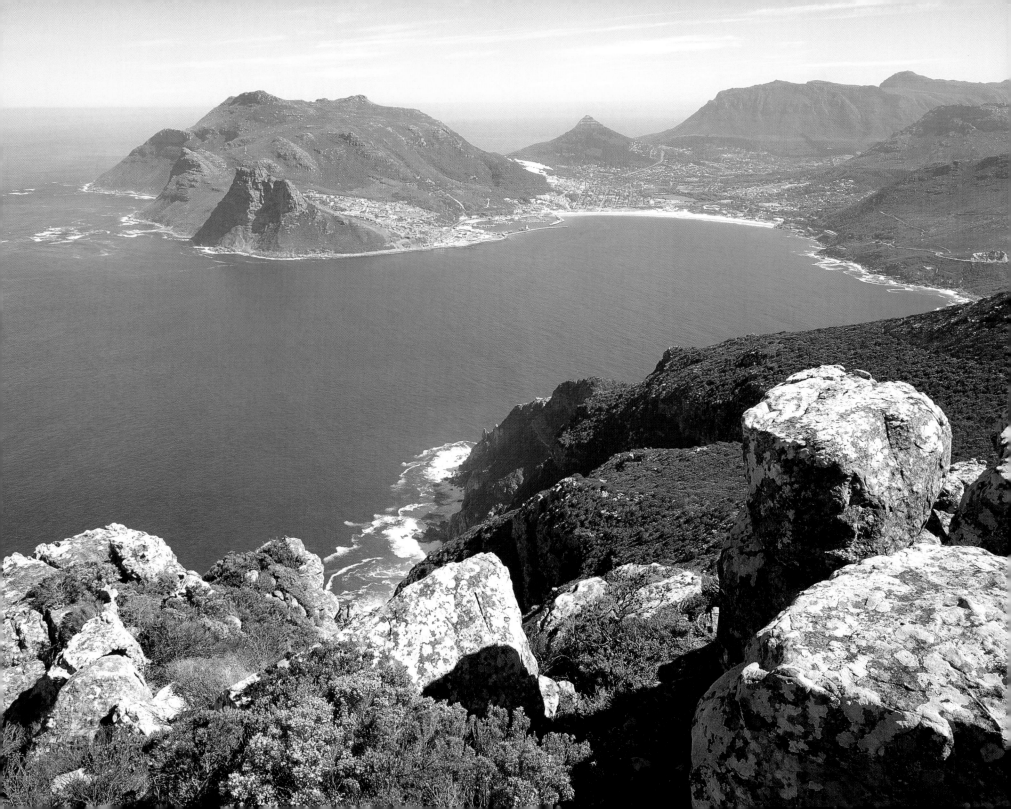

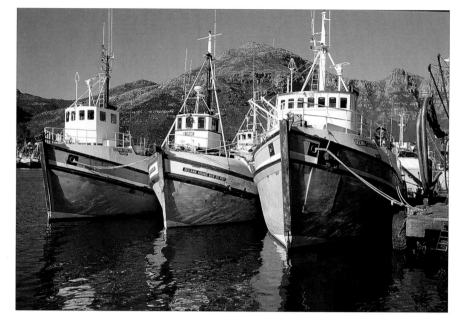

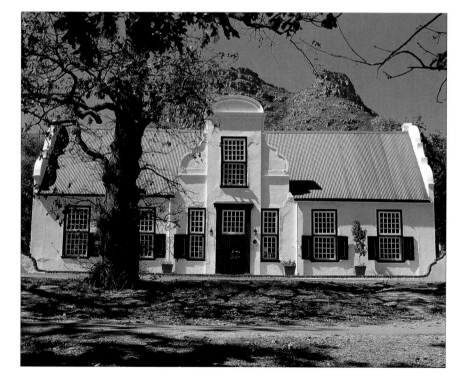

PREVIOUS PAGES Guarded by the imposing hulk of The Sentinel on the left and Chapman's Peak Drive on the right, the village of Hout Bay has, in the most part, remained true to its harbour origins and is still an important base for the fishing industry.

TOP LEFT Standing sentry over the settlement of Hout Bay is a bronze statue of a leopard atop the rocks close to the shore, and is a sad reminder of the days when the Cape Peninsula teemed with an assortment of wildlife.

LEFT This landmark Cape Dutch home was built at the turn of the 18th century by a Johannes van Helsdingenand and has seen many uses since.

ABOVE Despite the rapid development that has enveloped much of the peninsula and the Hout Bay valley, the small fishing village in the heart of the settlement remains much as it has always been and many of the locals still depend on fishing for their income.

OPPOSITE Overlooking the waters of Hout Bay, The Sentinel guards the waters of the bay that once played a vital role in the Cape's timber industry.

OVERLEAF, LEFT Chapman's Peak Drive, undoubtedly the most scenic of the Cape's coastal route, winds precariously along the mountain slope for about 10 kilometres, offering superlative views across the ocean below.

OVERLEAF, RIGHT Famed Chapman's Peak Drive winds through the heart of the Cape's unique *fynbos* biome, leading to the small coastal settlement of Noordhoek, a small, sleepy village blessed with an inordinately beautiful setting.

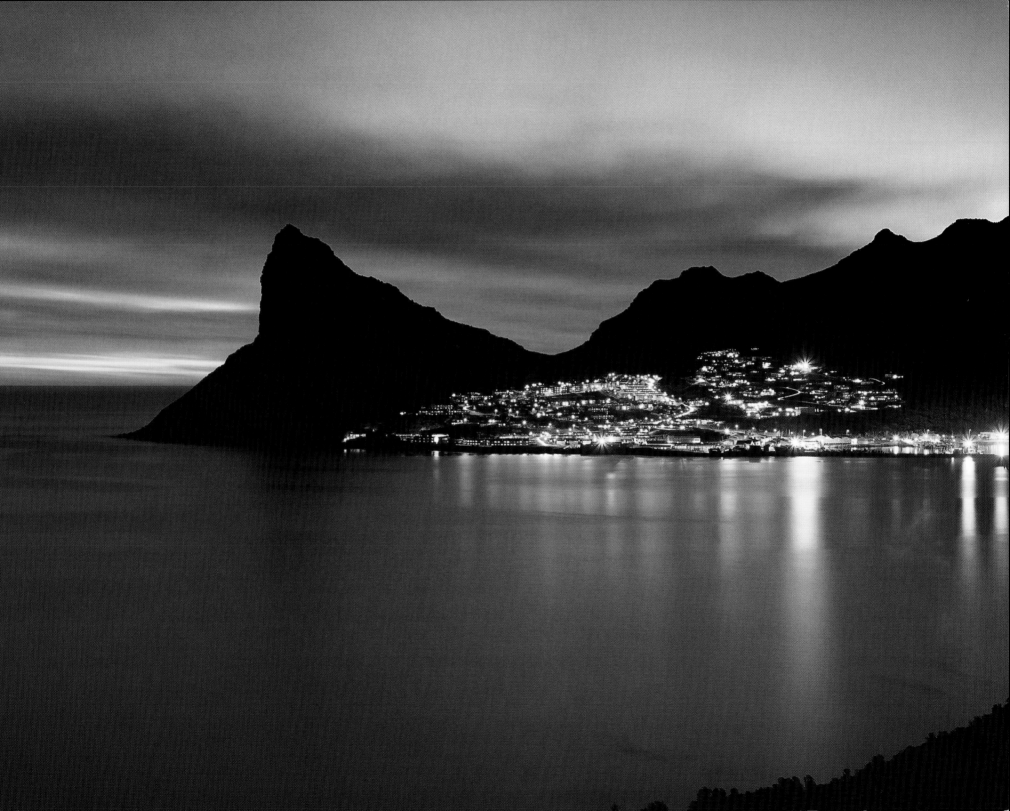

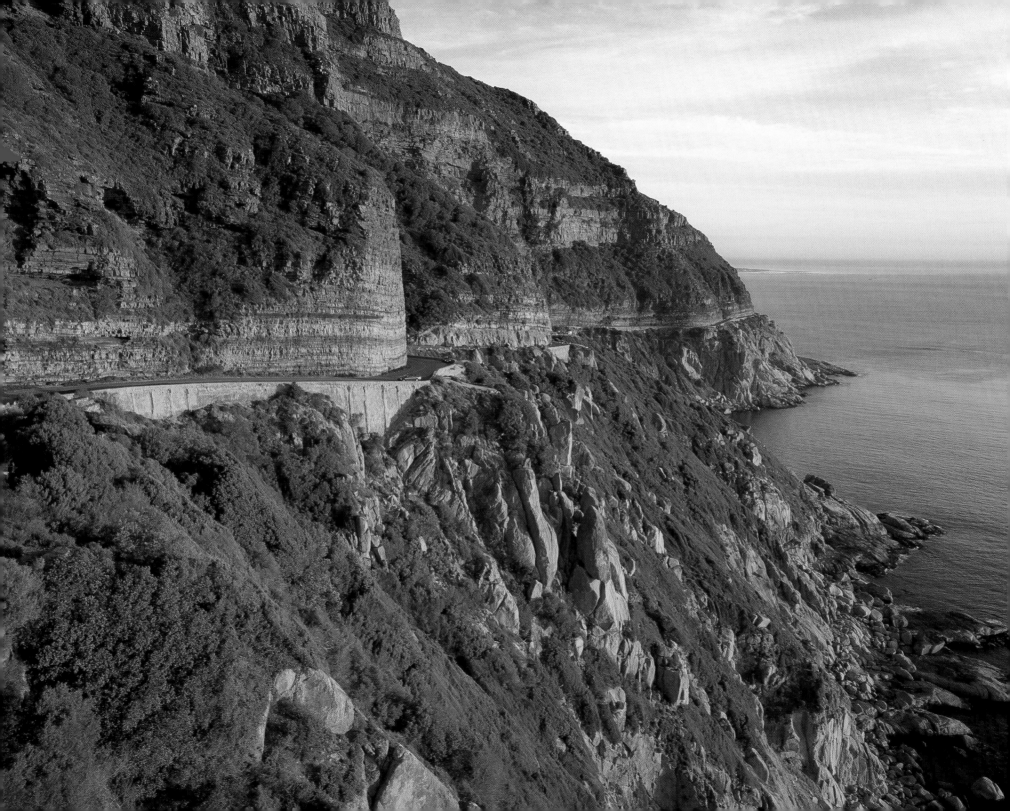

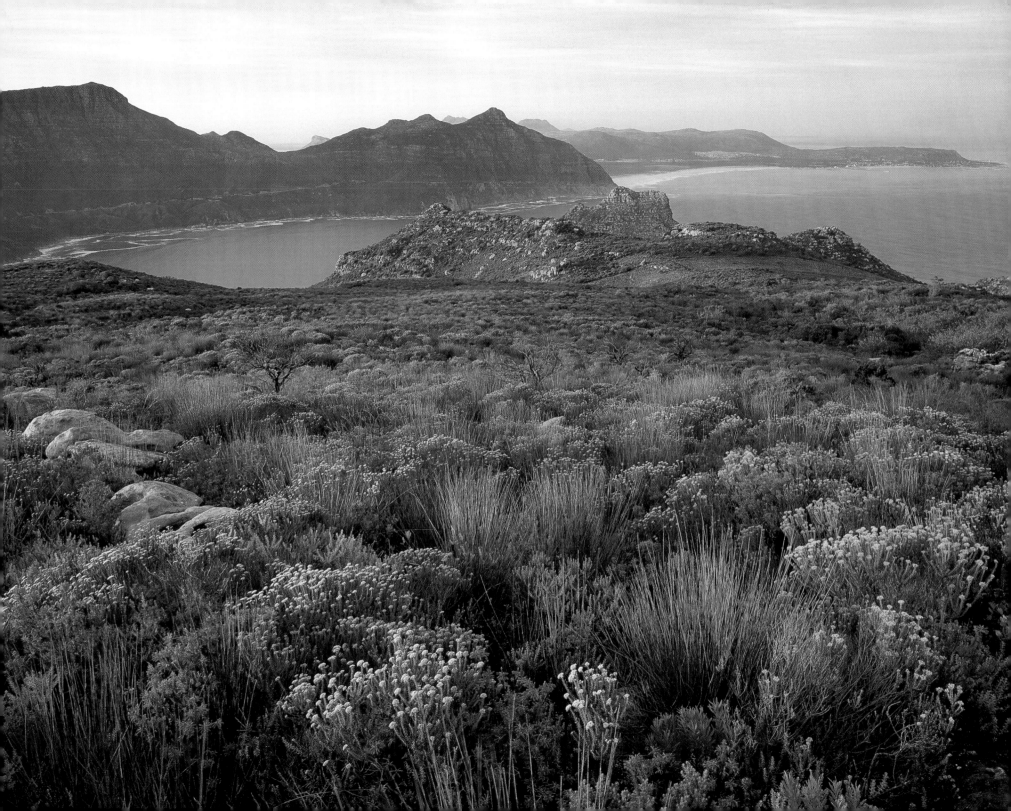

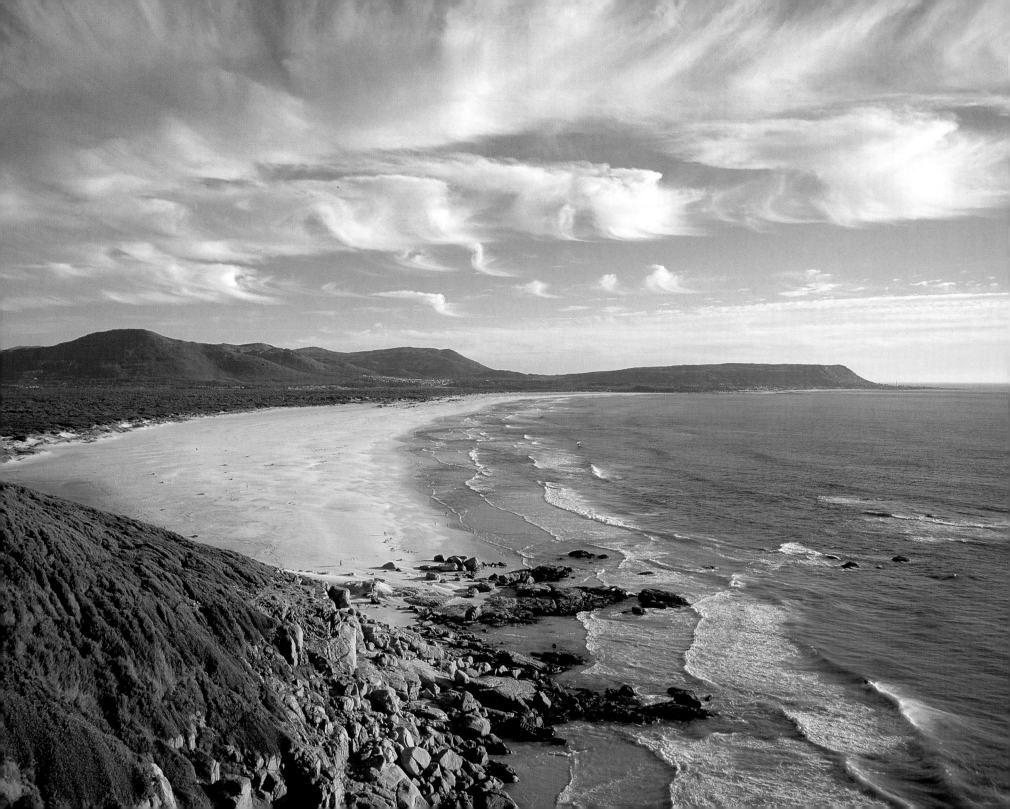

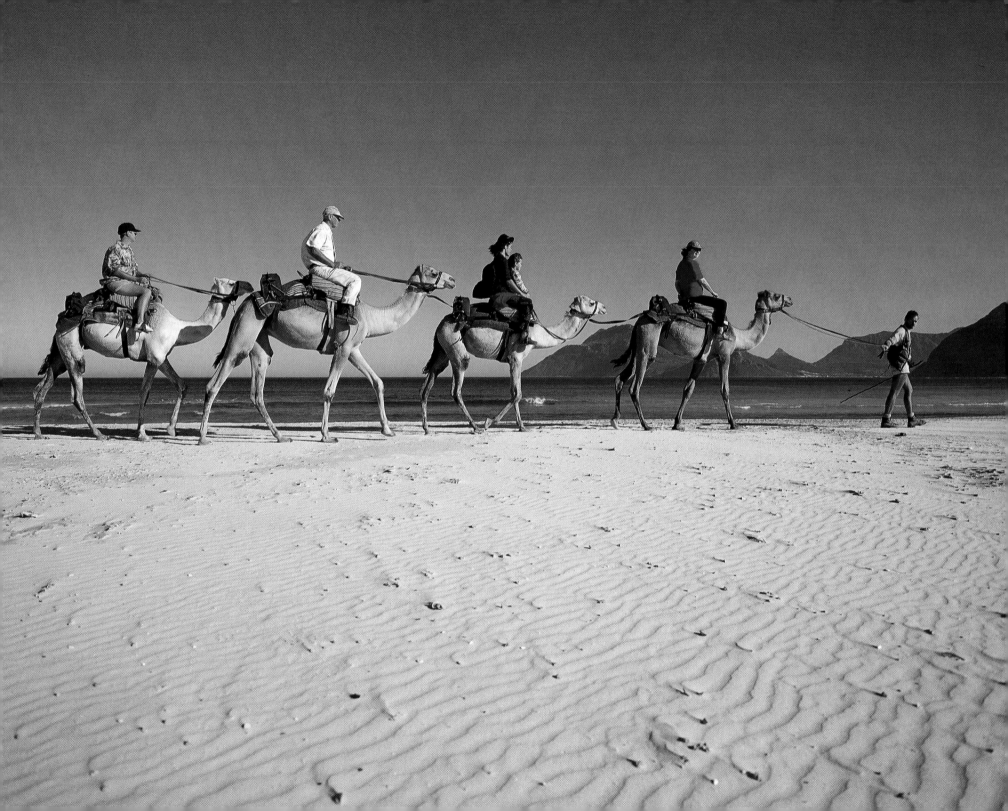

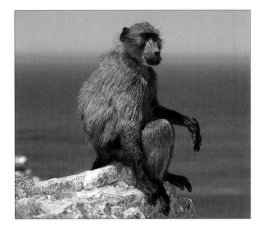

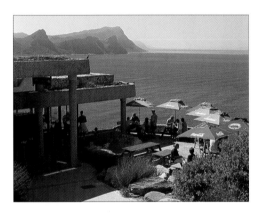

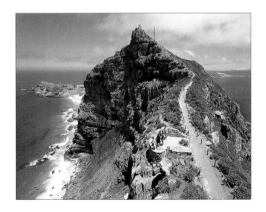

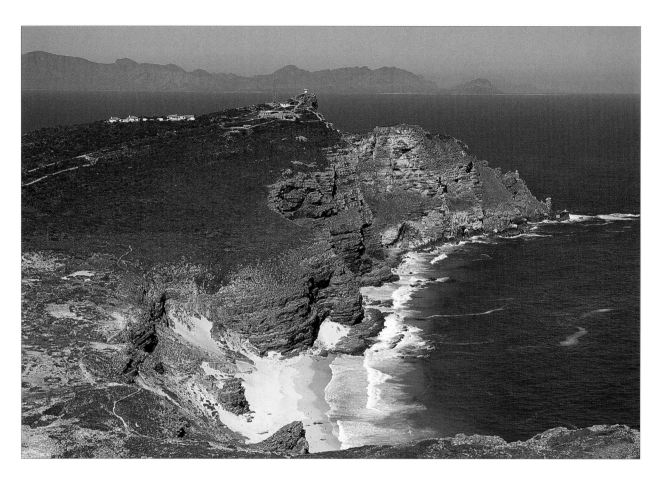

PREVIOUS PAGE, LEFT The Noordhoek Valley is most famed for its exceptional natural heritage and unsullied environment.

PREVIOUS PAGE, RIGHT The gentle sands on the west end of Noordhoek is ideally suited to a quiet stroll, horse ride or a camel trek.

TOP LEFT The baboons found along the roads of the southern peninsula are so accustomed to receiving morsels from enchanted onlookers that their instinct to hunt has, to some degree, been lost and visitors are warned not to feed them.

CENTRE LEFT The popular Two Oceans Restaurant offers not only excellent food and outstanding service, but a panoramic vista of False Bay and beyond.

LEFT Stretching some 40 kilometres along the peninsula's south coast, the Cape Point Nature Reserve – the narrow finger tipped by Cape Point, which falls within the boundaries of the Table Mountain National Park – boasts a variety of indigenous flora and fauna.

ABOVE Many doomed vessels have met their fate on this rocky shore, and the wrecks lay scattered around this hazardous shoreline.

OPPOSITE The splendour and breathtaking views draw nearly half a million people a year to the Cape of Good Hope Nature Reserve.

OVERLEAF Although tourism continues to play a role in the preservation of the peninsula's ecosystem, conservation remains a priority and visitors are urged to leave the natural environment as they found it.

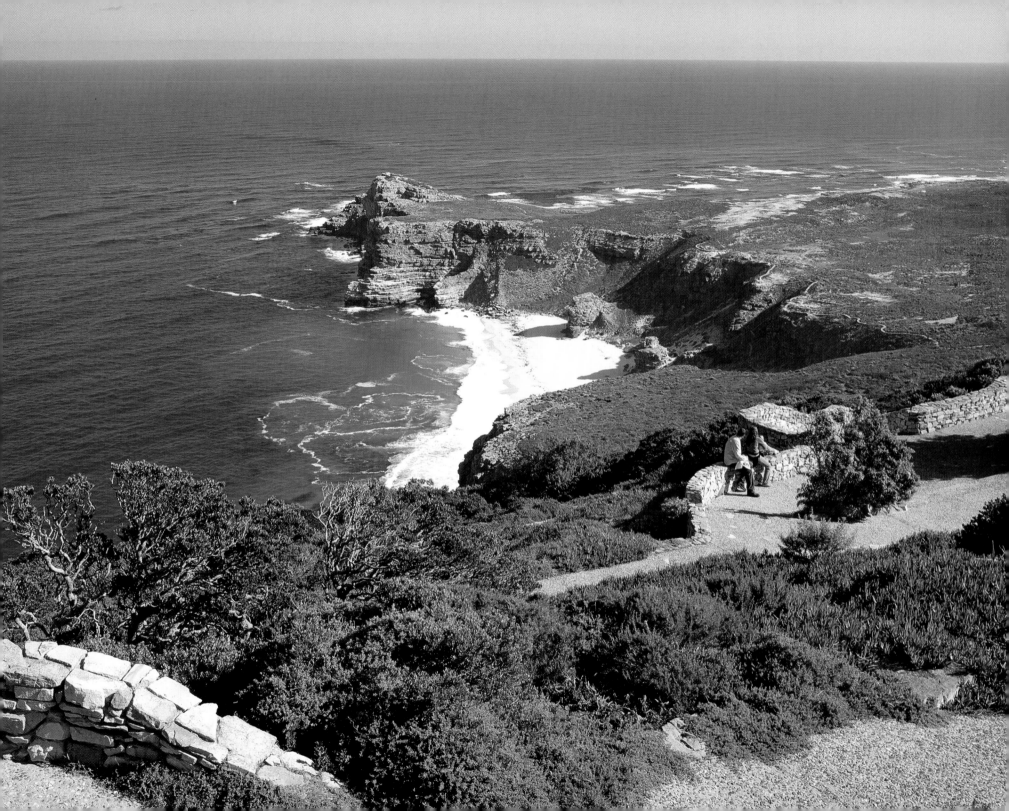

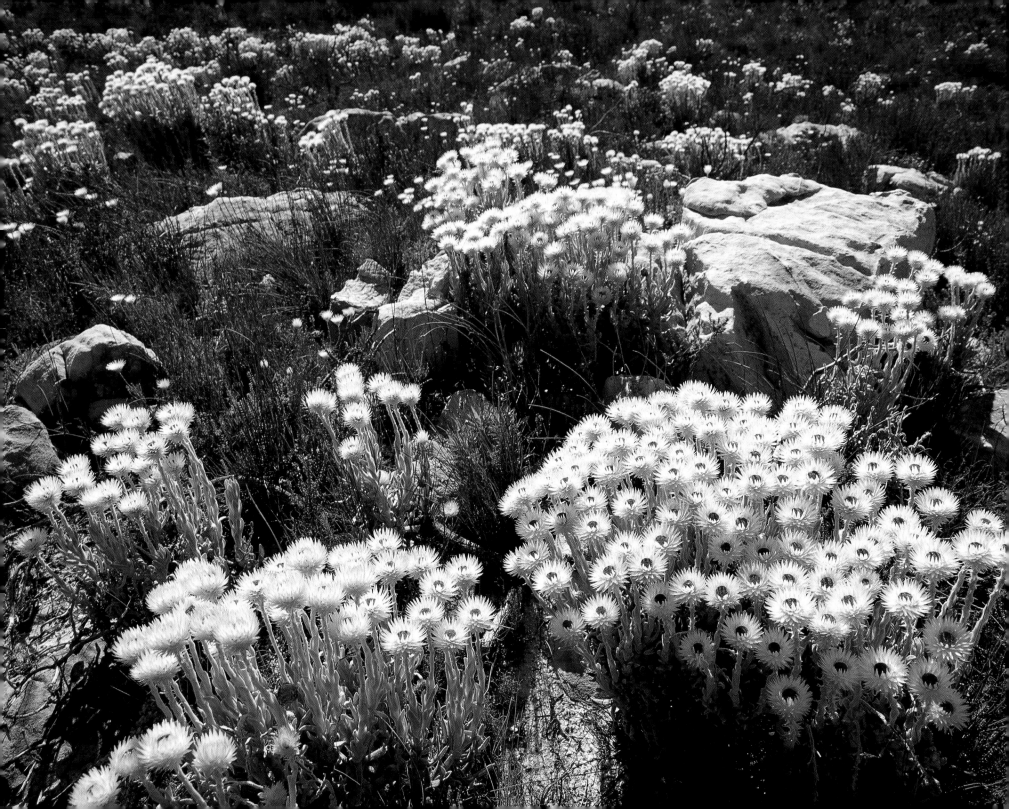

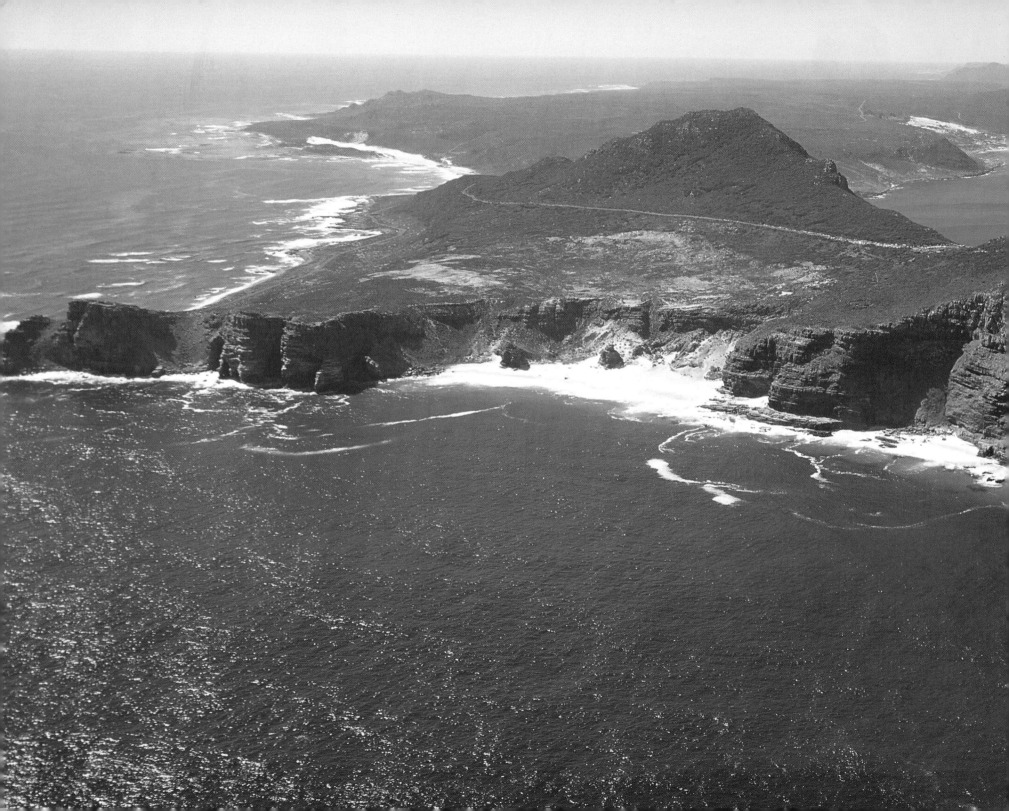

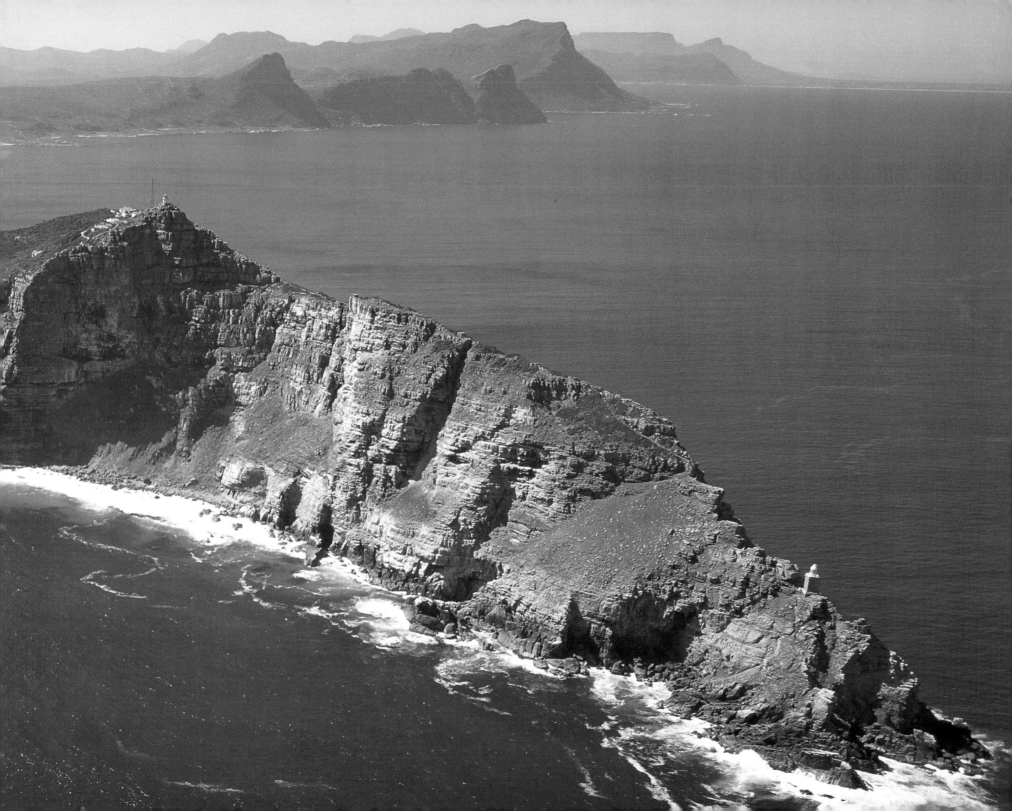

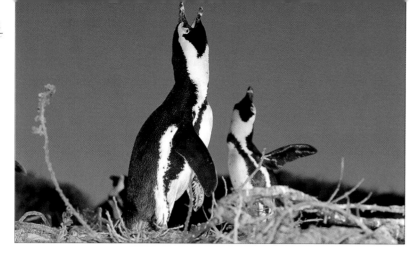

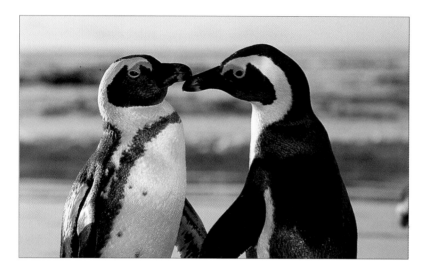

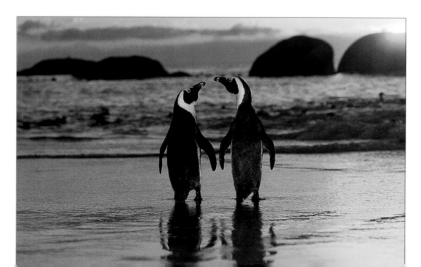

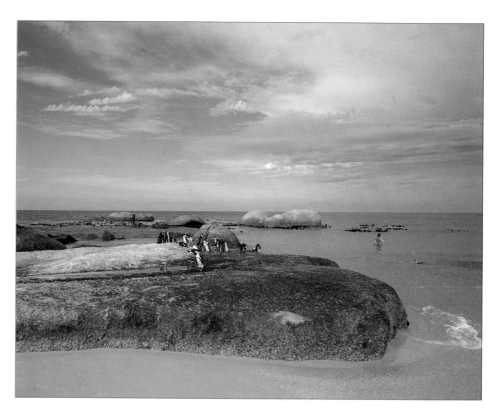

PREVIOUS PAGES Cape Point, a picturesque sliver of land jutting out into the sea, comprises a series of exceptional beaches, and a rugged and rocky landscape covered with *fynbos* vegetation.

THESE PAGES For centuries a vital source of meat and eggs for seamen circumnavigating the Cape of Storms, the African penguins that still occur off the southern peninsula are now protected. Today, a colony of these penguins have made their home at Boulders Beach, a small cove sheltered by granite outcrops and lapped by warm waters, which serves as a refuge for these flightless birds.

OVERLEAF In 1743, Baron von Imhoff established a dock in a small but safe cove in what had become known as False Bay. This was the start of a long and impressive maritime history for Simon's Bay, for nearly 150 years, a vital base for the Royal Navy and still home to the South African naval fleet.

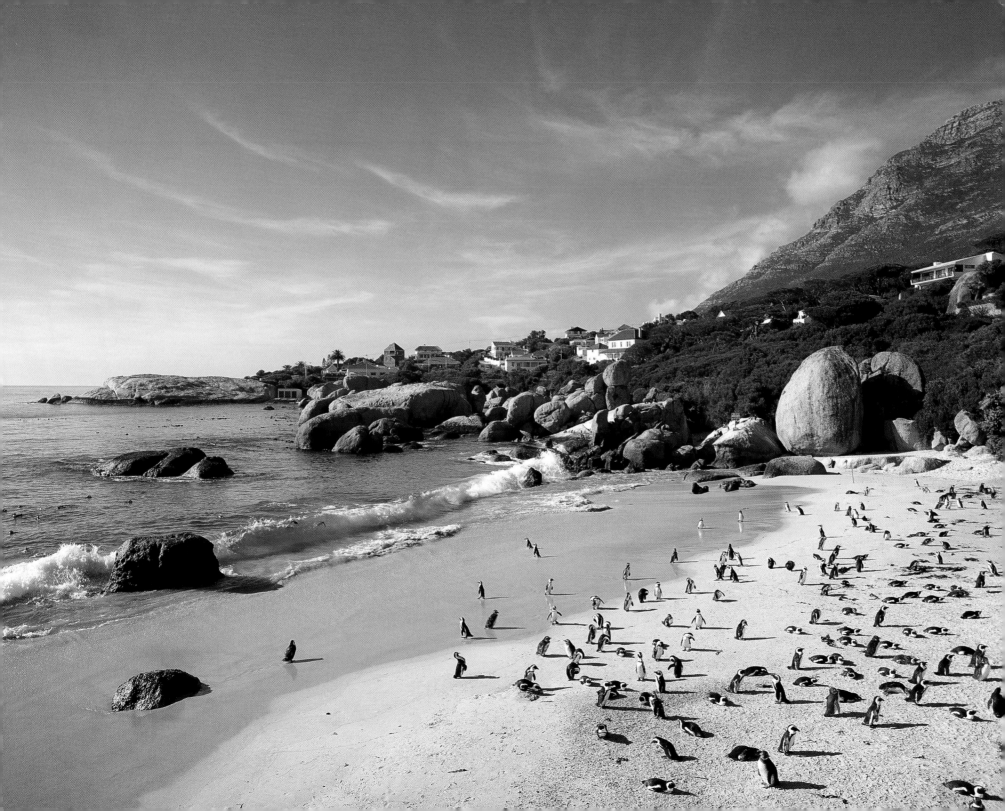

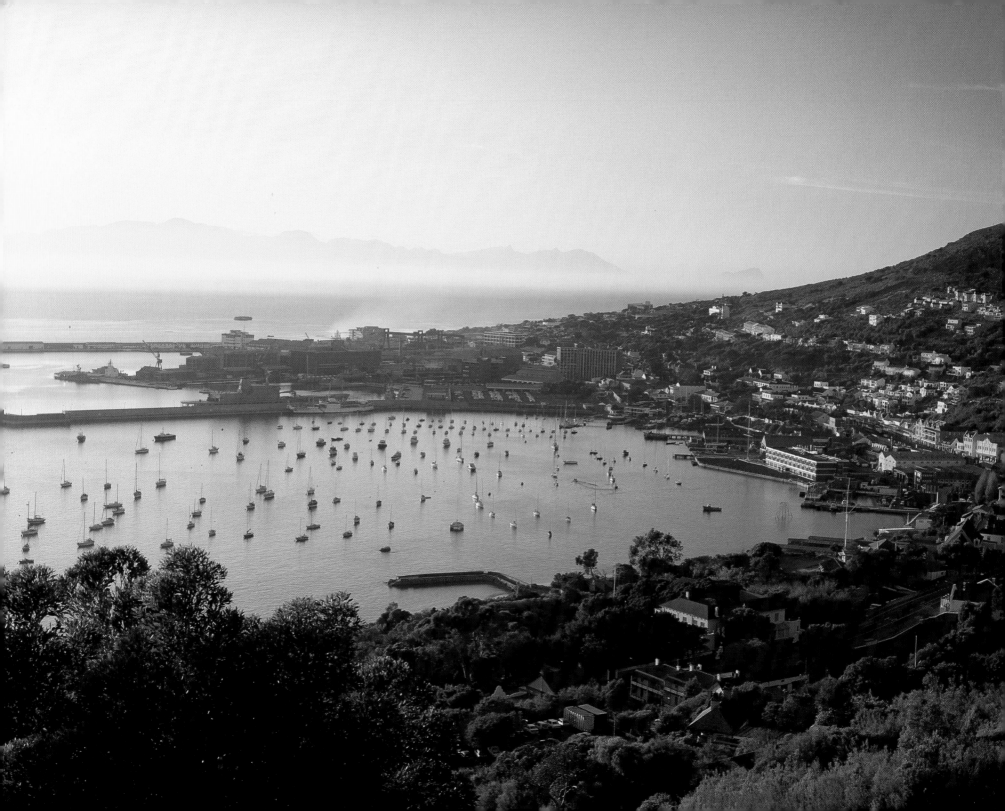

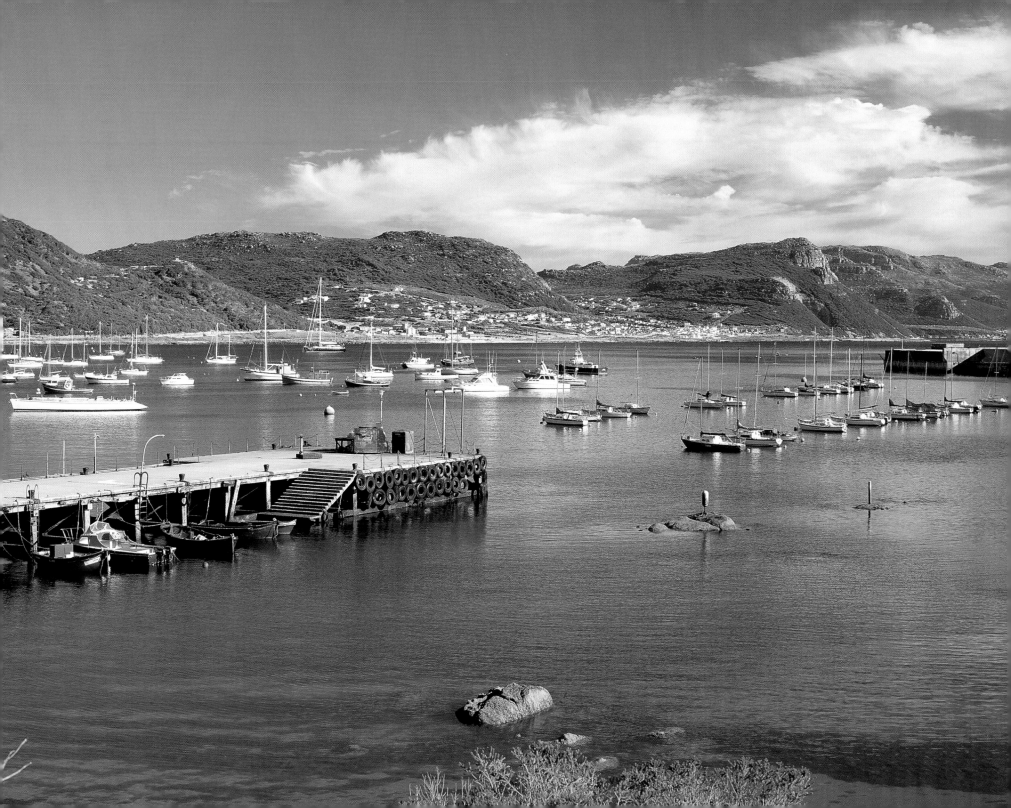

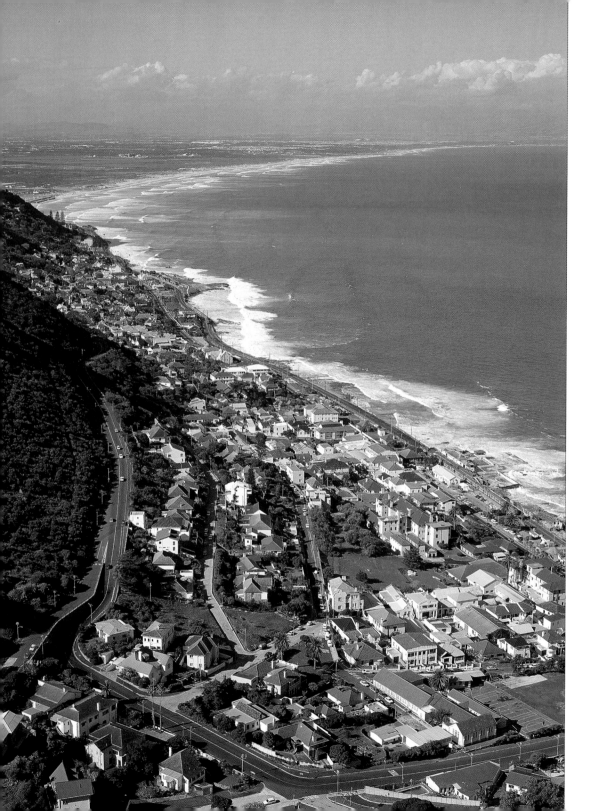

LEFT By the early 1800s, Kalk Bay already boasted a small, active harbour serving local fishermen and whalers who plied the waters off the coast.

TOP Many of the oldest enclaves along False Bay, among them the hamlet of Fish Hoek, date back to the early days of the fledgling Cape settlement.

ABOVE Despite a diminishing fleet, the fisherfolk who work the waters of False Bay and beyond remain a vital element of the local fishing industry.

OPPOSITE The warm and relatively gentle waters of Fish Hoek attract hoards of watersport enthusiasts.

OVERLEAF, LEFT In the early 20th century, Muizenberg became a favourite resort, and a string of impressive homes was erected on the False Bay mountainside.

OVERLEAFE, RIGHT The brightly painted bathing booths on Muizenberg beach are colourful reminders of the town's Edwardian heyday.

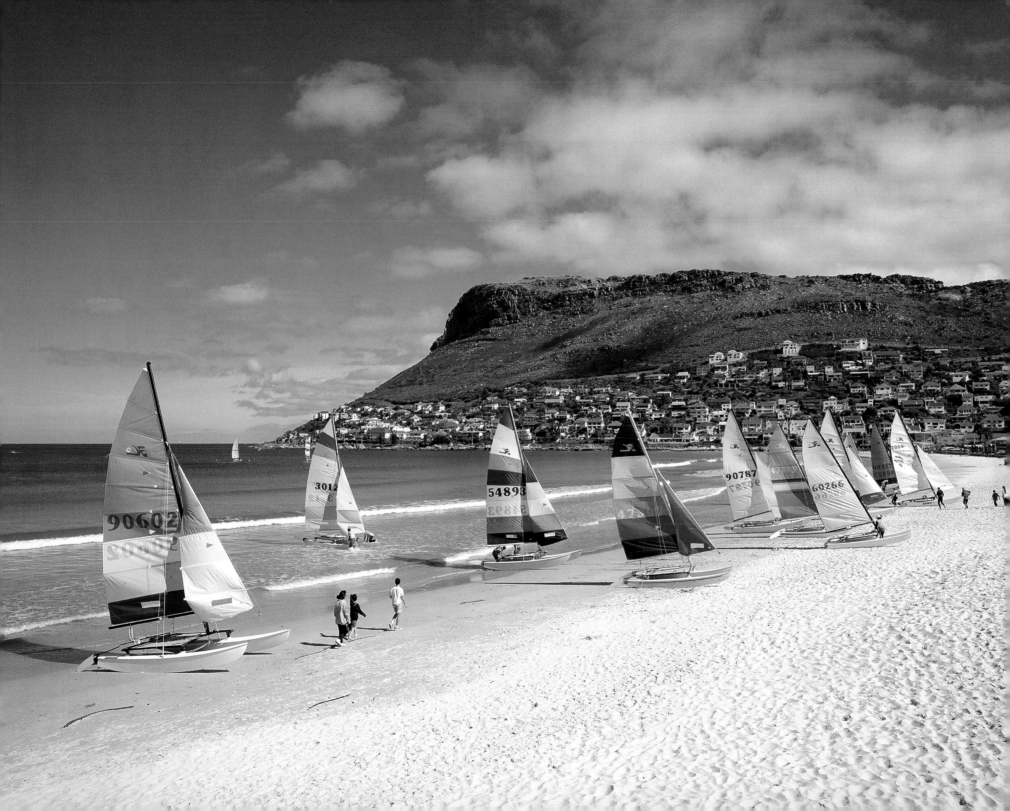

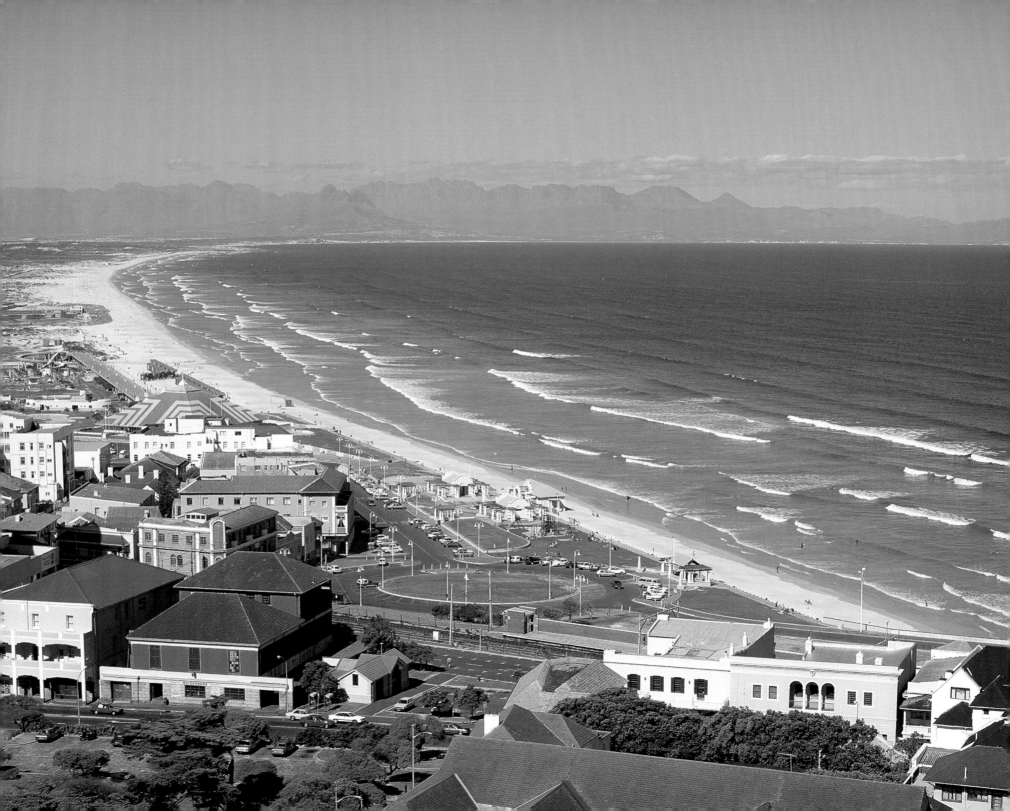

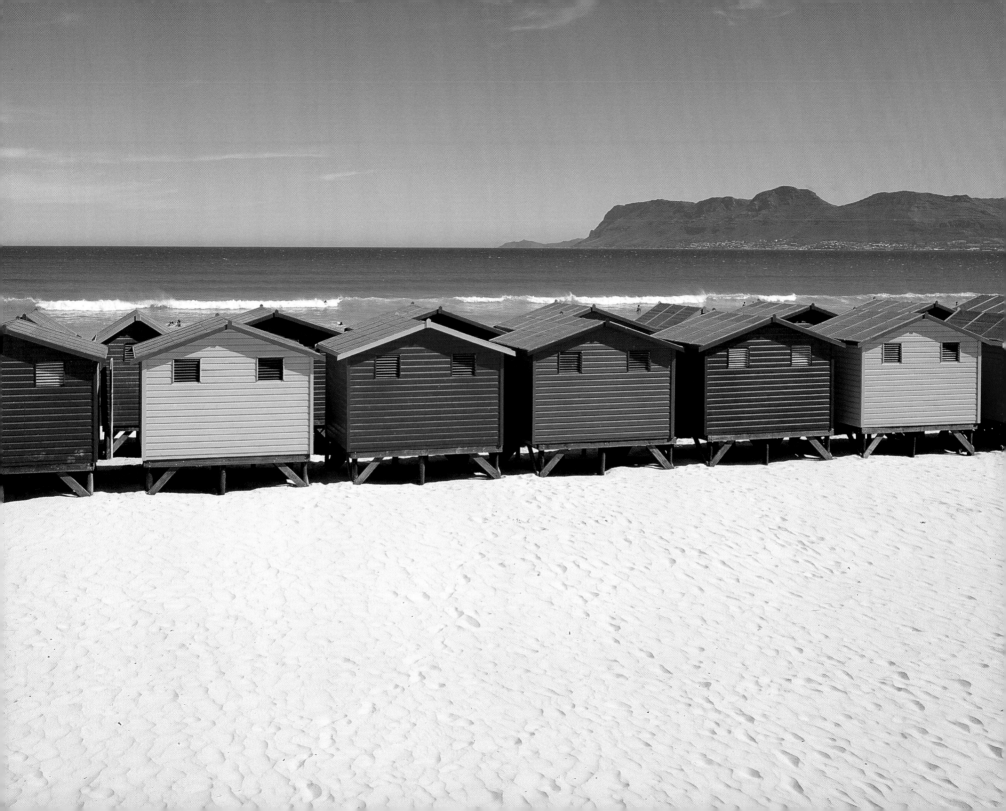

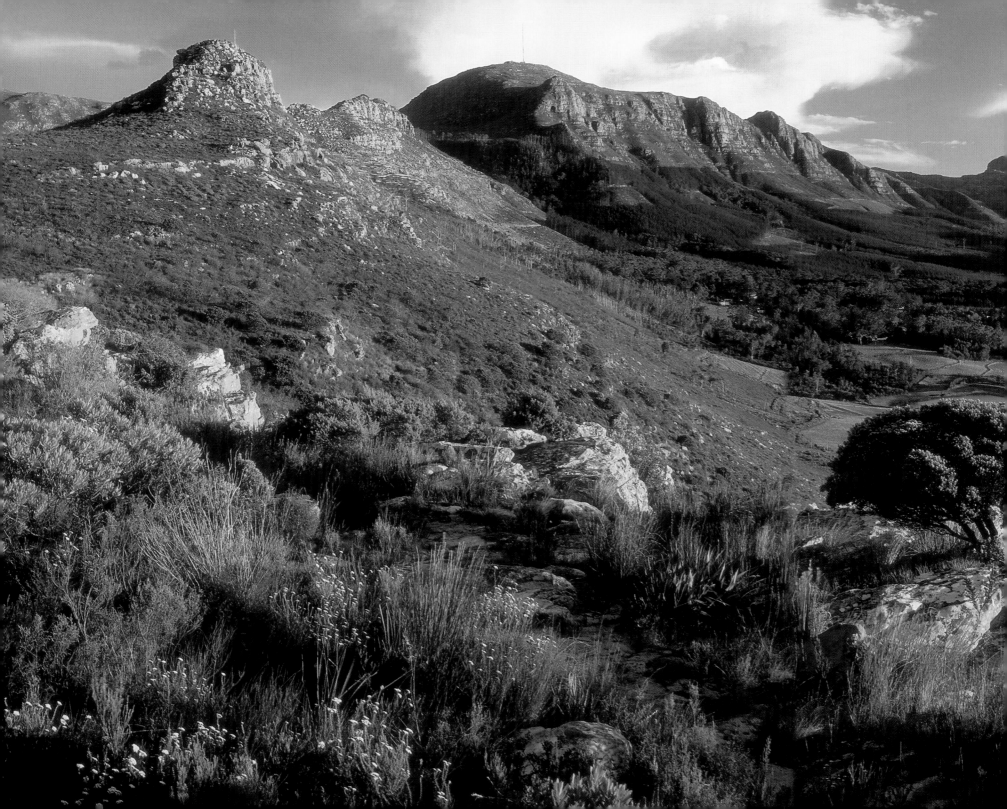

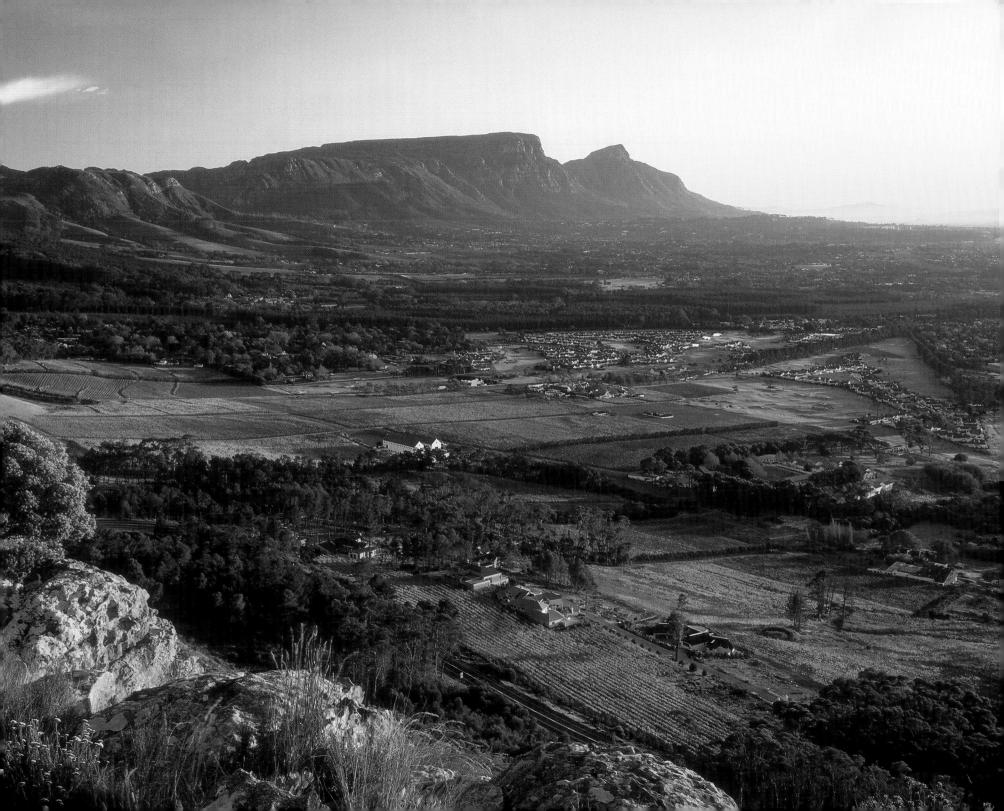

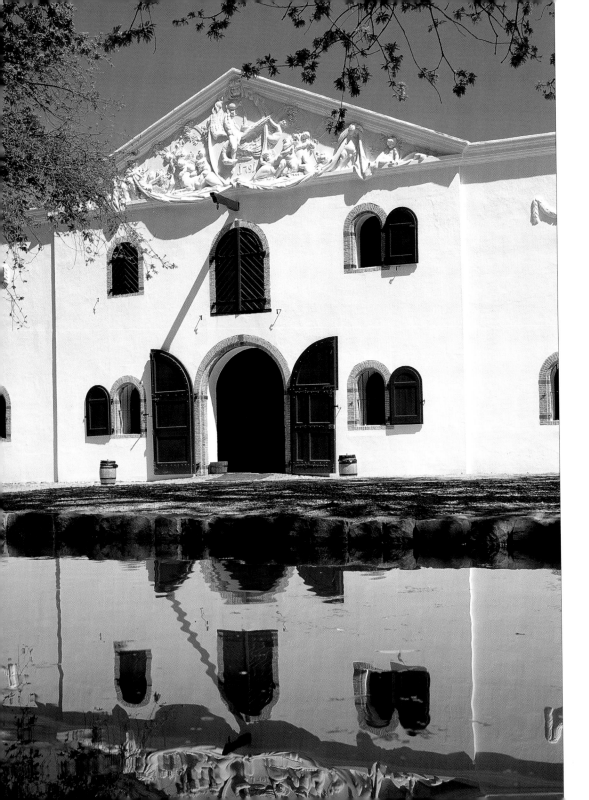

PREVIOUS PAGES Although set aside by Governor Simon van der Stel as a silver mine in 1687, the mountainside now known as Silvermine Nature Reserve – on the upper reaches of the picturesque Constantia Valley – revealed no trace of the metal, and today encompasses not only some of the finest expanses of *fynbos* on the peninsula, but also a variety of wildlife.

THESE PAGES The Groot Constantia estate forms the heart of the only wine route on the Cape Peninsula. The farm still produces some of the Cape's finest wines, and the modern winemaking operation offers both tours and tastings for the visiting public.

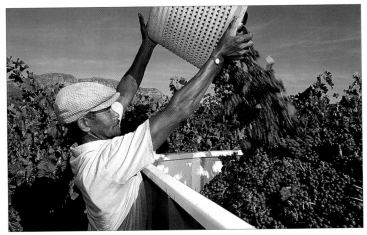

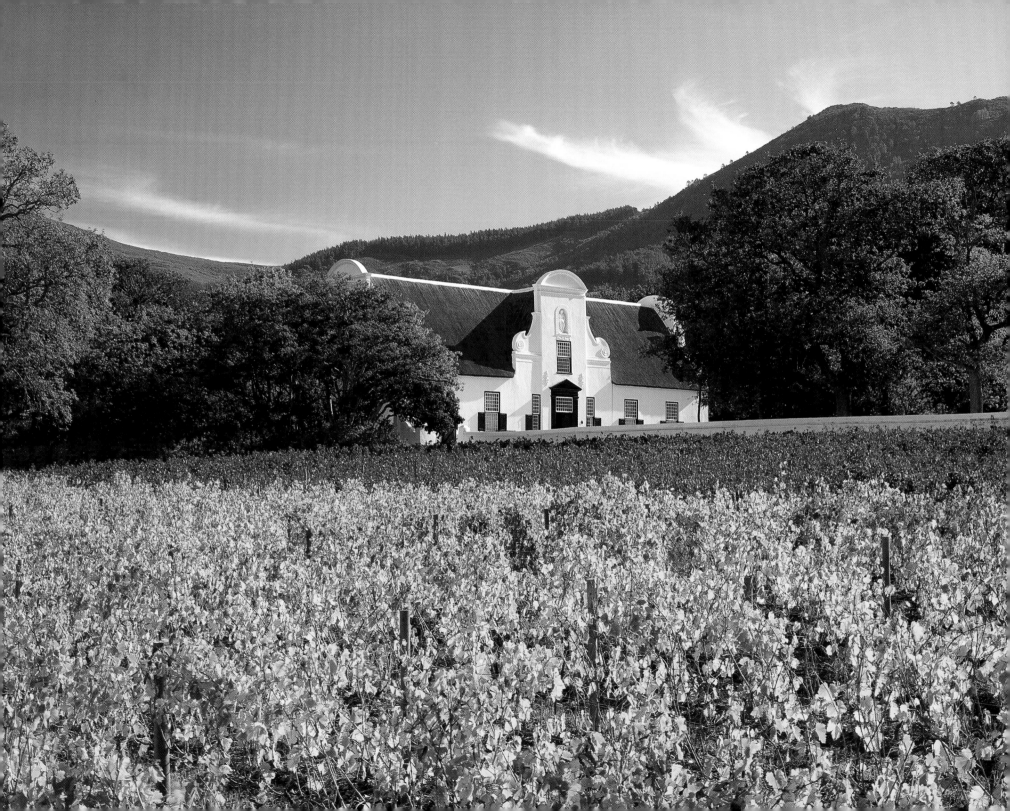

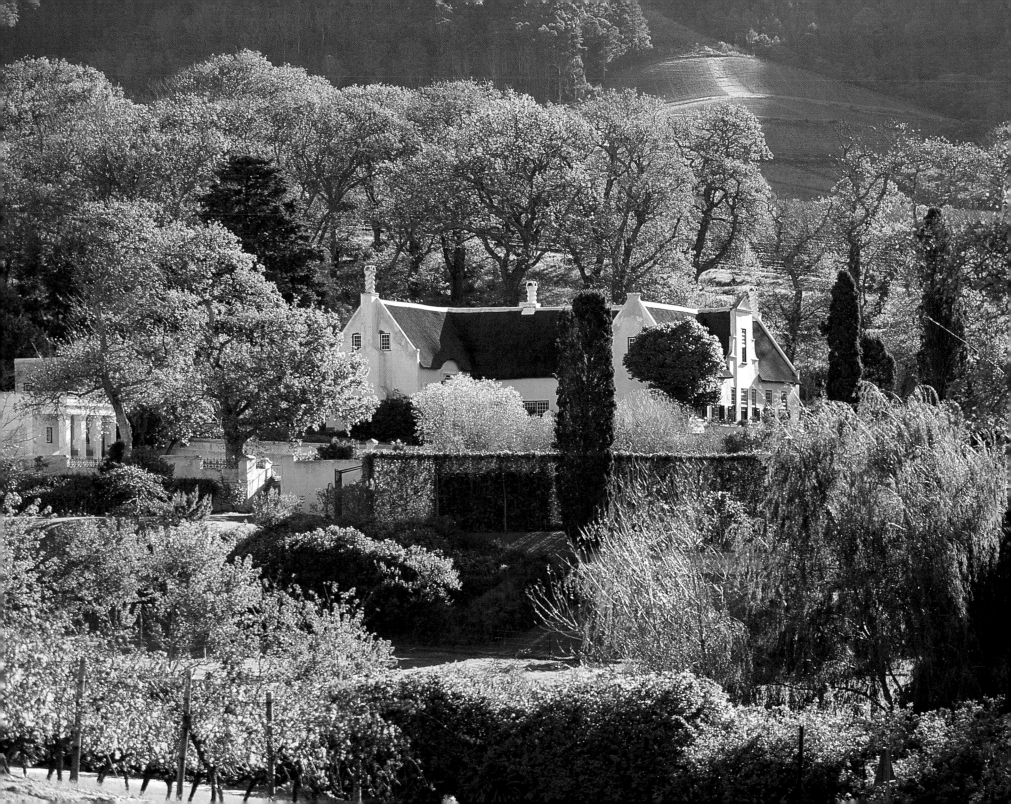

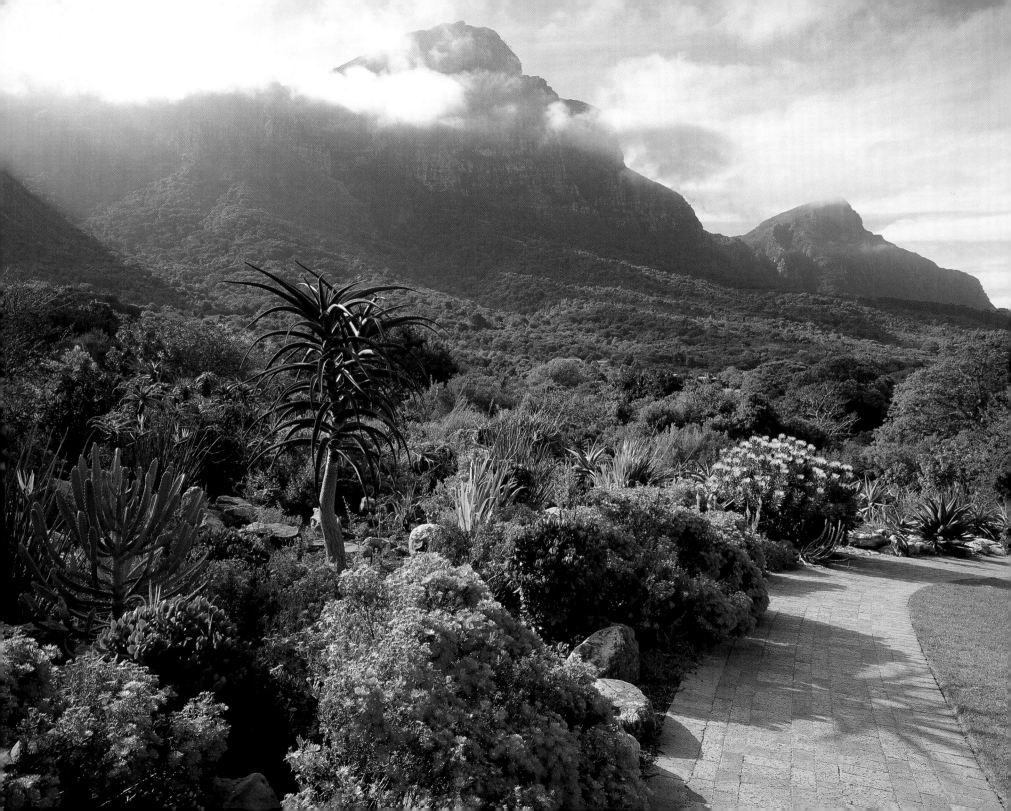

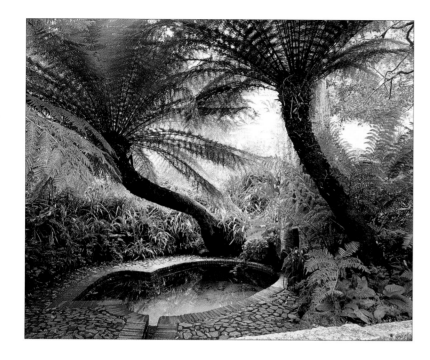

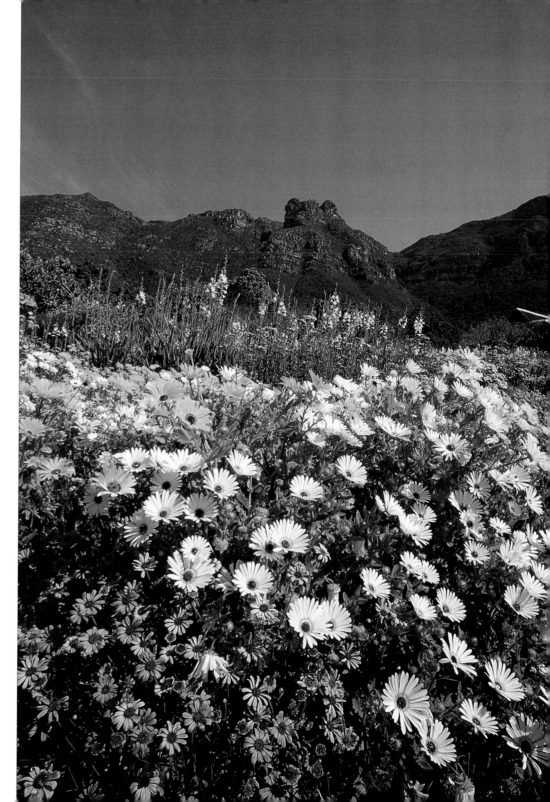

PREVIOUS PAGE, LEFT Gracing the slopes of the lush Constantia Valley, the grounds of
Klein Constantia offer splendid views of the surrounding wineland.

PREVIOUS PAGE, RIGHT The Groot Constantia manor house was erected by Governor
van der Stel when he established the vineyards here over 300 years ago and is today
the oldest of its kind in the country.

OPPOSITE The magnificent Kirstenbosch National Botanical Garden remains one of
the country's top tourist spots, and its unparalleled natural splendour attracts about
two million visitors every year.

ABOVE In the Dell below Kirstenbosch's Cycad Amphitheatre stands Colonel Bird's
Bath – popularly known as Lady Anne Barnard's Bath – a bird-shaped well commonly
thought to have been shipped in from Batavia for Lady Anne Barnard, wife of the
governor's secretary.

RIGHT Castle Rock towers over the lands bequeathed to the nation by premier
Cecil John Rhodes. Established in 1913, the over 500 hectares of *fynbos* and forest
includes nearly 7 000 species of indigenous plants, and is an important centre for
botanical research.

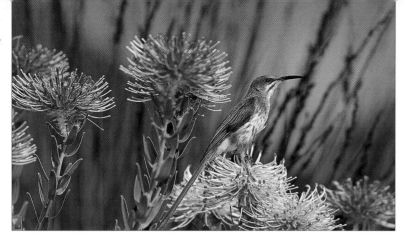

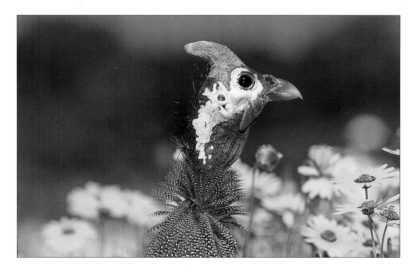

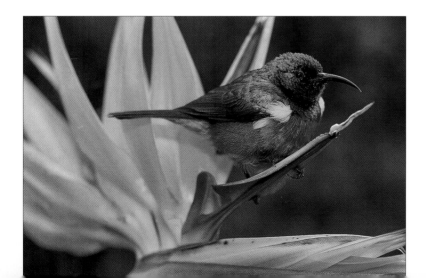

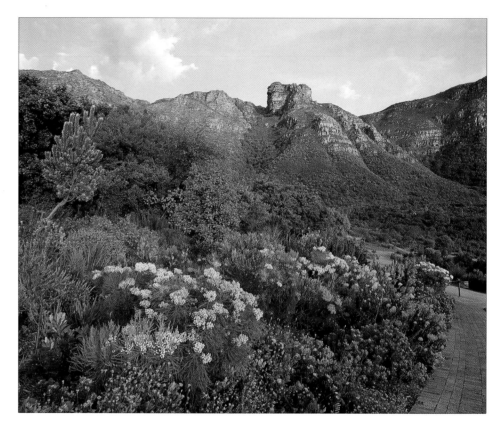

TOP LEFT As a protected haven for indigenous flora, the gardens at Kirstenbosch inevitably attract endless varieties of endemic birds, among them the Cape sugarbird.

LEFT Often seen scurrying among the dense foliage of the shrubs and bushes that cover the slopes of Kirstenbosch are family groups of helmeted guineafowl.

BOTTOM LEFT Flitting between the colourful blooms in Kirstenbosch is the equally striking lesser double-collared sunbird.

ABOVE The undulating landscape of Kirstenbosch National Botanical Garden is punctuated with the angular shape of famed Castle Rock.

OPPOSITE Under the auspices of the National Botanical Institute, Kirstenbosch spreads across the eastern slopes of Table Mountain and up to MacClear's Beacon. The lush gardens, filled with colourful blooms, laced with a network of walks and visited by a variety of indigenous birds, is also the setting for summer sunset concerts.

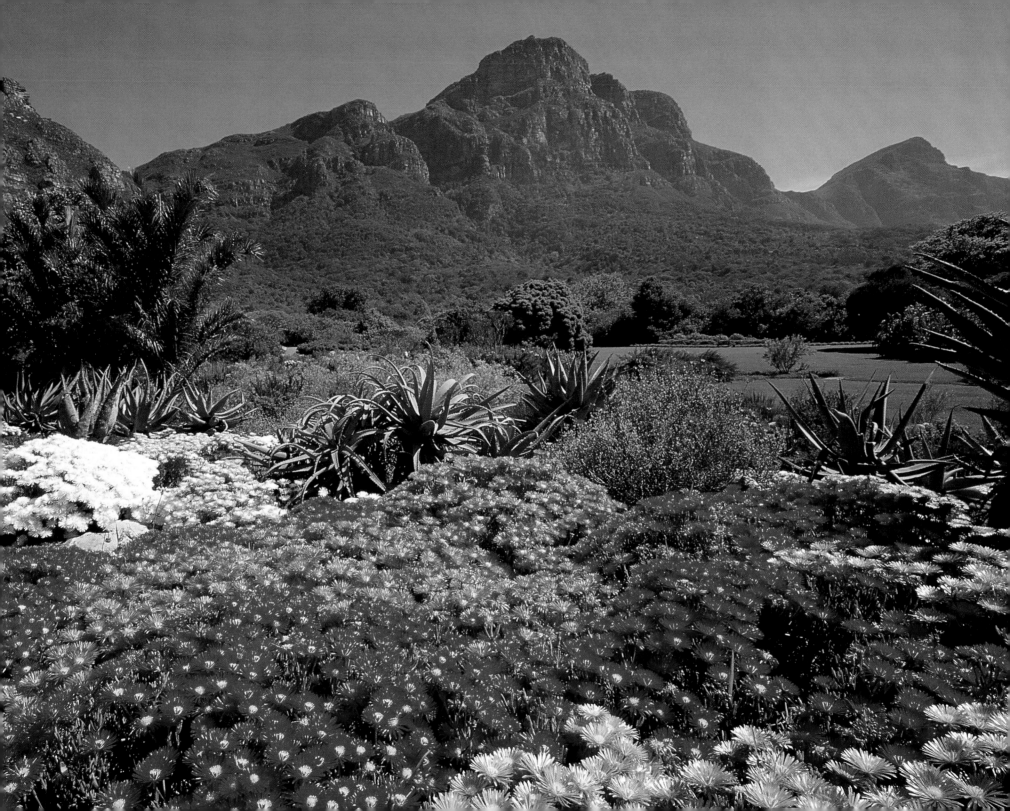

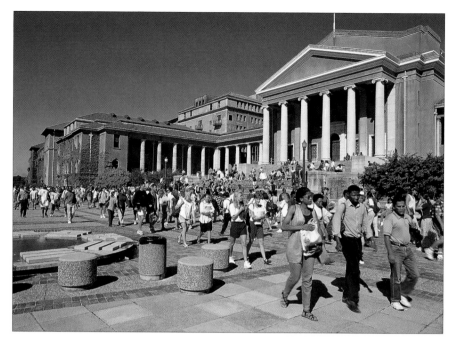

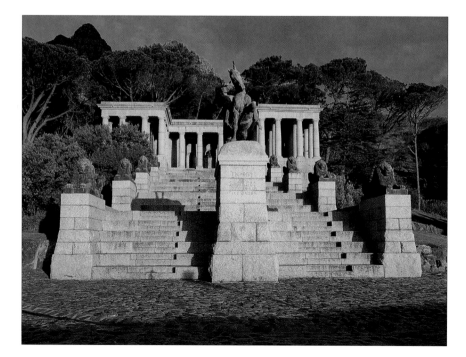

TOP LEFT Situated on the Groote Schuur estate left to the people of South Africa by Cecil John Rhodes, the neo-classical sandstone buildings of the University of Cape Town house part of the upper campus.

LEFT A constant reminder of the legacy of the great statesman, Sir Herbert Baker's memorial to Rhodes was built from granite excavated from Table Mountain.

ABOVE The much-lauded University of Cape Town is the country's oldest institution of tertiary education, and is the academic home of about 15 000 students.

OPPOSITE A treasure trove of valuable art, Genadendal – formerly known as Groote Schuur (meaning 'great barn', after its original purpose as a store for the colony's grain supply) – was, until recently, the Cape Town home of the South African president and is now being converted into a museum.

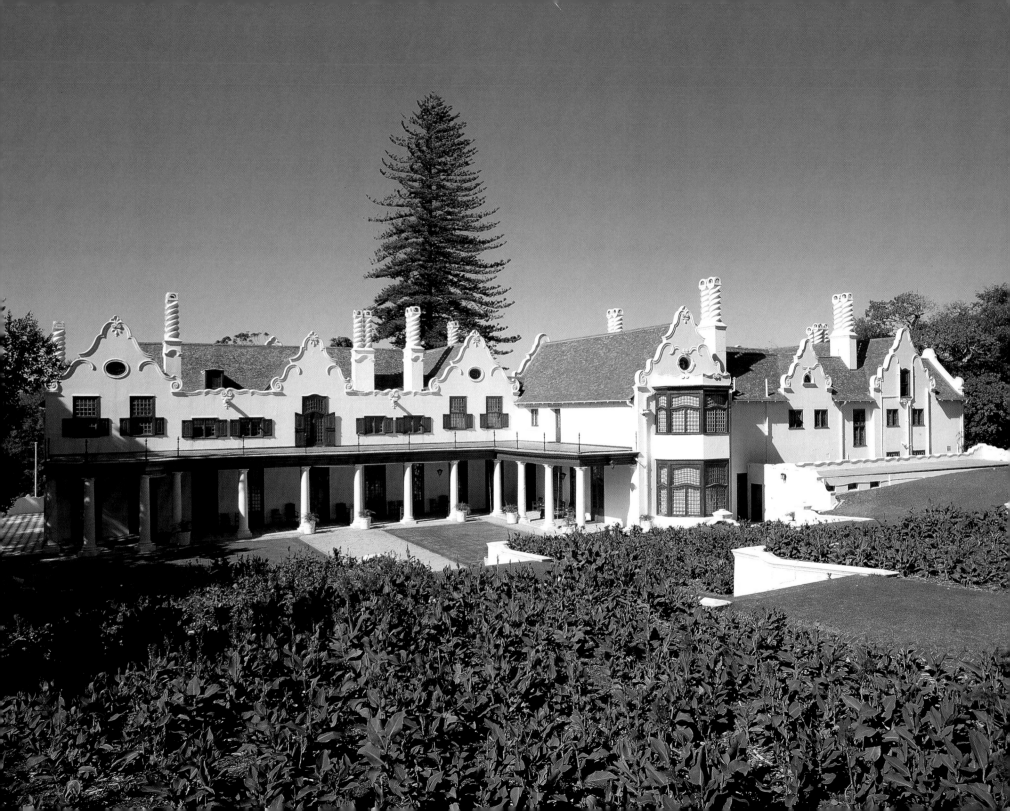

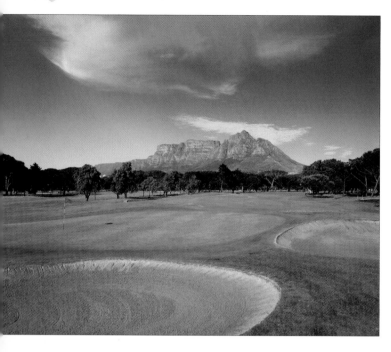

THESE PAGES True to the international trend that has seen the establishment of new golf courses both as centres of leisure and the setting for sought-after residential property, the Cape Peninsula plays host to a surprising number of acclaimed greens – despite what may seem limited land. Some of the city's golf courses – including those at Mowbray (top left) and Clovelly (bottom left) – are established landmarks with a long and proud history, while others such as Erinvale (below) and Atlantic Beach (opposite) are relatively new but equally impressive newcomers to the golfing scene.

OVERLEAF Weekends at Club Mykonos, a leisure resort on the Cape's West Coast, draw hordes of fun seekers to the beaches, and the waters are inevitably dotted with the colourful sails of an assortment of pleasure craft.

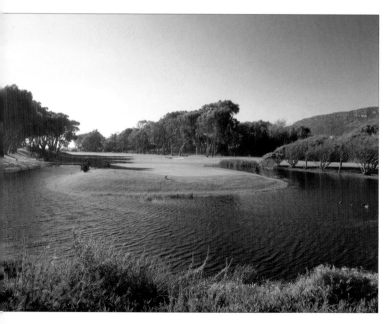

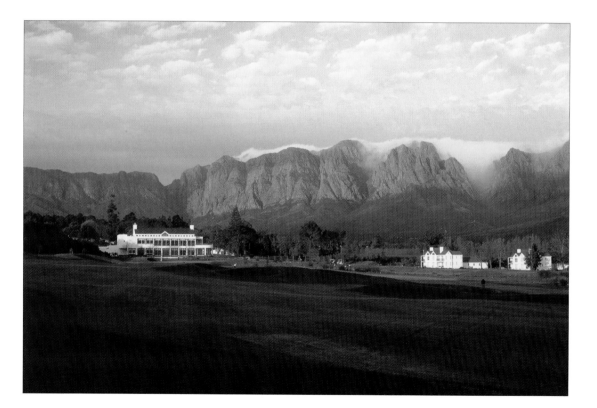

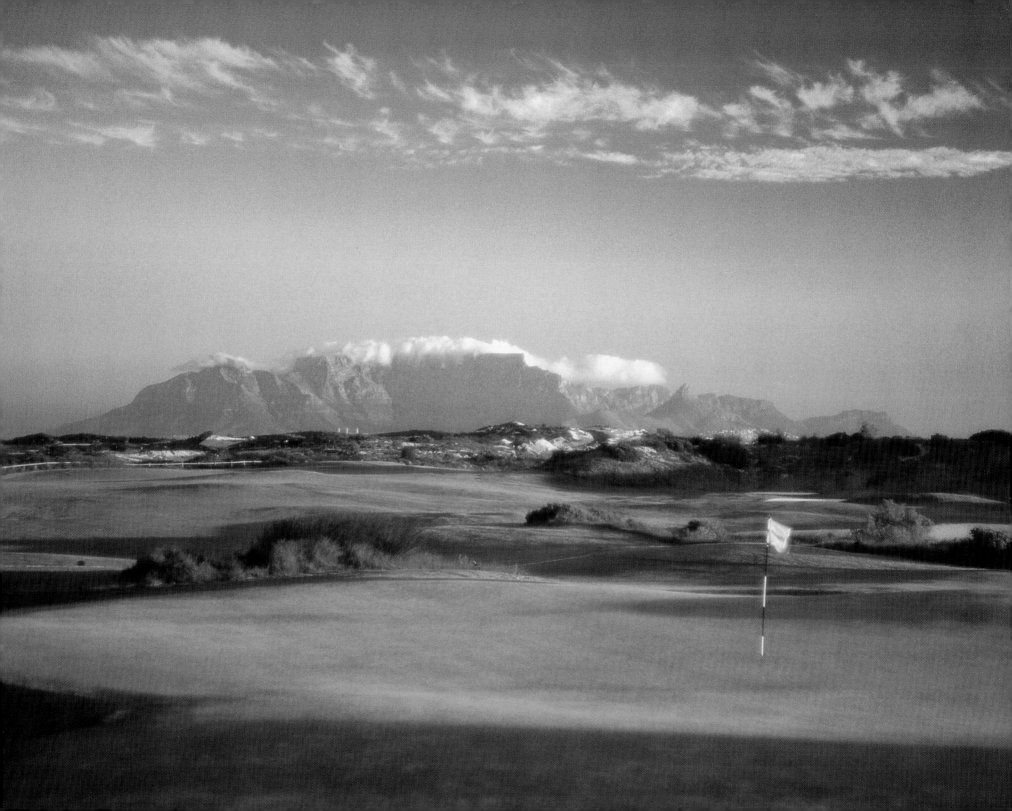

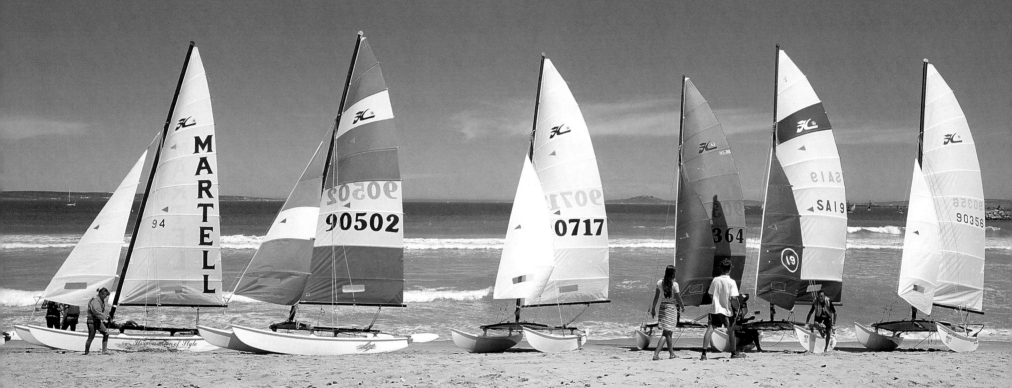

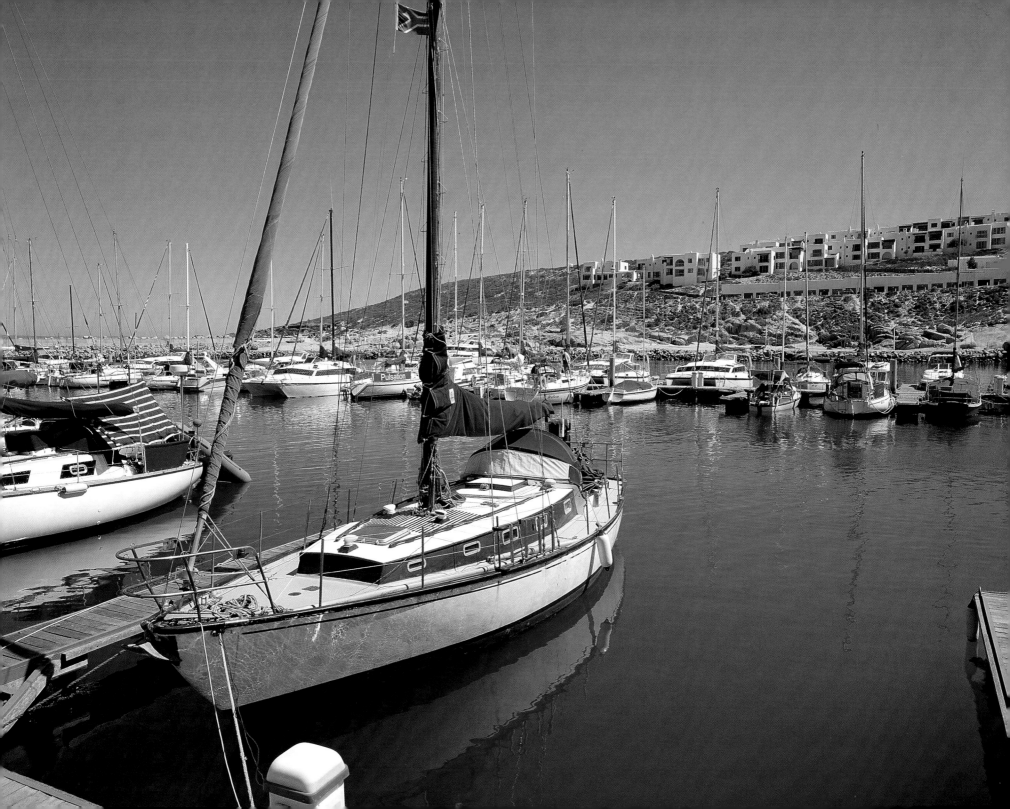

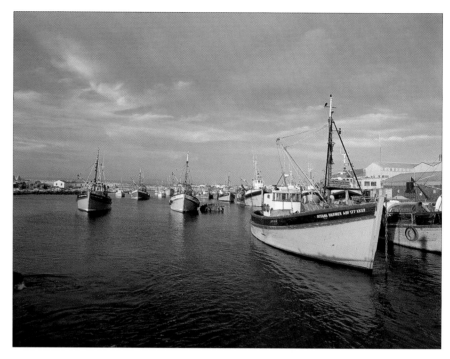

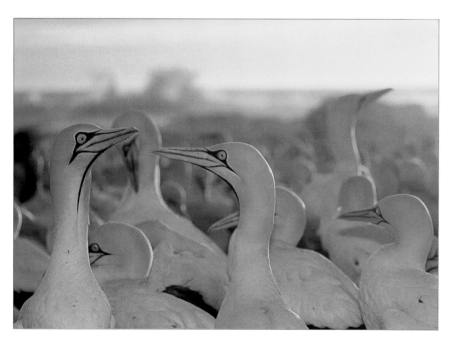

TOP LEFT AND ABOVE Having started out as little more than a quaint fishing village, Lambert's Bay lies at the heart of the West Coast and the local fishing industry remains important to both the economy and people of this West Coast town.

LEFT AND OPPOSITE The natural heritage of this strip of coastline, rugged and craggy in its simple beauty, is its most important asset. Apart from the region's abundance of wild flowers, it also boasts a prolific birdlife, most populous of which are the Cape gannets.

OVERLEAF, LEFT The rural landscape of cultivated lands and indigenous vegetation of outlying Stellenbosch is set against a pastel backdrop of the magnificent Helderberg range.

OVERLEAF, RIGHT The Stellenbosch district is backed by the magnificent range of the Simonsberg, named after the early Dutch governor Simon van der Stel.

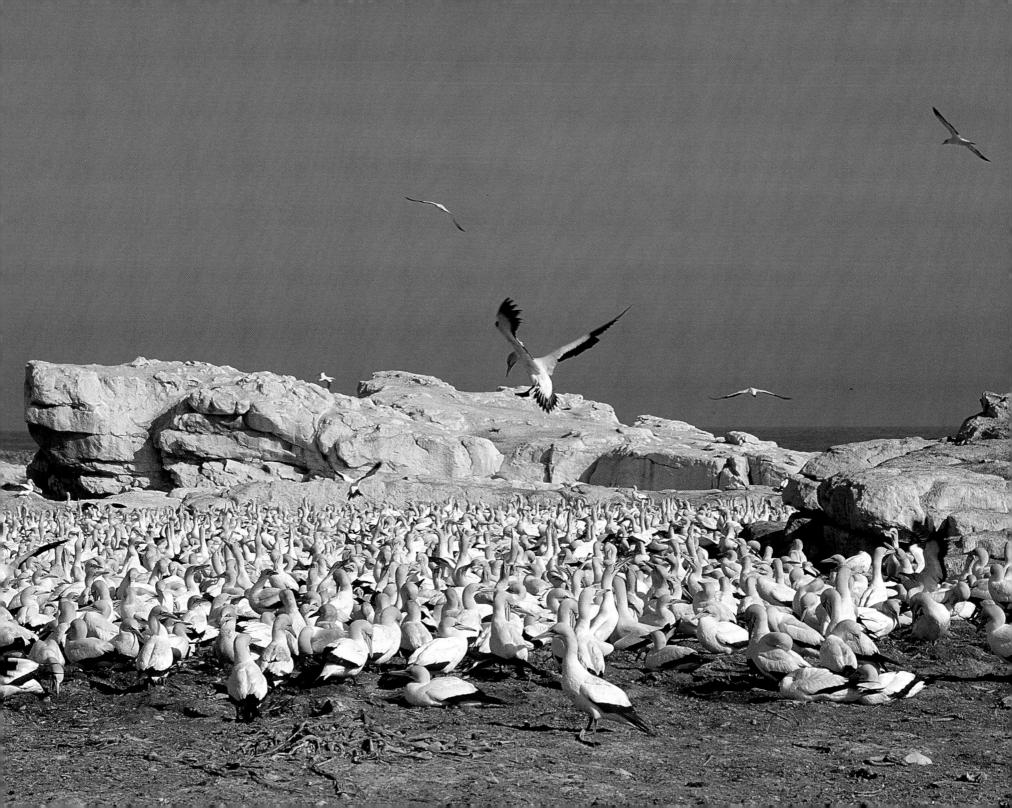

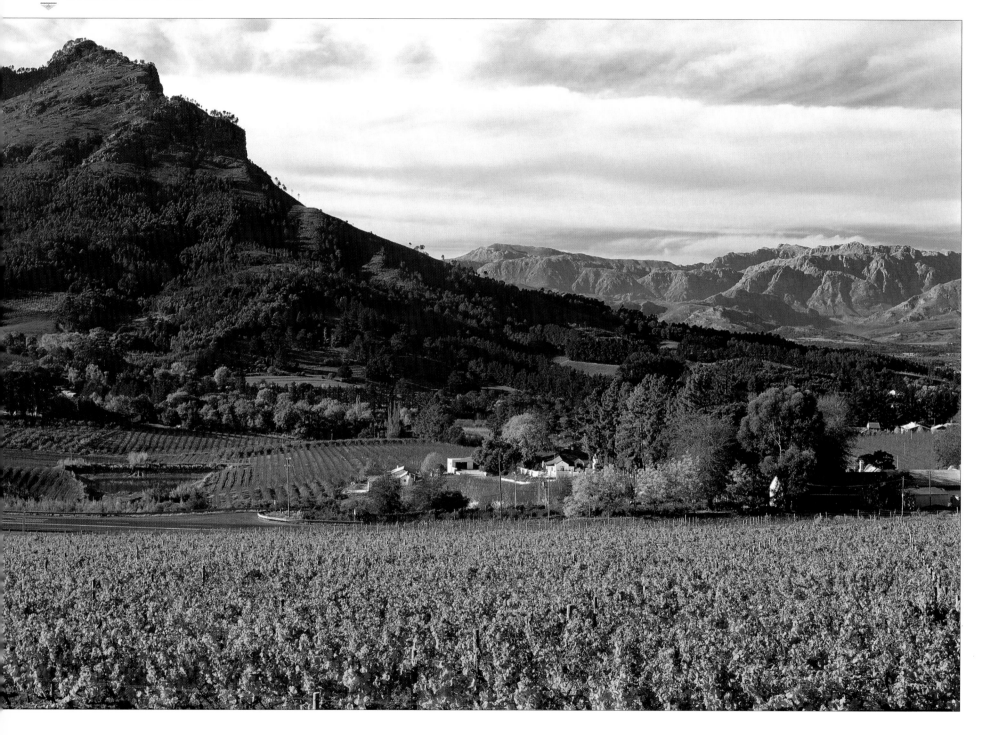

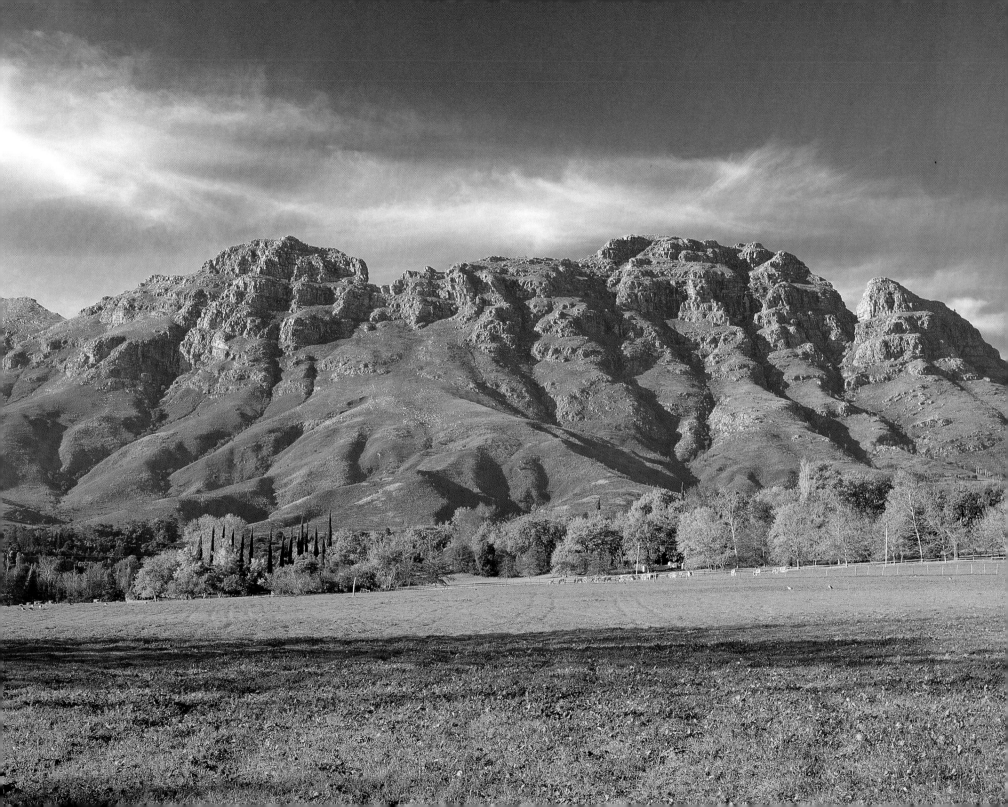

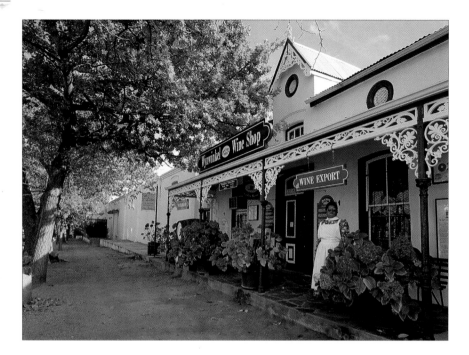

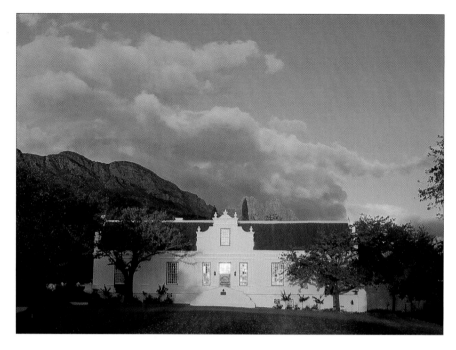

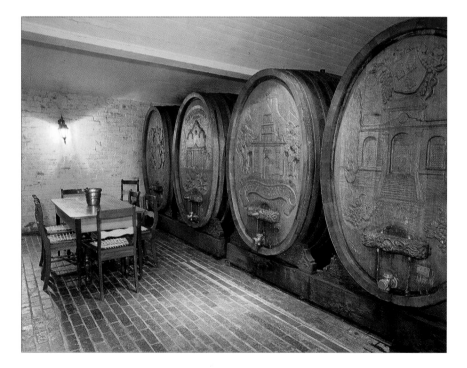

TOP LEFT The most renowned feature of Stellenbosch's Dorp Street is the quaint Oom Samie se Winkel, the Victorian-style general dealer that now also serves a wine merchant.

LEFT One of the Cape Wineland's many acclaimed wine estates, the cellars at Bergkelder boast a fine tradition of viticulture and are open to the public.

ABOVE Most of the district's old estates, such as Lanzerac, feature grand Cape Dutch homesteads that date back to the early years of viticulture at the Cape.

OPPOSITE The 1814 family home at Neethlingshof now serves as the famed Lord Neethling restaurant, whose wine list includes the wines of Stellenzicht, also owned by Neethlingshof's current landholder, Hans-Joachim Schreiber.

OVERLEAF, LEFT The Gydo Pass above Ceres was carved from the slopes of the Cederberg, most famed for the snowfalls that cover its peaks and slopes during the winter months.

OVERLEAF, RIGHT The towering spire of the Dutch Reformed church against the snow-capped range above Worcester marks the spot where early settlers to the region first gave thanks for the blessings of this picturesque and hospitable land.

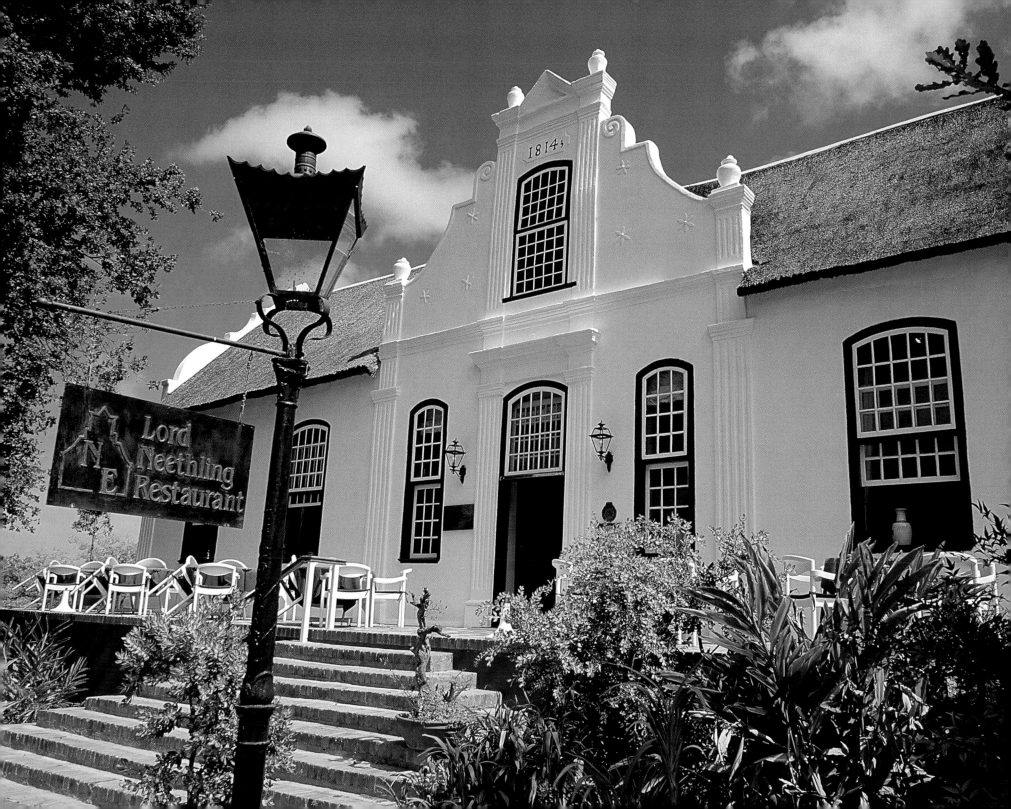

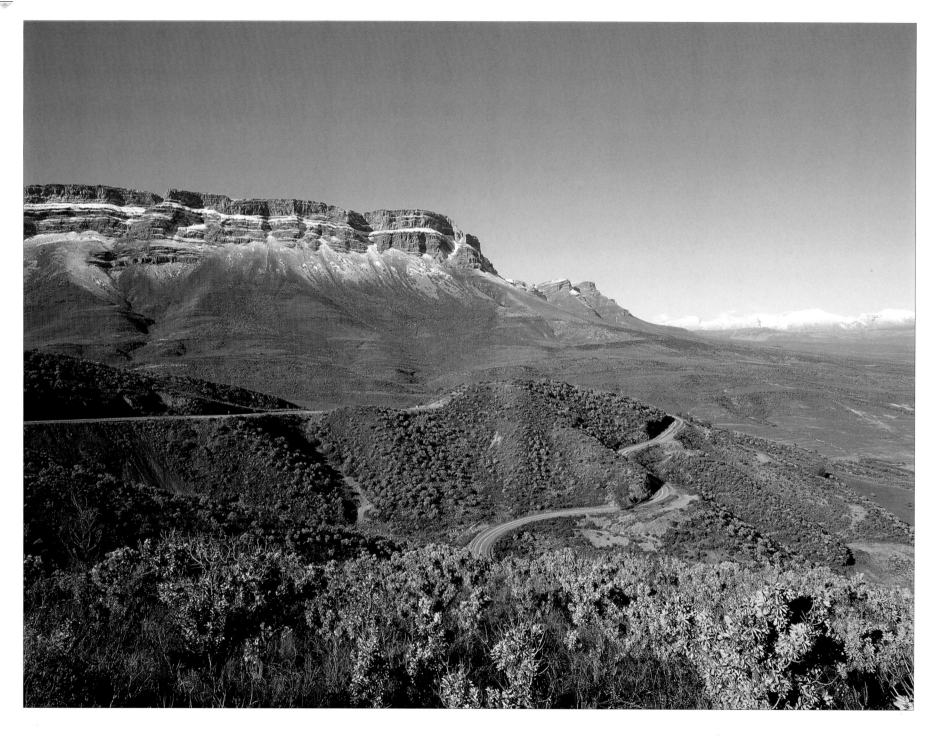

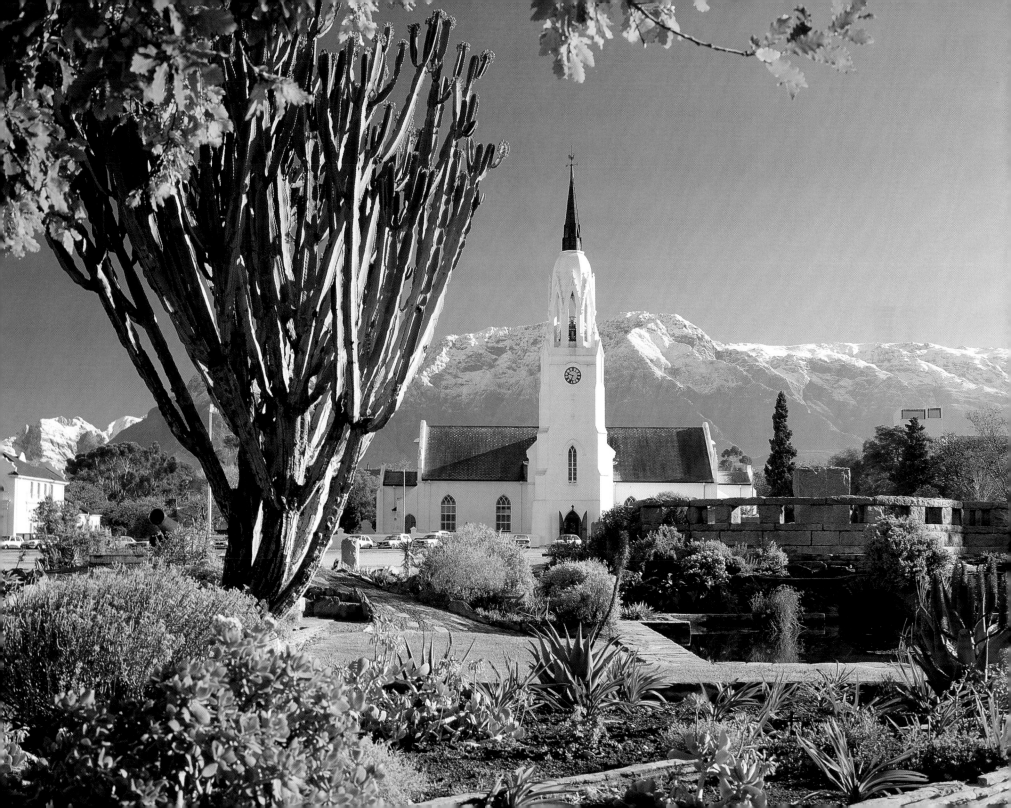

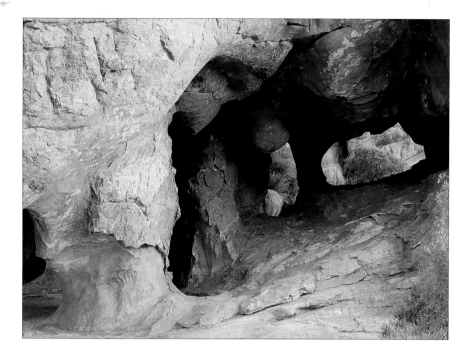

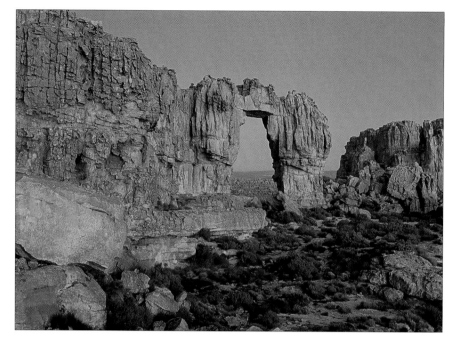

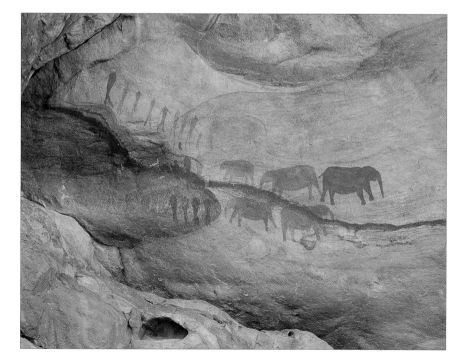

TOP LEFT The wondrous shapes and forms within the Stadsaal Caves at Matjiesrivier in the southern Cederberg were sculpted by thousands of years of erosion by wind and water.

LEFT The San rock paintings of elephants at Elephant Cave in the Cederberg are said to be illustrated by *shaman*s, or medicine men, following visions from their ancestors.

ABOVE The Cederberg's famed Wolfberg Arch is a 30-metre natural rock formation that overlooks the rugged landscape of the Tankwa Karoo and Bokkeveld mountains.

OPPOSITE At 20 metres, the Maltese Cross is the most recognisable landmark of the craggy Cederberg landscape.

OVERLEAF Although much of the landscape of the Hex River Valley is cultivated, the emerald oasis that is this mountain pass marks the start of the mostly arid lands of the Karoo.

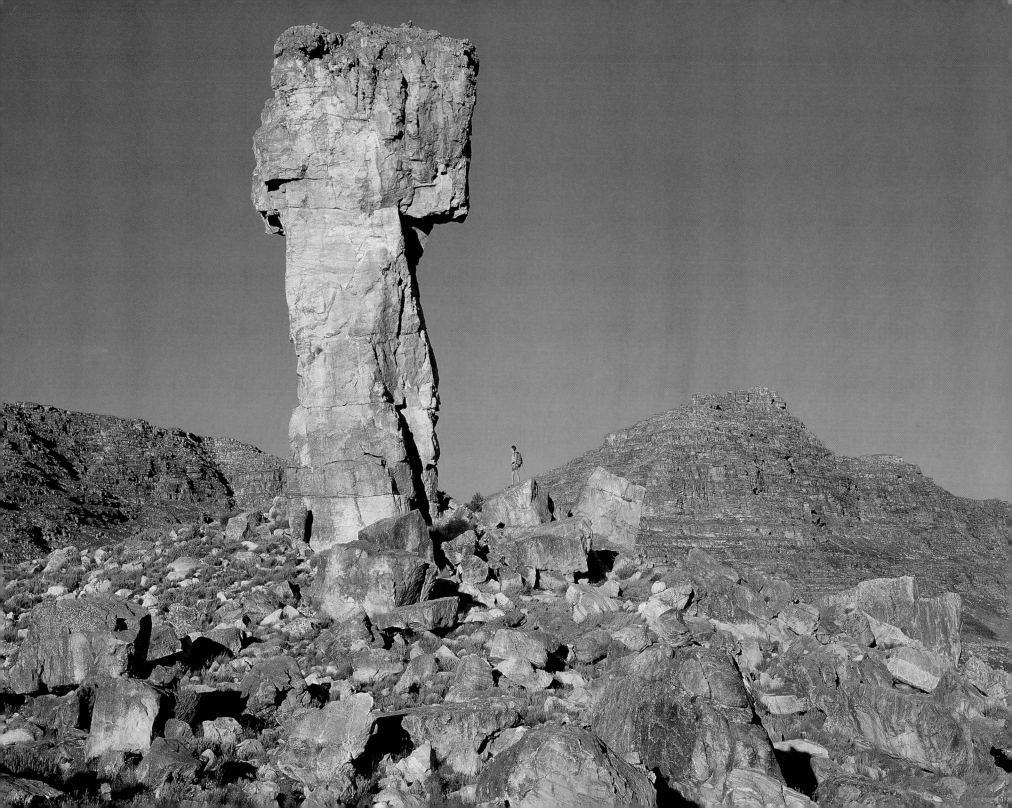

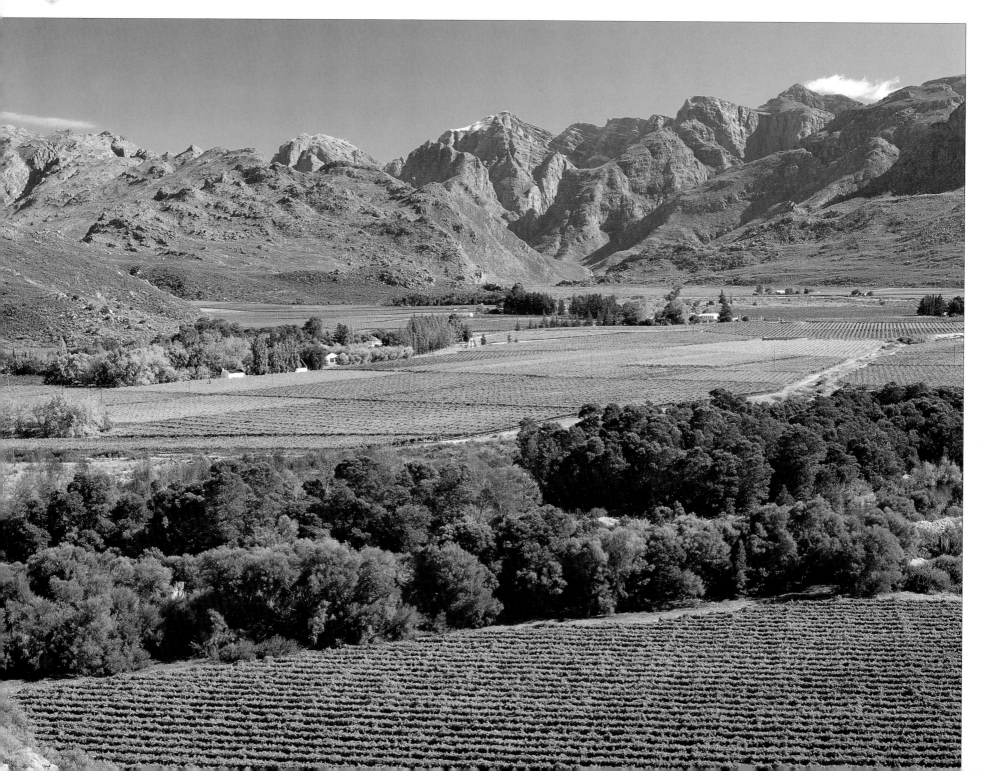

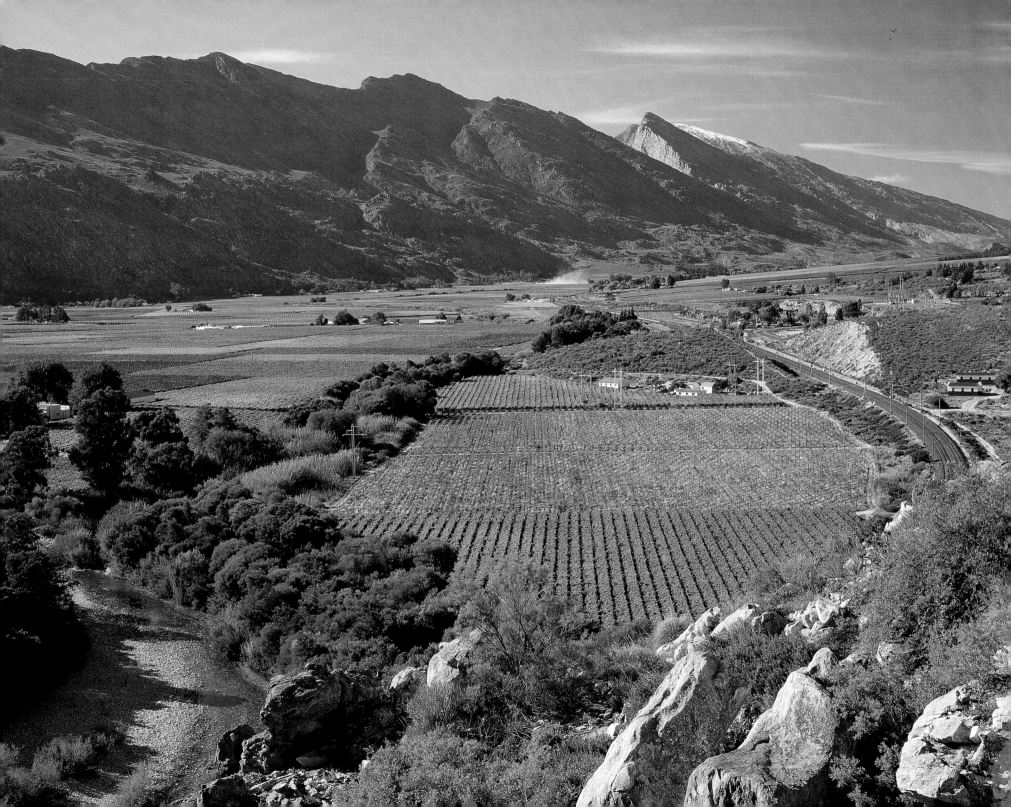

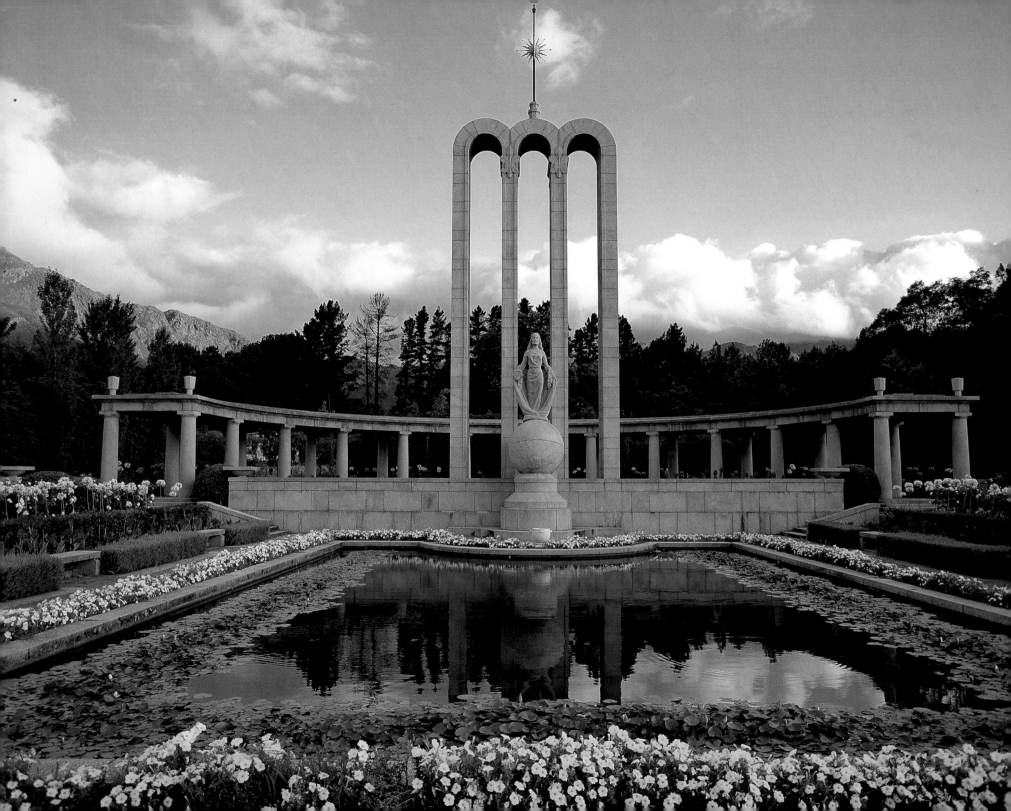

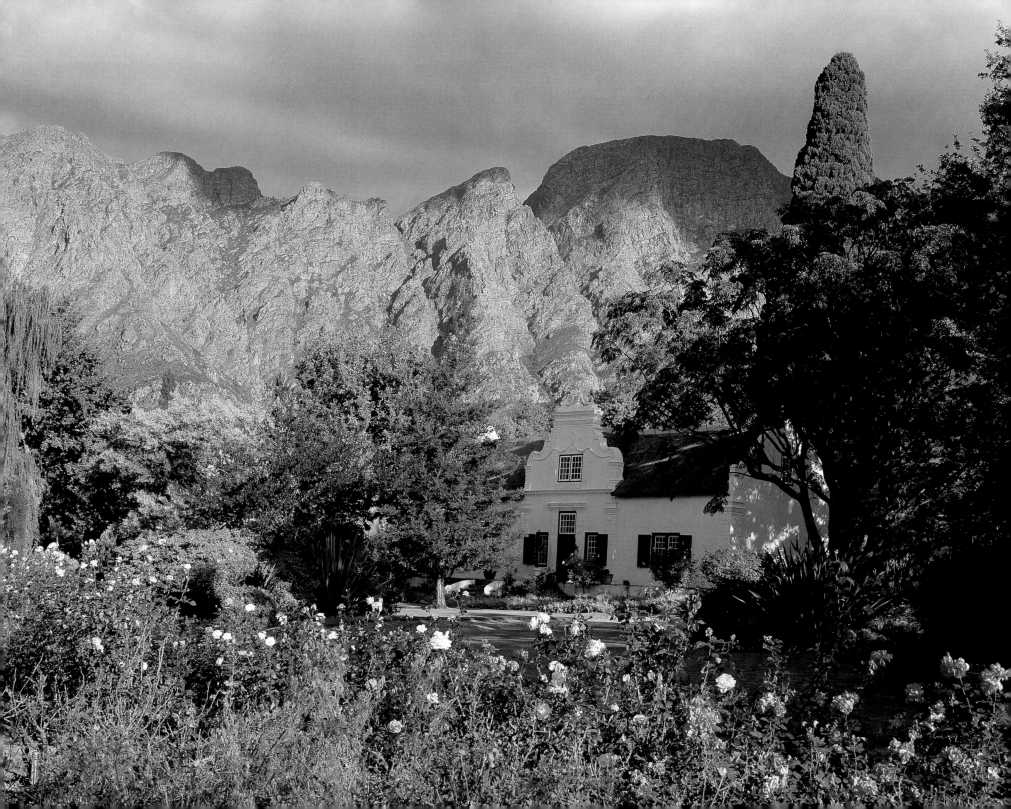

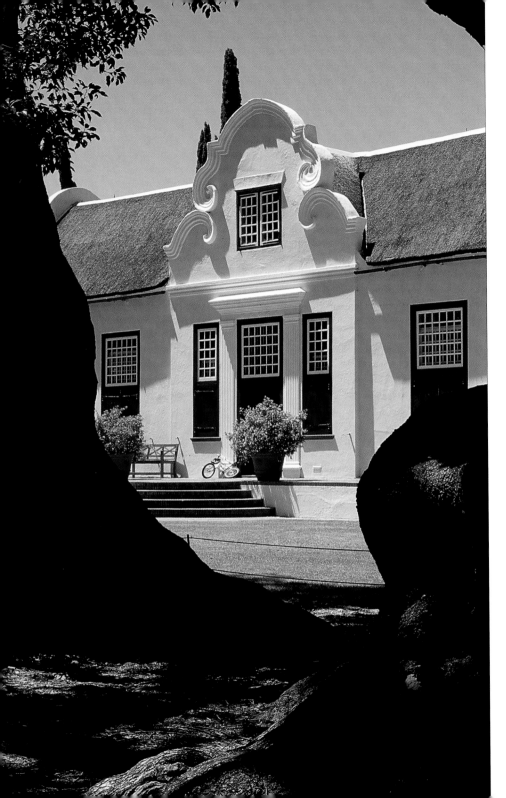

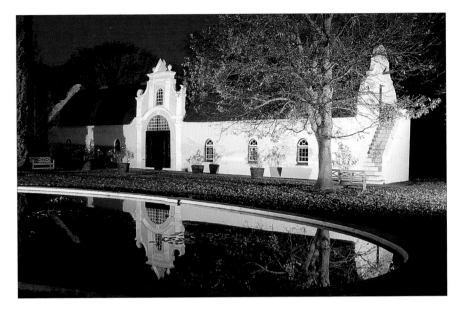

PREVIOUS PAGE, LEFT The Huguenot Monument on Lambrecht Street in historic Franschhoek – meaning 'French Quarter' – is testimony to the religious freedom of the French Huguenots who settled in the valley in the 17th century.

PREVIOUS PAGE, RIGHT The private estate of Le Dolphine is enveloped by the lush lands of the mountain slopes that enclose Franschhoek: Wemmershoek, Franschhoekberg and the Groot Drakenstein.

LEFT The imposing manor house at the Vergelegen estate, one of the most highly regarded wine producers of the Franschhoek district.

ABOVE The impressive library that graces the Vergelegen wine estate.

OPPOSITE Vergelegen, one of the country's oldest and most acclaimed wine-producing estates, is set in a garden of extraordinary beauty.

OVERLEAF, LEFT The Old Harbour of Hermanus is still in operation, but its second most popular attraction are the old fishing boats – some dating to the mid-1800s – on display here, and Harbour Museum, which tells the story of the local whaling and fishing industry.

OVERLEAF, RIGHT During the holiday season, Gordon's Bay bustles with holidaymakers, and caters largely for the leisure requirements of visitors who flock to the seaside resort.

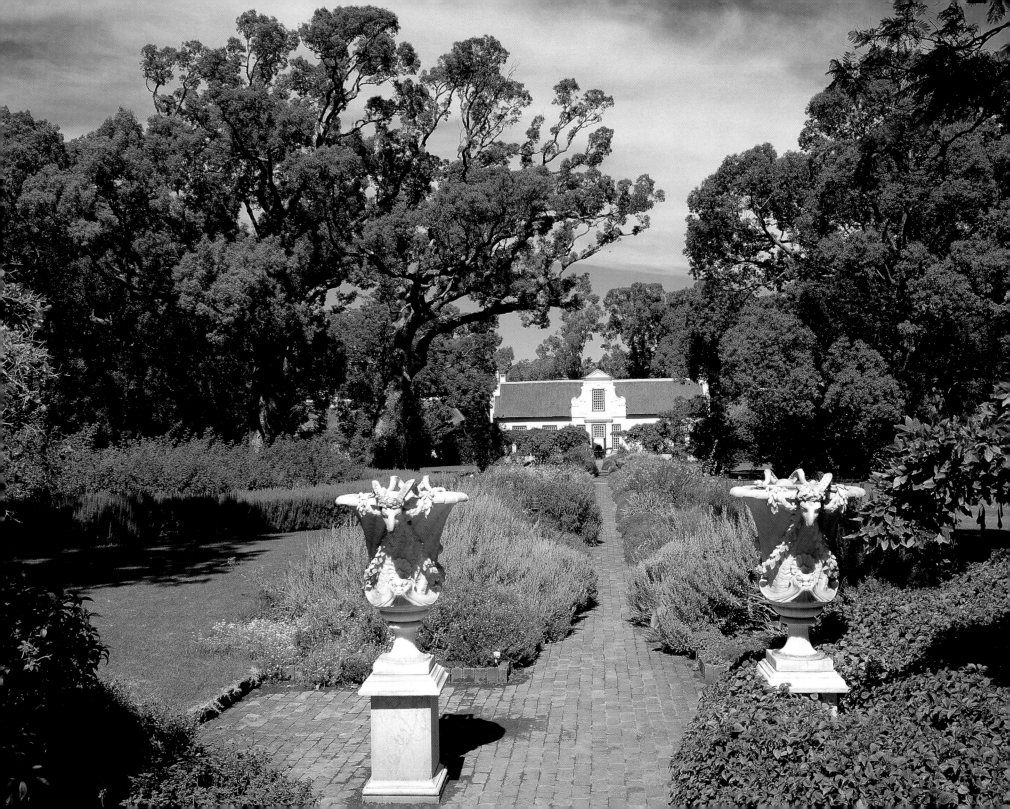

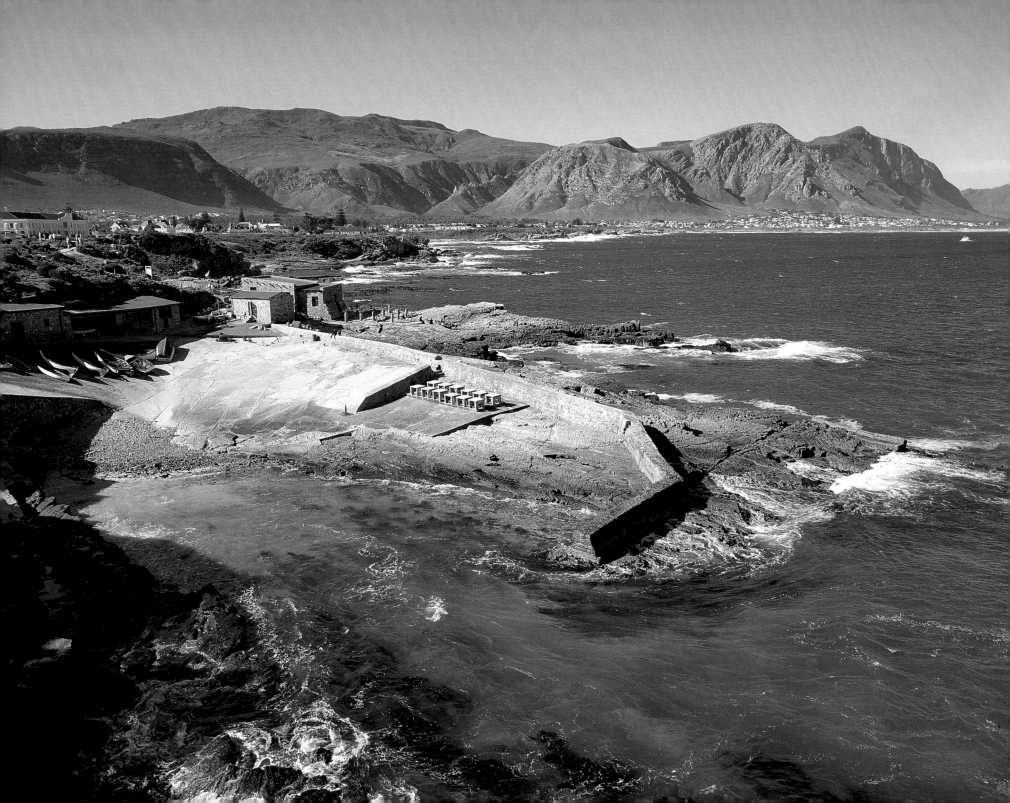

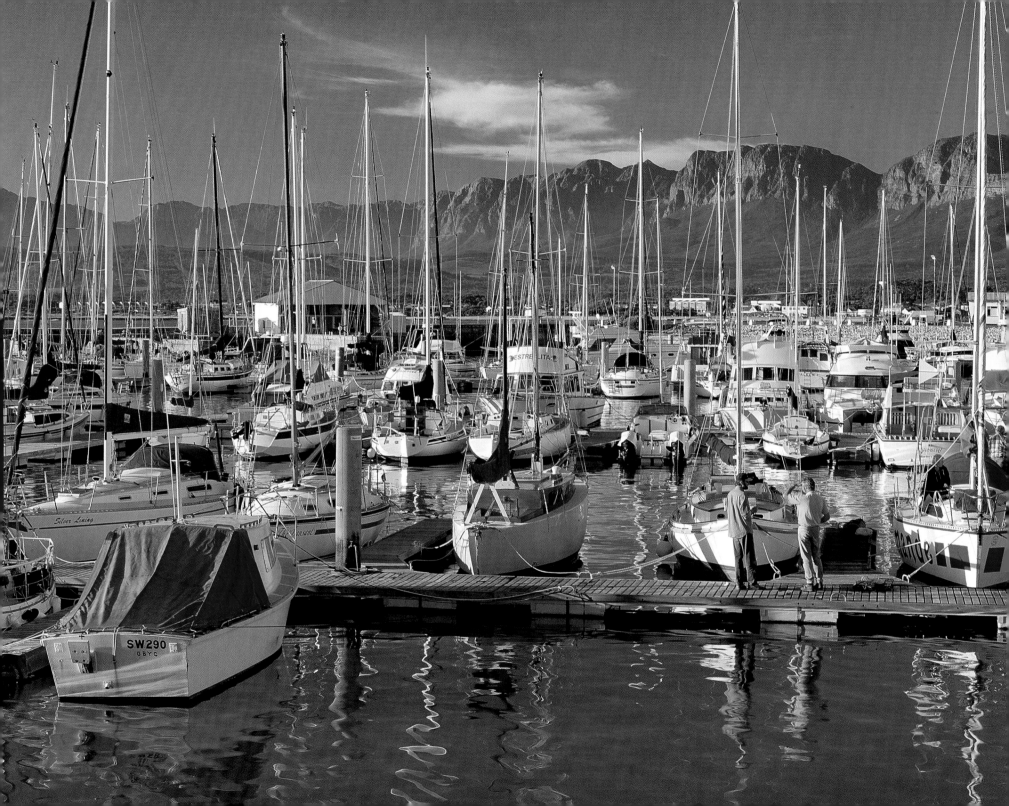

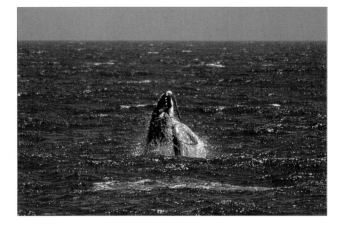

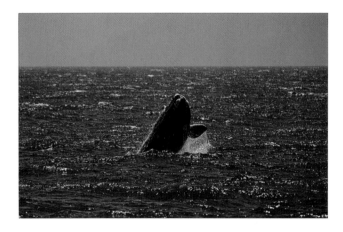

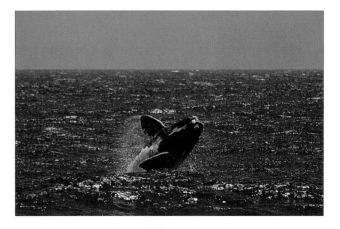

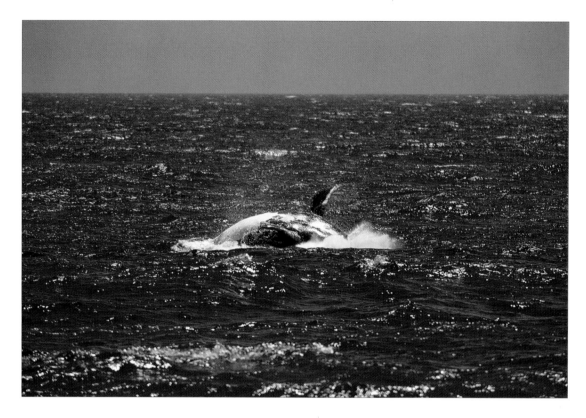

THESE PAGES The most popular spot to see the migrating southern right whales is Walker Bay in Hermanus, the heart of the Whale Route, and one of the best sites for whale-watching in the world. The whales spotted along this coast are attracted by the warm waters and abundance of food, and it is here that they give birth to their young, nursing them until they are strong enough to return to icier southern climes.

OVERLEAF, LEFT Much of the southern Cape coast is dotted with historic little villages, but the most charming must be the little town of Stilbaai, with rows of thatched fishermen's cottages on the shore and fishing boats bobbing in its often turbulent waters.

OVERLEAF, RIGHT L'Agulhas and its famed Cape Agulhas Lighthouse, erected in 1848, marks the southernmost tip of Africa and the confluence of the Indian and Atlantic oceans.

FINAL PAGE The boom in the local travel industry and the increased media attention visited on South Africa, and in particular Cape Town, means that the Mother City has consistently topped the list of Africa's most-visited destinations.

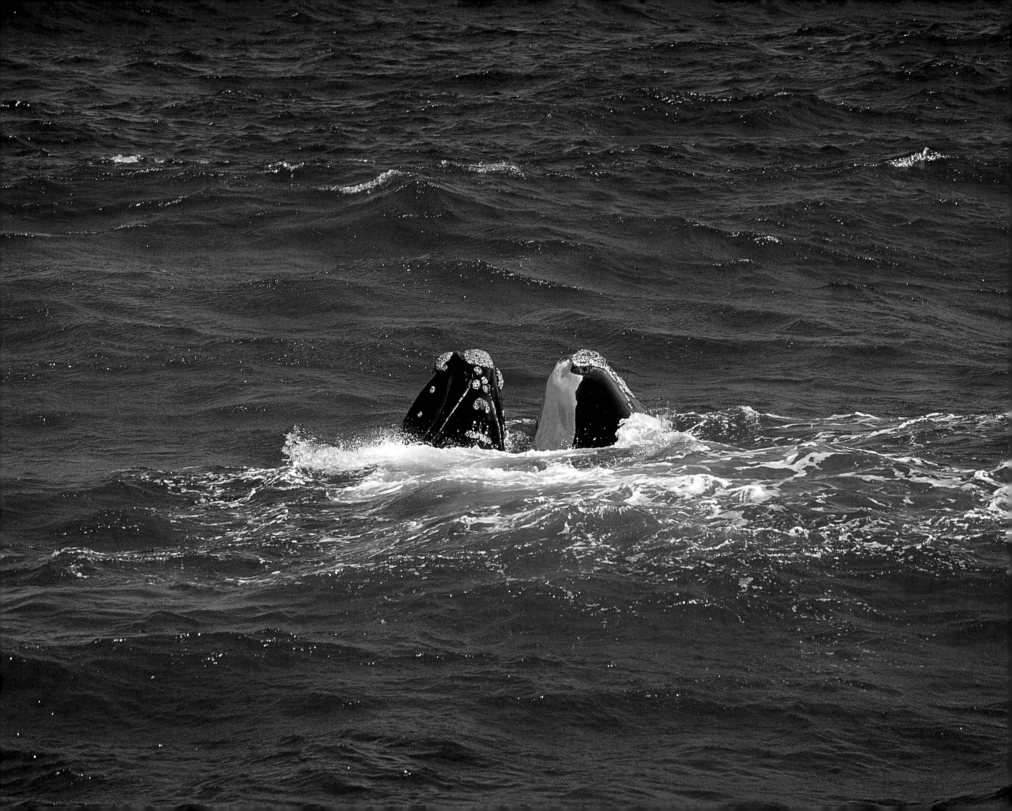

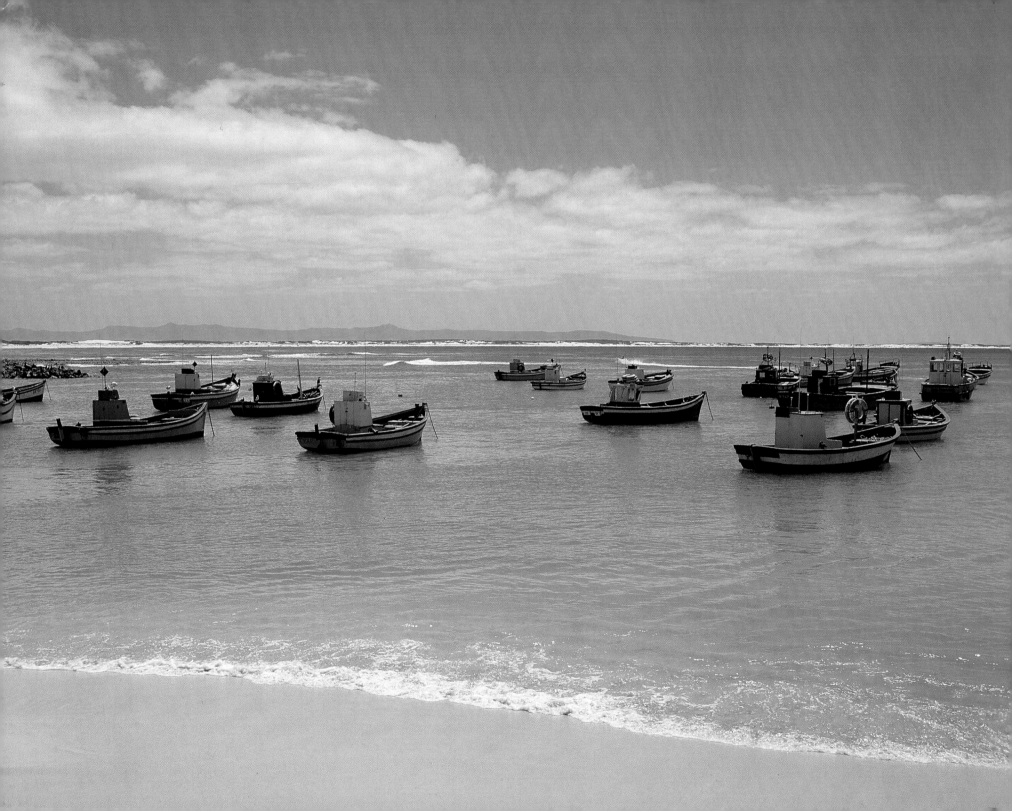

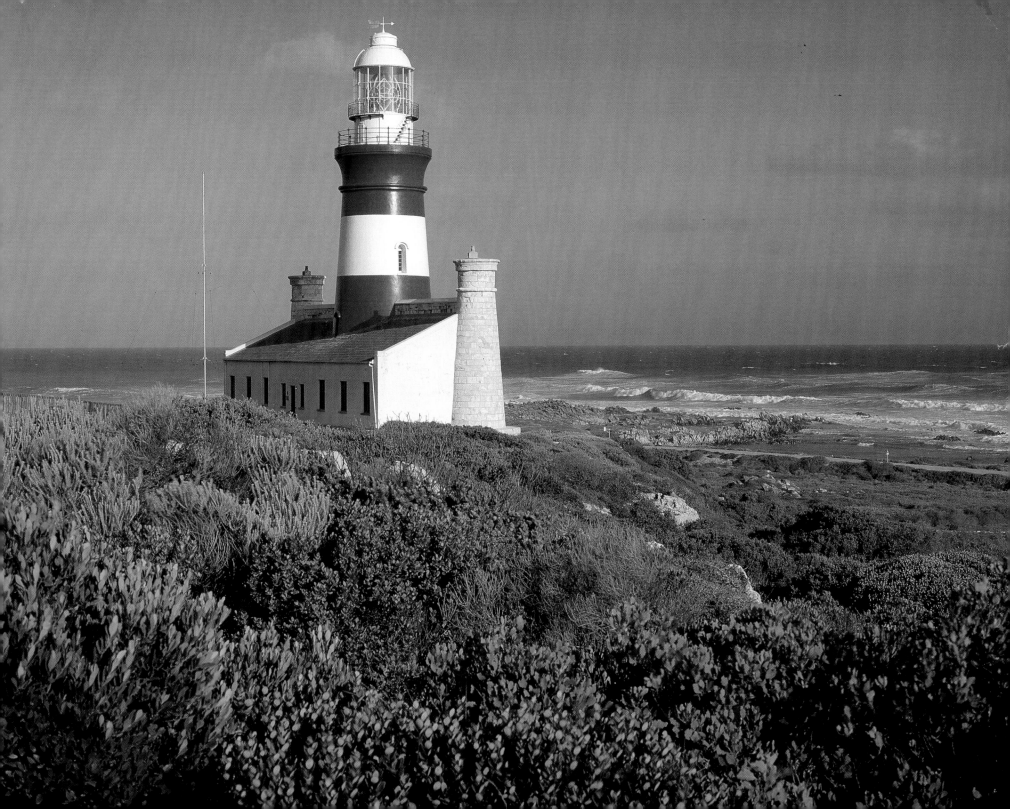

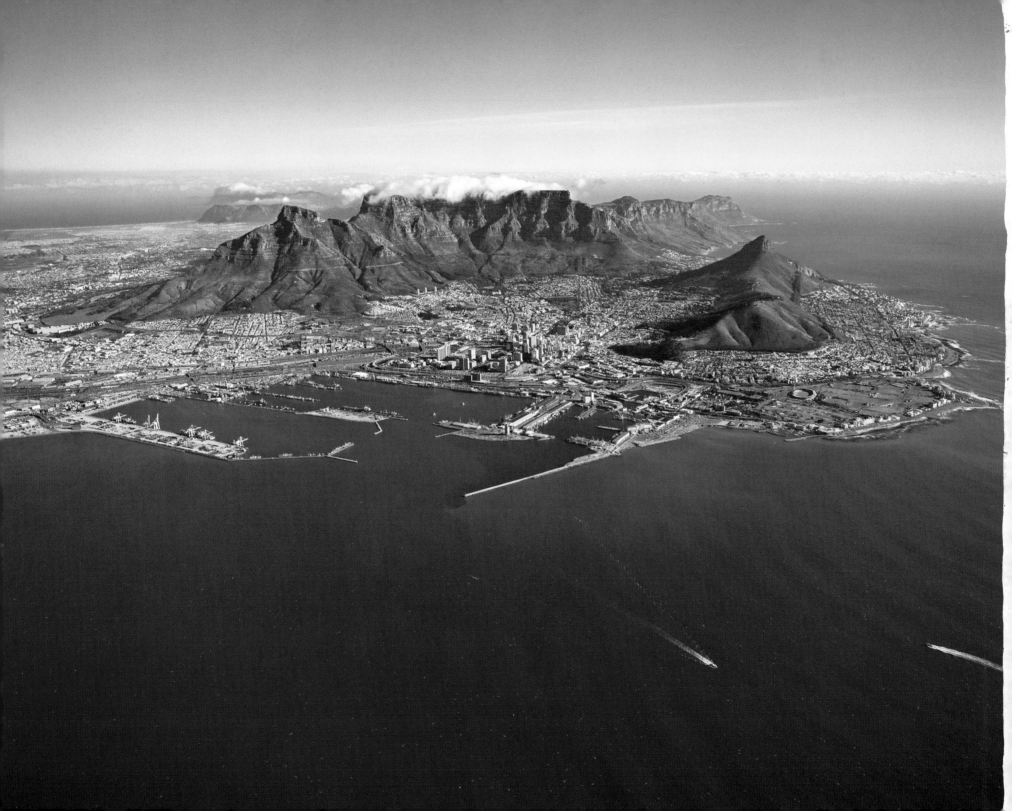